OUTDOOR PHOTOGRAPHY

Aonach Mor, Scotland: Hoar frost crystals on a foreground rock add interest, and it's unlikely a tour bus will reach here!

OUTDOOR PHOTOGRAPHY

PEOPLE • ACTION • PLACES

by
Jon Sparks and Chiz Dakin

2 POLICE SQUARE, MILNTHORPE, CUMBRIA LA7 7PY
www.cicerone.co.uk

© Jon Sparks and Chiz Dakin 2002, 2011

Second edition 2011
ISBN: 978 1 85284 646 6
First edition 2002
ISBN-10: 1 85284 356 X
ISBN-13: 978 1 85284 356 4

Printed by KHL Printing, Singapore

A catalogue record for this book is available from the British Library.
All photographs are by the authors, as indicated – Jon (Sparks) and Chiz (Dakin).

DISCLAIMER

Every effort has been made to ensure that the instructions and techniques in this book cover the subject safely and in full detail. However, the authors and publishers cannot accept any responsibility for any accident, injury, loss or damage sustained while following any of the techniques described.

Front cover (main): Above Easedale Tarn, Lake District (Jon)
Back cover: On Parlick, Forest of Bowland (Jon)

CONTENTS

FIRST LIGHT 9

1 BEYOND POINT AND SHOOT 11

2 HARDWARE FOR THE OUTDOOR PHOTOGRAPHER 27

3 PLACES AND PEOPLE 53

4 WILDLIFE AND NATURE 83

5 WALKING AND RUNNING 109

6 ROPED SPORTS – CLIMBING, ABSEILING AND MOUNTAINEERING 121

7 WHEEL SPORTS 135

8 ON THE WATER 151

9 UNDERWATER 167

10 TREKKING AND EXPEDITIONS 179

11 EXTREME CONDITIONS 193

12 BRING IT BACK HOME 213

13 PUTTING IT ALL TOGETHER 231

APPENDIX I Geekspeak 240

APPENDIX II Movies 243

APPENDIX III Links and further reading 247

ABOUT THE AUTHORS

Chiz Dakin is an award-winning freelance photographer, with particular interest in outdoor themes such as landscape, adventure sports and travel. Oh, and she never thought she'd say this, but wildlife too.

She's a keen mountain walker, scrambler/mountaineer and cyclist and enjoys a variety of watersports (sea-kayaking, diving and windsurfing in particular) whenever she gets the chance.

She also finds photography is a great excuse to indulge in her passion for travelling. She's now visited some part of all seven continents, and has made some epic trips, such as driving from Cairns to Perth via Broome in Australia, semi-circumnavigating Antarctica in an icebreaker and summiting a peak over 6000m high in Ladakh. She also publishes her own range of greetings cards, and runs workshops on outdoor photography in Derbyshire and Southern Spain.

Chiz lives in the Derwent Valley Heritage Corridor, very close to the Peak District.

She was the winner of the Outdoor Writers and Photographers Guild (OWPG) Award for Excellence in Photography in 2008.

Other Cicerone guides by Chiz
Cycling in the Peak District

Jon Sparks has been passionate about photography and the outdoors since childhood. A six-week trek in the Karakoram Mountains, Pakistan, in 1990 was a turning-point; the learning curve was steep, but the pictures were rewarding. His first exhibition soon followed, and four years later he became a full-time photographer.

Jon specialises in landscape and outdoor subjects, and his picture library includes images from New Zealand, Canada, Morocco, Australia, Pakistan, Jordan and more than 20 European nations. He also supplies images to the global libraries Corbis and Alamy. He publishes Lake District greetings cards and postcards, and so far has his name on over thirty books, including guides to every current Nikon digital SLR.

Jon is a member of the Outdoor Writers and Photographers Guild. He lives in Garstang, Lancashire, close to the Forest of Bowland – which can be a distraction from writing.

Other Cicerone guides by Jon
The Lancashire Cycleway

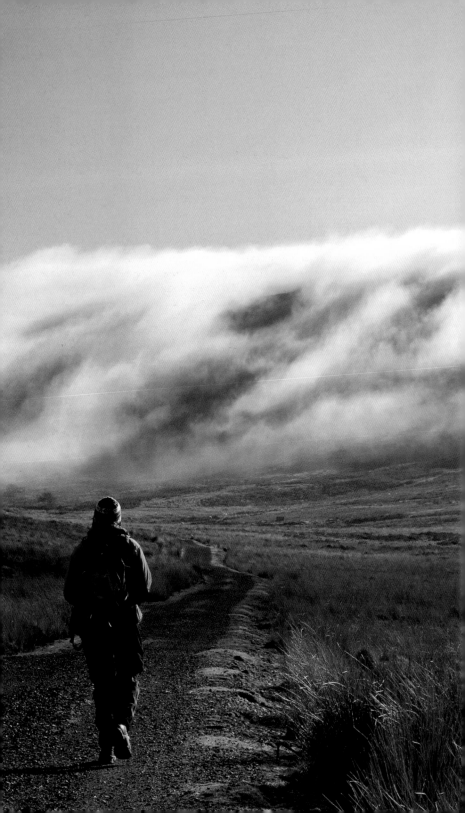

FIRST LIGHT

'Which comes first, photography or the outdoors?' For us this is like the question of the chicken and the egg. The two are inextricably entwined. However, there's no confusion as far as this book is concerned.

This book is written for people who love the outdoors and, above all, for people who love doing things in the outdoors. We assume that you want your photographs to reflect that passion. It's not about winning prizes at the camera club, or impressing people with your latest slide show. What it's about is getting out there. You want pictures that capture what it's like and how it makes you feel.

Photography should add to the outdoor experience. It shouldn't get in the way. If it helps you focus your mind on the texture of a rock or the play of light on a waterfall, it enhances your experience. If all you can think about is filters and f-stops, it does just the opposite.

However, if you're serious, photography can't just be an afterthought. Ideally it will be an integrated part of your outdoor activity. And if you are serious, you want to be in control of the picture-making process. You can't control what you don't understand. Blindly relying on camera automation leaves you clueless when the pictures don't work out, and dilutes the satisfaction when they do.

With most things in the outdoor life, the most interesting place is around the edge of the comfort zone. You don't improve your rock-climbing grade by trying to jump straight from VS to E6, but by testing yourself on a few HVS routes, consolidating at that grade, and then progressing again to E1. It's the same with photography. Think about what you're trying to achieve with your shots and where you'd particularly like them to improve. Then think about moderate, manageable steps that you might take to bring about these improvements.

A decent automatic camera will give you good results most of the time, but some understanding of the process helps you recognise when you need to take charge. This book will focus on understanding rather than 'technique'. It will use as little technical language as possible, but won't shy away from it when it is necessary. Essential concepts will be explained as clearly as possible. The basics of photography are not complicated, and certainly not rocket science.

To be an integrated part of your outdoor activity, photography must be light, fast and simple. This does not mean being casual or sloppy. Like the rest of your outdoor life, the more you put in, the more you get back. In photography, much of this input requires an investment of nothing more than time and thought. And much of this can be done when you're indoors.

In the end, it's your outdoor life and they're your photographs. What you want from your pictures isn't necessarily what we want, or anyone else wants. Everything in this book is based on experience, and it works for us, but that doesn't always mean it will work for you. This much we can say: it will be worth trying.

◄ Approaching Black Clough, Forest of Bowland (Jon)

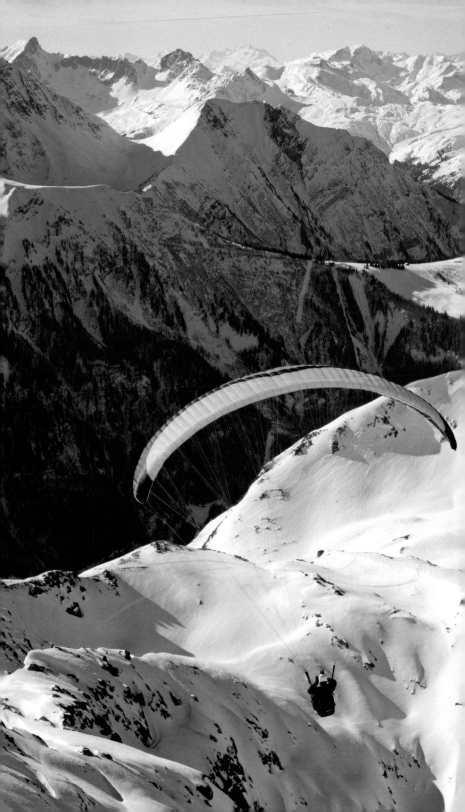

1 BEYOND POINT AND SHOOT

FIRST THOUGHTS

What's wrong with point and shoot?

It sounds like such a great idea. You point, you shoot, you get the picture. It sounds like exactly what we want – light, fast and simple.

The first thing wrong is that 'point and shoot' misses out one essential first step. It really should be 'see, point and shoot'. This may seem obvious, but it does no harm to state it. Seeing is a vital part of photography. Seeing is the main reason why we want to take pictures in the first place. And there's more to seeing than just going around with your eyes open. You need your mind open too.

So something you see makes you want to take a picture … But what, exactly? Maybe you come around a corner on a trail and a wonderful view suddenly opens up before you. The natural impulse is to grab the camera and get a picture. But if you take a second to think about a few possibilities, you'll almost certainly get a better picture.

What is it that makes the view so wonderful anyway? If you've been walking through a gloomy forest for five hours, almost any open view might seem pretty wonderful, but the photograph can't directly convey your state of mind. A series of photographs might tell the story, but a single shot can only show the view you saw (and it doesn't always manage that!).

Fell End and Pendle Hill, Lancashire (Jon)
It's often helpful to ask why you are taking a particular shot

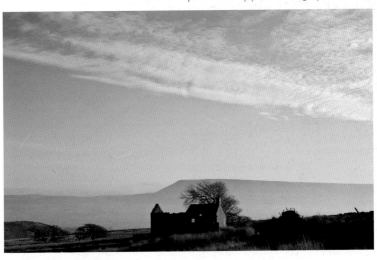

◄ *Alpine paraglider, Chamonix (Chiz)*
Being able to react quickly to changing light or unpredictable action is great, but this still requires a bit more than just 'point and shoot'

What you could do is use the last few trees to frame the view, which will at least give an impression of the way the view opened up. However, it may be obvious that by going on a bit further, you'll open it up even more. Of course, if you then decide that the framed view would have been better, you might have to backtrack.

There may be a fabulous array of peaks filling the skyline while the foreground is pretty boring. In this case you might frame the picture so it concentrates just on the peaks. On the other hand, there could be a deep green valley drawing the eye towards those peaks, in which case you might frame the shot quite differently.

At any moment there's a huge range of possibilities. You can give a group of people identical, totally automatic, cameras and send them on the same walk and you will never get two pictures exactly alike. Even if you never think about focusing or exposure – assuming that the camera can handle all that – every photograph you take is the result of a choice. Thinking about that choice, rather than just reacting and letting it happen, will make your photos a lot stronger. Why are you taking this shot? What is it you want to say? What kind of picture do you want it to be?

No doubt someone, somewhere, has estimated how many photographs have been taken since the very first one in the 1840s. Undoubtedly the number is many billions. And in every single instance, there was a reason for taking the shot. However, all too often, it's far from obvious afterwards what that reason was. And one of the principal reasons for this is that, all too often, the photographer was none too clear about it in the first place.

Another basic problem is that 'point and shoot' seems to promise that what you see is what you will get. In fact it never is. This is not an exaggeration but the simple truth. What you see through the viewfinder, or on the LCD screen, is not the same as what you see when you look directly at your scene or subject. The real world hardly ever packages itself in neat little rectangles.

Reality has four dimensions and a photograph has only two. The third and fourth dimensions – depth and time – can only be suggested in a photograph. This might seem to be a limitation, but in fact it may be a strength. 3D movies may be almost commonplace and 3D TV might just catch on, but 3D photography has been around a lot longer without ever really getting anywhere; it was more popular a hundred years ago than it is now. Similarly, movies and video have taken their place alongside still photography without ever threatening to replace it. Photography is irreplaceable; in its ability to crystallise an instant, it appeals to something deep within us.

So photography still matters – and isn't that why you've bought this book? But to get the best from our photography, we need to think photographically. That doesn't necessarily mean becoming obsessed with shutter speeds and f-stops. Suppose that the camera is clever enough to get that side of things right; much of the time, it probably is. But the camera can't decide what to point at or when to shoot. Far from being trivial, these are absolute fundamentals of photography.

WHAT TO POINT AT

Knowing why you're taking the shot is the first step. Knowing what you actually want in the shot is the next. What you leave out is just as important as what you keep in. This is where you really have to use your eyes properly, whether you're looking at the scene directly or through the viewfinder.

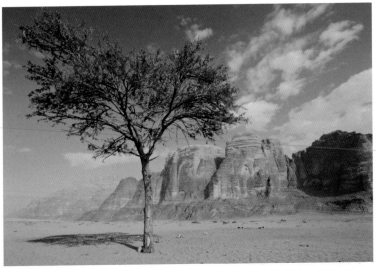

Wadi Rum, Jordan (Jon)
Very different results from two views of the same tree taken less than four minutes apart
(timing recorded by the camera)

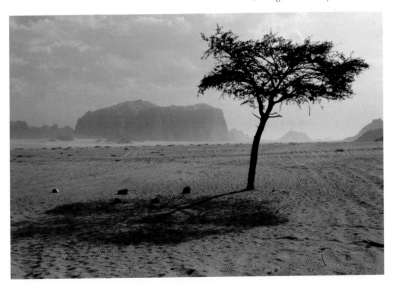

Seeing is something most of us take for granted. That's part of the problem. Seeing is more complex than we realise; 20:20 vision doesn't mean you see everything. It's well worth thinking a little more deeply about how we see.

Our eyes work in a dynamic way. In fact what we 'see' is controlled by the brain as much as by the eyes. This gives us the ability to see 'wide-angle' and 'telephoto' views almost simultaneously. When you spot a friend in a crowded room, your eye

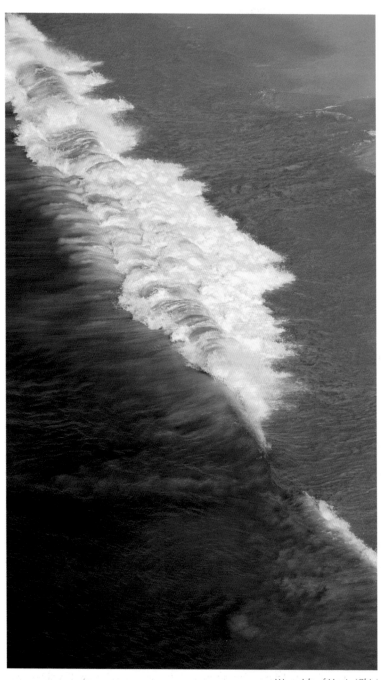

Wave, Isle of Harris (Chiz)
What you leave out is just as important as what you keep in; simplicity is often the key

does not physically zoom in on them. It's your brain that does the zooming. We all have a 'mental zoom lens' that – most of the time – operates without our even being aware of it.

Suppose you decide to take a quick photo of your friend before they realise you've spotted them. You pick up the camera, point and shoot. All too often the result is a photo of a crowd, one of whom happens to be your friend. This happens because you looked through the viewfinder but your brain was still 'zoomed in' on that one person and disregarded everyone else. What you saw – or thought you saw – was not what you got.

Seeing your friend in that instant only gave you the potential for a picture. The picture you actually got was cluttered up by all the other people. If you'd only stopped for a fraction of a second to look at the viewfinder you would have seen them. If you'd seen them you could have zoomed in – with a real zoom lens this time – or else physically moved closer. Of course in moving closer you might have missed the picture. But if you couldn't get it from where you were, you're no worse off.

Seeing what's actually in the viewfinder (or on the LCD screen) is a big step on the road from snapper to photographer. It doesn't demand any extra equipment, nor does it require you to learn loads of technical stuff. It just takes a bit of thought. The more you think about it, the more you practise, the easier it gets. Before too long it's practically automatic. And it's a great leveller. The 'gear freak' who spends thousands on the latest state of the art equipment but neglects this aspect will get fewer really good shots than someone with a simple camera and an engaged brain.

Seeing what's in the finder is fine, but an awful lot of time and trouble can be saved when you start to anticipate what you'll see there. This is one aspect of what's often called visualisation. This, too, you can develop easily and naturally – but only if you start by seeing.

Visualisation means that you can see your friend across the room and your brain can zoom in on the potential picture – but without even picking up the camera you know that you won't actually get the shot from where you are. And if you can visualise the shot and work out where you actually need to stand, still without picking up the camera, you'll be a lot less conspicuous too. This does improve the chances of getting a spontaneous shot, rather than one of someone reacting to the presence of the camera. A crowded room may be the antithesis of the wide open spaces, but the principle is just the same whatever you are photographing.

Indoors or out, the person who gets the best shots won't necessarily be the one who spends most time looking through the viewfinder. Photographer A looks through the viewfinder, moves a few paces forward, looks again, takes a step or two to the left, looks again, crouches down a bit, looks again, moves a step back right, looks again, and so on. Photographer B looks at the scene, moves about a bit, looks through the viewfinder, makes a couple of fine adjustments to their position, and takes the shot. Photographer A may get a good shot in the end. With a relatively static subject, such as some landscapes, the extra time may not matter. On the other hand, if the sun's just about to hit the horizon, time is of the essence, just as much as with action shots.

Of course C, who is just a snapper, wonders what all the fuss is about. He sees a nice view, points, and shoots. And afterwards? 'This was a lovely view. Pity about those two idiots with tripods in the foreground, though …'

WHEN TO SHOOT

Most photographs are taken in a tiny fraction of a second. This ability to catch a moment in time is one of the most distinctive aspects of photography. It doesn't quite define what photography is, since some photos may take a much longer time, but it is certainly a very important part of what makes photography special.

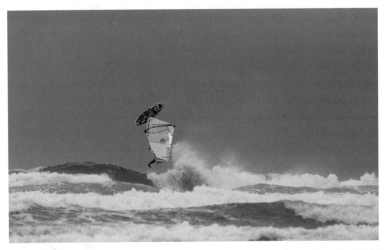

Wipeout, Newgale, Pembrokeshire (Chiz)
The ability to catch a moment in time is one of the most distinctive aspects of photography

Tom Sparks, Pentland Hills, Scotland (Jon)
This shot did not just happen. I spotted the potential in the arrangement of the trees and waited while nephew and dog walked on ahead

So it's no coincidence that the photographer considered by many to be the greatest of all, Henri Cartier-Bresson, is forever associated with the concept of 'The Decisive Moment'. This is summed up in his own words as follows:

Photography is the simultaneous recognition, in a single instant, of on the one hand the significance of a fact and, on the other, the rigorous organisation of the visually perceived forms which express and give meaning to that fact.

One (and only one!) of the things that makes Cartier-Bresson's images great is the super-precise timing that so many of them demonstrate. A moment sooner, a moment later, and the shot would have been utterly different. You can see the same sort of timing very clearly in the best sports photography.

Cartier-Bresson may not have planned every shot but he certainly didn't just 'get lucky'. No-one can be lucky that often. In another well-known phrase: 'chance favours the prepared mind.' In a photographic context, it's important to be both physically and mentally prepared. Physical preparation means having the camera ready to hand, with the right lens fitted for the sort of shot you anticipate. Mental preparation means that

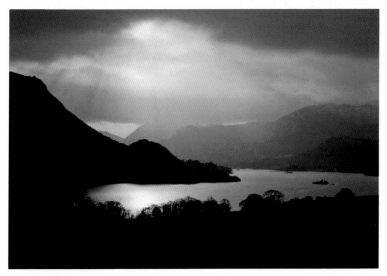

Ullswater (Jon)
Even in landscape photography, things can happen fast. A beam of sunlight may strike through heavy cloud, picking out a peak or lake for just a moment

you are actively looking for shots and thinking about the sort of opportunities that may arise. Even in landscape photography, things can happen surprisingly fast. A beam of sunlight may strike through heavy cloud, picking out a peak or lake for just a moment.

BASIC CONCEPTS

What you see is not necessarily what you get. Cameras seem to promise that it will be, but it's never completely true, and the picture can often differ radically from what you saw.

We've already hinted at some of the differences between what the eye sees and what the camera sees, like the two 'missing' dimensions of depth and time. These apply equally to drawing or painting, but there are some other more specifically photographic factors.

Sometimes the camera will see more than you do. Sometimes it will see less. Sometimes it will see differently. And sometimes it will do all three! Today, with digital cameras, it's much easier to compare what we saw with what the camera recorded. It really is worth looking attentively at those playback images, especially with important shots, to see how they measure up. For one thing, if they don't look quite how you wanted, you may be able to do something slightly differently and shoot again. For another, it all helps to build up an understanding of how the camera sees.

Life through the viewfinder

We've already given an example of the camera seeing more, the friend seen across a crowded room. Human beings tend to see what they are interested in: cameras are not so selective. Sometimes the result is that your intended subject almost disappears into its surroundings – like your friend into the crowd. At other times the result may be that the intended subject is sitting in the middle of the frame but surrounded by acres of empty space.

The answer to these problems is learning to use the viewfinder. The 'point and shoot' way is to see the subject, aim the camera and press the button. The photographer's way is to look through the viewfinder and see the whole image before composing the best shot. It is rather like the difference between looking through a window and looking at a picture. The view through a window has three dimensions and the eye tends to home in on whatever is most interesting. A picture is in two dimensions and it's relatively easy to see it as a whole. If you're not using a viewfinder at all, but looking at the screen on the back of a digital camera, then what you're looking at is more picture-like already.

But whether you're looking at a screen or through a viewfinder, you still need to be aware of two things: the boundaries of the frame, and what's contained within them. This awareness develops with practice, and with digital cameras you can help it develop by looking carefully at playback images too.

However, the sad fact is that, however carefully you look at the screen or the viewfinder, what you see still isn't necessarily what you get. To complicate matters further, there are different types of viewfinder, which behave quite differently, as well as the camera-back screen. In simple terms, there are two main types of viewfinders. These are direct-vision and reflex.

Direct-vision finders are found on compact cameras – if they have a viewfinder at all; many digital compacts don't bother. A direct-vision viewfinder is essentially just a small window. The window's frame may correspond to the borders of the image you'll shoot, or there may be a marked area within the window to show the actual picture area. In this case, round the edges of the finder you can see stuff which won't appear in the final picture.

Because looking through a direct-vision finder is like looking through a window, your eye can adjust to focus on close or distant objects. Just as when you are looking around you normally, whatever you look at appears in focus, so you get the impression that the whole scene is in focus. However, it's by no means guaranteed that everything

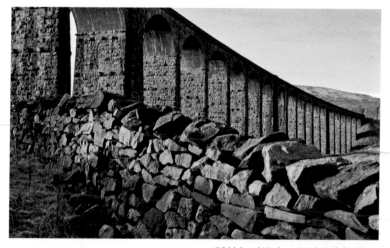

Ribblehead Viaduct, North Yorkshire (Jon)
When looking at the SLR finder the eye stays focused at a constant distance.
This can weaken our sense of depth, but the third dimension is always there and in some shots
it's immensely important

in the final shot will be in focus: things that seemed clear in the viewfinder may be blurred, even blurred beyond recognition.

With a reflex finder, and with the LCD screen, you actually view through the camera lens – the same lens that takes the picture. In a single-lens reflex (SLR) camera the image is relayed to your eye by a mirror that flips out of the way when the shutter is pressed. We can lump reflex viewfinders and camera-screens together as 'through the lens' (TTL) finders. Surely TTL viewing means that what you see matches the photo you'll get? You can certainly be forgiven for thinking that it should, but it's not that simple. Sometimes it gets very close, but at other times it doesn't.

Actually, the SLR finder image is a bit of an illusion. It is not a three-dimensional image; you aren't literally looking through the lens. What you really see is the image projected by the lens on the focusing screen. When you look directly at the world, your eye has to refocus to look at distant or near objects (even although we often don't notice that it's happening). When looking at the SLR finder the eye stays focused at a constant distance (of course the lens may have to refocus to give a sharp image of things at different distances). And with your eye to the viewfinder of an SLR, the image becomes your entire field of view, and there's a tendency to look at it piecemeal rather than in its entirety.

Next time you look into an SLR viewfinder, think about the fact that you are looking at a projected image which has no more real depth than the image on your computer screen. Let's hope that this helps to focus the mind on the image as an image.

Another problem is that the viewfinder doesn't necessarily show you the full picture area. Unfortunately, a true 100% viewfinder image is largely the preserve of professional SLRs – most others shave a good 5–10% off what you actually get in the image. Digital camera screens are much more likely to give closer to 100% view, but you should always check.

There's an even more significant reason why what you see in TTL viewing isn't always what you get. This is all to do with something called depth of field. We'll explore this in more detail in Chapter 3, but for now, depth of field simply means what is in focus and what isn't. If the image shows one object sharply focused, with everything else out of focus, depth of field is small. If, however, objects both nearer and more distant also appear in focus, depth of field is large.

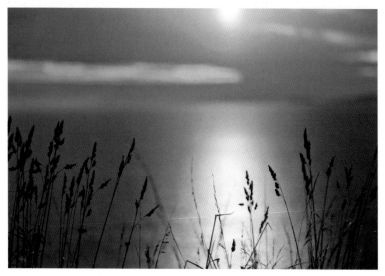

Druidston, Pembrokeshire (Chiz)
Focus is on the closest grasses, depth of field is small, and distant landscape soft

Focusing and depth of field: what's sharp and what's not

While a direct-vision finder gives you the impression that everything is in focus, with an SLR you can often see that some things are in focus and some aren't. Focus on a nearby leaf and the distant landscape may well appear soft. This could be a good thing if you want to concentrate attention on that leaf. The problem is that when you take the shot, the background sometimes looks much sharper than it did in the finder or screen. In other words, depth of field in the shot is much greater than in your TTL view.

With direct-vision finders, the opposite is often true. When you view, everything appears in focus but this is rarely, if ever, matched by the final shot. With a little luck the main subject is still in focus, but foreground and background may not be. In this case, depth of field is much less than it appeared in the viewfinder.

It's not hard to understand that a direct-vision finder doesn't match the final photo. You're looking through a separate window, not through the camera lens. But in TTL viewing you are looking through the camera lens, so surely what you see should match the final photo?

Well, no. You are looking through the same lens, but it isn't necessarily doing exactly what it does when it takes the photo. Specifically, the aperture is often different. When you view, normally the aperture is at its widest and depth of field is minimal.

When you take the shot, however, the camera often sets a smaller aperture, causing depth of field to increase. Camera manufacturers set things up this way as it lets the most light in at the viewing stage, and therefore gives the brightest image in the view-finder (easier to see than a darker one!), regardless of the settings you use to actually capture the shot.

Once you know this, it becomes very easy to check the image on playback and change the aperture if required to reduce or increase the depth of field. Or even use a button called depth-of-field preview to check this before shooting (if your camera has this it's usually found near the lens mount)

Exposure and contrast

The accuracy of modern autofocus systems means that the camera usually gets the main subject sharp – although this does require you and the camera to agree on what the subject is! Depth of field, however, means that there's rather more uncertainty about whether other things in the shot are or aren't sharp.

There's a very similar relationship between exposure and contrast. Just as the human eye adjusts focus so fast it gives us an impression of immense depth of field, it can adjust almost instantaneously between deep shadow and bright sunlight. Most of the time we don't see shadows as completely black or bright objects as totally white. We might call them black or white but we can still see detail within them.

However, digital images (like film before them) can't always stretch this far. If the brightness range (sometimes called tonal or dynamic range) of a scene is too great, the most a camera can do is aim somewhere in the middle.

Again, we'll go into more detail on this later on. The key point now is that this is another way in which what the eye sees can be different from what the camera records. And understanding that fact is the start of being able to deal with it.

Aperture and shutter speed

Some cameras now have more exposure modes than you can shake a trekking pole at: Landscape mode, Portrait mode, Night portrait mode, Party mode, Alpine bivouac mode (OK, we made that last one up)… And yet the most important task that all of these modes perform is to determine how the camera sets aperture and shutter speed. You might never set these manually but they are still key to every shot.

Aperture just means 'opening'. There has to be an opening to admit light into the camera, to reach the sensor (or film) which captures the image. Varying the size of that opening is one of two ways in which we control the amount of light admitted.

However, varying the aperture also affects depth of field. This is a bad thing if it gives us results we didn't expect, but it becomes a very good thing when we can exploit it to get more control over our results.

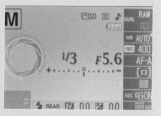

Graphical display of aperture on screen of a Nikon D3100 (Jon)

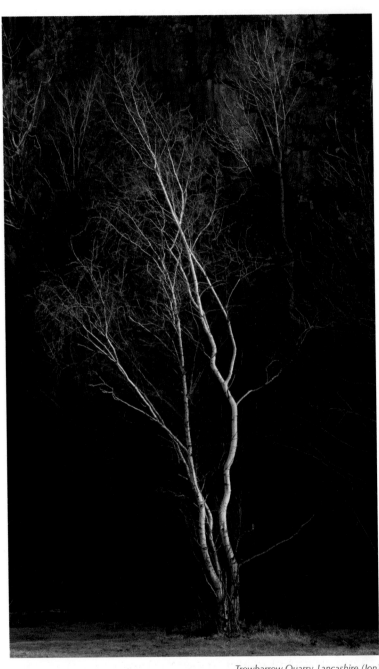

Trowbarrow Quarry, Lancashire (Jon)
There are deep shadows behind this brightly lit white tree and the dynamic range is very high.
However, the shot simply would not work if detail was lost in the tree bark

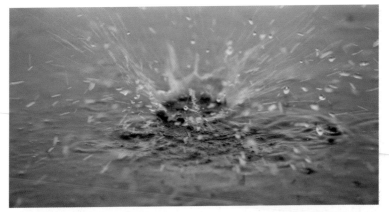

Raindrop (Jon)
Sometimes the camera can freeze movement the eye can't follow (shutter speed 1/250 sec)

Aperture, as we've already indicated, plays a key role in determining depth of field. The combination of these two controls determines the total amount of light that gets through to the digital sensor.

Shutter speed is principally important in determining how movement is captured in the photo. And movement, naturally, is another major way in which what you see can be very different from what you get. This is inevitable in a still picture! The eye sees movement, but the picture is a still.

> **Aperture** dictates how wide the lens opening will be: **shutter speed** determines how long it stays open.

Sometimes the camera can freeze movement that the eye can't follow; sometimes movement appears as a blur. Extremely slow movements, like those of the stars, can also be recorded although they appear static to the eye. All of these results depend on shutter speed.

Sensitivity

Well, of course photographers should be sensitive: sensitive to light, to mood, to the fact that your partner's getting cramp balanced on that pinnacle waiting for a shaft of light... But that's not what we're talking about here. We're talking about what used to be called film speed and is now called ISO sensitivity.

This is a measure of how readily the sensor reacts to light. A low ISO sensitivity rating means relatively bright light is needed to get a decent image. With a higher ISO rating, you can shoot with much less light

In the (good?) old days, we couldn't change this at will. When you loaded a roll of film you had to keep shooting at the same ISO setting till the film was finished. You might load a slow film which was great for shooting landscapes in bright sunlight, then next day you'd run into all sorts of problems trying to shoot mountain bike action in a shady forest.

Digital cameras have a much wider range of ISO sensitivity settings and you can change the setting shot by shot. This is immensely liberating. In fact it's one of the best things about digital, and it doesn't get half the credit it deserves.

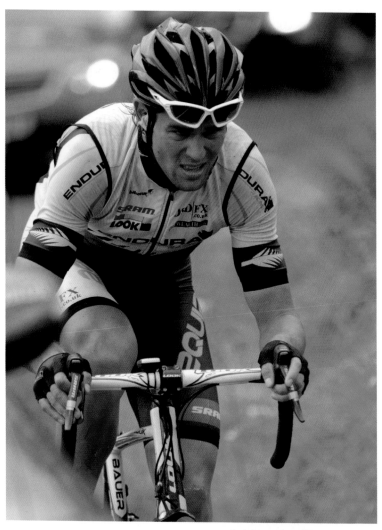

Jack Bauer, Tour of Britain 2010 (Jon)
High ISO allows action shots even in low light – notice the car headlights
(ISO rating 800 and shutter speed 1/1600 sec)

With film, you really only had two controls to play with – aperture and shutter speed. If you wanted to set a small aperture to give good depth of field, you probably had to set a slow shutter speed to maintain the overall exposure level. Now you have the option to increase the ISO level as well, which may allow you to keep the shutter speed the same. This doesn't just add to the possibilities, it multiplies them.

Most cameras now can vary the ISO automatically to suit the shooting situation. However, if you're into taking control of the camera (and we repeat, it's a good idea!), then just remember there are three fundamental controls, not just two.

FINAL THOUGHTS

At this point you could certainly be forgiven for feeling discouraged. On the other hand, perhaps you're beginning to understand why some of your shots don't turn out the way you expected. And understanding a problem is always a major part of correcting it.

The concept of 'point and shoot' is almost irresistible in its attraction, but the reality is always likely to be disappointing, at least until the day that the camera can actually read your mind. Even then, some people will still get better pictures than others, because you will still need to have a clear idea of what it is you want your picture to say and to show.

'Point and shoot' also suggests that photography is merely incidental to your outdoor activity, rather than being an integral part of it. Investing just a little more thought and time in your photography will bring much better results, not so much because the shots are better in any narrow technical sense but because you were more involved and had a clearer sense of what each shot was about.

There's yet another argument. By paying attention to what you're doing, you'll get more good shots in the first place. Not only this, if a shot doesn't quite work, you'll probably have a much better idea what you need to do differently next time. And when you get a really great shot you'll have much more idea what you did right. If you never go beyond 'just' point and shoot, you'll never learn anything very much. And since cameras don't learn either, your photos will never get much better.

Leaving everything up to the camera may give you a shot that 'comes out', at least most of the time. It's less certain, however, that it will give you a shot that matches what you actually saw, let alone what you wanted to say. The key to this is understanding how cameras and lenses see the world, and relating that to how you see it.

Kayaker on Ullswater, Lake District (Jon)
Although a lucky shot in the sense that the kayaker just happened to pass by, it did help that I was already shooting the landscape and had the exposure settings already dialled

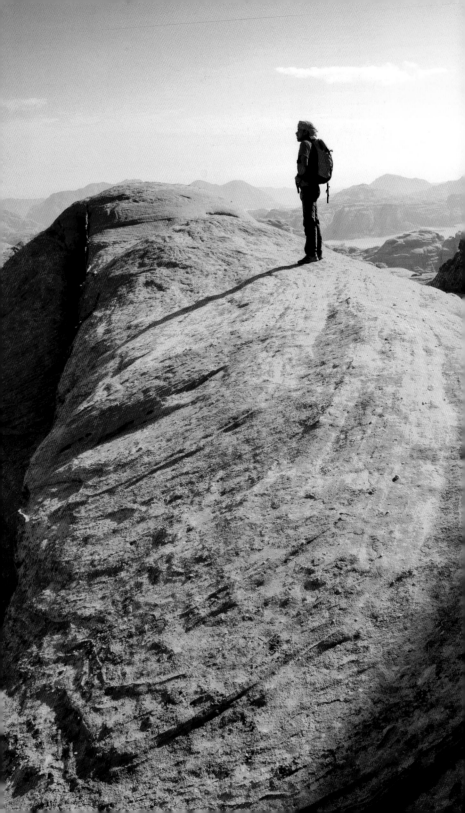

2 HARDWARE FOR THE OUTDOOR PHOTOGRAPHER

FIRST THOUGHTS

There is no such thing as the perfect camera. There may not even be such a thing as the perfect camera for any one individual. What seems ideal when you're shooting exquisite landscapes during a leisurely walk may be far less so on a spindrift-haunted winter climb or a wild mountain bike ride. Only if you specialise exclusively in one type of photography are you likely to get close to finding one camera that suits you perfectly all the time.

If you had limitless money you might think that owning lots of different cameras would be the answer, but actually it probably isn't (we can't say for sure as neither of us are in that position!). The more cameras you have, the more you might struggle to choose the right one for any given outing – the more, too, you might be tempted to take two or three to cover every eventuality and end up hating it because you're so overloaded. And the harder it would be to feel really familiar and at ease with every camera.

> Hang on, what about **film**? If you're still using film and you're happy with the results, stick with it. And if you really want to master photography in all its aspects, there's definitely a place in the learning process for shooting, developing and printing your own black and white pictures. But apart from that, you'd need a very good reason to buy a new film camera today, and if you're in that situation you probably know it already.

Emperor penguins, Antarctica (Chiz)
The heart-shaped moulting pattern on this penguin chick is entirely normal, if unexpected

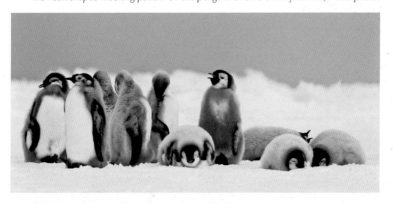

◀ *Mohammed Hammad, Jebel Khazali, Wadi Rum, Jordan (Jon)*
A wide-angle lens (27mm equivalent) makes the most of light and texture in the foreground

For most of us it's a moot point anyway. Money isn't limitless and we don't have time to master lots of different cameras. In the real world, camera choice is always going to be a compromise. There's no perfect camera but there are lots of good ones. It shouldn't be that hard either to find the best camera for your needs or to get the best out of the camera you do have. But one thing is key, and that's being as clear as possible about what you want. What sort of situations do you want to shoot in, and what sort of results do you want to achieve? Maybe these are questions you can't answer fully until you've read the rest of this book. That's OK. We had to put this chapter somewhere!

There's one thing we can be pretty clear about. In the first edition of this title Jon was fairly sceptical about digital cameras – and with good reason at the time. But things changed pretty rapidly within the next few years. Quality went up, prices came down, and digital rapidly became mainstream. Today we feel fully justified in assuming that the vast majority of our readers use digital cameras.

CAMERAS

The sensor
The heart of every digital camera is the sensor, the image-forming chip which has taken the place of film. If you believe the hype, all that really matters about a sensor is how many megapixels it has. This is rubbish. Most digital cameras today have more pixels than you need, and there's a strong argument that some have too many.

But first, what is a pixel anyway? The word is short (sort of) for 'picture element'. In essence it's a coloured dot. Blow up any digital photo big enough on your computer screen and you can see the individual dots of which it's made. In a 6-megapixel camera, for example, there are (approximately) six million of these individual dots, in an (approximately) 3000 x 2000 pixel array.

Sunset over hills behind Garden Cove, Campbell Island, Sub-Antarctic New Zealand (Chiz)
Bigger pixels are better at holding detail from deep shadows and bright highlights

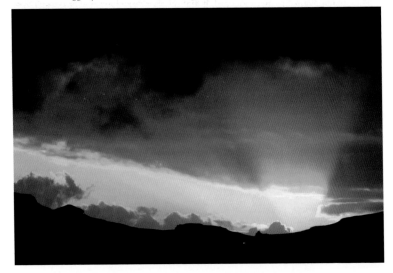

Lyth Valley, Cumbria (Jon)
It's much easier to build wide-angle lenses for larger sensors – and without a wide-angle lens
(24mm) this dramatic sky would have been lost

The camera's processor has to read, record, and subsequently reassemble data from each and every one of these pixel-sites. Actually it has to do even more than that. The individual pixels in almost all cameras only record data of one colour. If you could enlarge an image straight from the sensor, you would see it's made up of red, green and blue dots of varying brightness. Recompiling these into a genuine full-colour image is a complex process called demosaicing.

For each shot the camera has a lot of number-crunching to do before it can save a JPEG image file to the memory card. If that number-crunching power doesn't keep pace, then adding more pixels will make a camera slower.

There's another, even more basic, reason why the mere number of pixels is not the only issue. If you have two sensors of the same physical size, one with six megapixels and one with 12, it's obvious that the individual pixel-sites on the 12mp sensor are going to be smaller; each will only have half the area, which means it can only collect half as much light. This may not matter too much when there's loads of light around, but that's not always certain in the great outdoors.

This indicates that we should be less obsessed with pixel numbers and more concerned with pixel size. Pixel size is determined by the number of pixels and the size of the sensor. However, while the pixel number is plastered all over advertising and packaging, you'll usually have to dig deeper for any information on sensor size.

So here it is in a nutshell:
- SLR-type camera: big sensor
- Compact camera: small sensor
- Mobile phone camera: teeny tiny sensor.

There are variations within each category – for more information, see under 'camera types', below – but very crudely, SLR sensors are somewhere in the postage-stamp

size bracket. Compact camera sensors are smaller than your smallest fingernail. And cameraphone sensors are so small you can barely see them.

To coin a phrase, you can't change the laws of physics. There are physical limits, set by the wavelength of light among other factors, which mean pixels can't go on indefinitely getting smaller and smaller. Cameraphones are close to the limit already. Ultimately, the only way to add more pixels will be to use a bigger sensor.

> Even an HD TV screen is only equivalent to about a two (yes, two) megapixel image. So exactly who needs 14 or 16 megapixels?

Alternatively, a bigger sensor allows the use of bigger pixels. Because bigger pixels grab more light they perform much better in lower light levels. This means less need to use flash, which is usually a good thing. But bigger pixels also produce cleaner, less noisy, images at all light levels. They're also better at holding detail from deep shadows and bright highlights – something else which is often an issue in outdoor photography.

Of course bigger pixels require bigger sensors, which in turn means bigger cameras and bigger lenses. As far as outdoor enthusiasts are concerned, this is unfortunate. No-one wants to carry extra weight and bulk on the hills. However, there is an extra factor: larger sensors make it much easier to build wide-angle lenses, which are great for all sorts of shots. There's more on lenses below.

The image

Large or small, the sensor is not the only factor determining the quality of the final image. Digital images go through a complex series of processes before you can actually view them, even on the camera's own screen. This is especially true of those images which are recorded by the camera as JPEG files (extension .jpg).

The advantage of JPEGs is that they land on the camera's memory card in a ready-to-use form. You can print them or upload to sites like Flickr right away. But this advantage can also be a disadvantage. Because the image has already been processed by the camera, there's a lot less room for manoeuvre if you want to do more to it later. You can open it on your computer and make it lighter or darker, make the colours warmer or cooler, and so on, but the fact is that a lot of the original data has already been discarded, leaving a lot less to play with.

> A few cameras still offer the option to record files as **TIFF** format, but there's rarely anything to be gained by it and they take up a lot more memory card space than JPEGs.
>
> Converting them to TIFFs on the computer later could be a good idea, but that's another story – see Chapter 12.

If you do like working on your photos on the computer, or if you're concerned to get the best possible results even (or especially) from tricky shots, then many cameras offer an alternative, known as shooting RAW.

RAW is a generic term arising from the fact that these image files record the raw data from the camera's sensor. It's not an acronym and there's no clear reason why it's become customary to write it in capitals. Each camera maker has its own

Seppo in kayak, Doubtful Sound, New Zealand (Chiz)
Portrait mode keeps colours slightly muted, and doesn't sharpen the image too much

RAW format with its own file label: Nikon's is .NEF and Canon's is .CR2 or .CRW, for example.

RAW files require further processing on the computer before you can do anything useful with them. This doesn't mean that you have to spend ages picking over each image individually, as processing can be semi-automated, but it does mean that you need suitable software.

For more about software, see Chapter 12; the key point now is that the choice between shooting JPEG for convenience or RAW for ultimate quality and flexibility is a very important one.

It might seem obvious that you'll shoot JPEG for an easy life, but it's not that simple. If you shoot RAW, then getting camera settings right is important. If you shoot JPEG, then getting camera settings right is absolutely vital. And this doesn't just apply to basic exposure settings. JPEG processing deals with a lot more than whether the image is too light or too dark. It also locks in values such as colour balance and colour saturation. Yes, you can alter these afterwards, but within much tighter limits.

Let's take one quick example. Many cameras have a Portrait mode. This will set a fairly small aperture to limit depth of field and concentrate attention on the subject, and shooting RAW or JPEG will make no difference whatsoever to depth of field. However, Portrait mode also tells the camera to process the image in a certain way, keeping colours slightly muted, and not sharpening the image too much – all with the aim of being kind to skin tones. If you absent-mindedly leave the camera on Portrait mode when you switch to another subject (we've all done it!), these settings may be far less appropriate. In a JPEG file they're already locked in but if you shoot RAW you can easily shift the colour balance, boost the colour saturation, and so on.

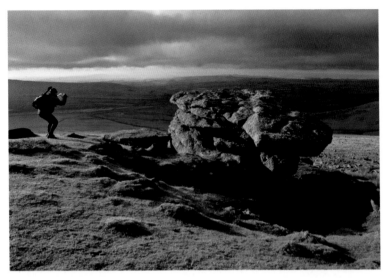

CAMERA TYPES

Cameraphones

Mobile phone cameras have ridiculously tiny sensors, often with absurd numbers of pixels crammed onto them – even though most of their images are viewed on other mobile devices or online, where they don't need to be big anyway. As a result the images are usually noisy even at reasonable light levels and even worse when the light is poor. This leads you towards using flash, but the flash (if there is one) is usually pretty pathetic.

The excessive number of pixels combined with limited processing power (to be fair, these devices do an awful lot in a very small package) also means that mobile phone cameras are slow. The response to your urgent press on the shutter button is often anything but urgent: shooting any sort of action with these babies is a very hit-or-miss affair. For calling out the mountain rescue, they're great; for anything else related to outdoor photography, they're far too limited.

Compact cameras

Unlike mobile phones, compact cameras are worth considering for serious outdoor photography. Well, some compacts, anyway: the term covers a multitude of sins. At one end there are cameras which aren't much better than a mobile phone. At the other there are cameras which cost more than an entry-level SLR and have a raft of serious features; these are often marketed as a 'pocket' camera for professionals.

A very few cameras, like Sigma's DP-2 and Fujifilm's resolutely retro-styled X100, have **SLR-size sensors in compact-size bodies**. If you can live with a fixed focal length lens they're a really intriguing prospect.

The undeniable advantage of compact cameras for outdoor use is their, er, compactness. Small size and light weight are surely desirable, and so is the ease with which a compact can be stowed in a pocket and pulled out in a second. However, smallness is a mixed blessing. It can make cameras harder to handle, especially when wearing gloves, and particularly when you want to change settings; often the control buttons are so small that they're fiddly even with bare fingers.

We could fill the whole book with advice on choosing a compact camera, but that's not what we're here for, and fortunately there are many magazines and websites which already do that job. What we can do is outline a few factors that could help you narrow down the field.

- **RAW Shooting.** Any DSLR can shoot RAW, but many compacts do not give you the option. The ability to shoot RAW is worth taking into consideration even if you don't think you'll want to use it. At least the option will be available if you change your mind later. It's also a good basic indicator of a serious camera.
- **Lens range.** Some compacts have quite a wide lens zoom range, but never as extensive as you can get on an SLR. In particular, you can't get such a wide view. Many compacts go no wider than about 35mm focal length (for the meaning of these numbers see p43). A fair number go to 28mm, a few reach 24 or 25mm, but that's it. If you're interested in wide-angle shooting, maybe for big landscapes, this can be a serious limitation (there is always the option to create a wider view by 'stitching'). You can eliminate most compacts from your enquiries by insisting on a lens of 28mm or wider.
- **Sensor size.** Almost without exception, compacts have much smaller sensors than SLRs. If the lens is good they'll probably still produce decent results at moderate ISO ratings but start to struggle at higher speeds (typically 800 and above), and they'll never match a decent SLR for dynamic range, which can count for a lot in uncontrolled outdoor light.

 But not all compacts are equal. Sensor sizes do vary. Unfortunately, sizes are usually given as a reciprocal (eg 1/2.5in). We can only assume this is done deliberately, to obscure the truth of how small these sensors are. Take the common 1/2.5in size, for example; this sensor measures about 5.8 x 4.3mm, which is less than one-fifteenth the light-gathering area of a typical SLR. 1/1.8in is a large sensor for a compact. It's still a lot smaller than an SLR but it is at least another way of narrowing down the excess of choice.
- **Speed of response.** This used to be a major weakness of compacts in general compared to SLRs. The delay between pressing the button and actually taking the picture could be half a second or more. This may not sound much but in fact it's excruciating. Fortunately most compacts are now much livelier, although they still trail behind SLRs for real action shooting. In choosing between compact cameras, shutter response (aka shutter lag) definitely helps narrow down the field. However, many manufacturers are still coy about it; you may have to drill deep into spec sheets for this figure, or go to independent reviews. Be careful not to confuse this with 'shooting speed', which usually refers to how many frames per second a camera can capture. Being able to shoot four or five frames per second is helpful, but it's no substitute for a nippy shutter response.
- **Viewfinder**. In essence, can you manage without a viewfinder? Lots of cameras now don't have one. This may not seem important, as so many people use the

HARDWARE FOR THE OUTDOOR PHOTOGRAPHER

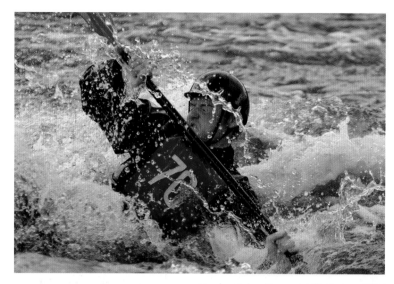

Kayaker, Holme Pierrepoint, Nottingham (Chiz)
This image was taken on a Canon DSLR; compact cameras will struggle (and often fail) to capture fast-moving action at the 'decisive moment' (shutter speed 1/350s)

screen for framing their shots anyway. However, most camera screens are hard to see clearly in bright sunlight; this is a major drawback in outdoor use (yes, even in Britain!). Using the screen rather than a viewfinder also increases the risk of camera shake.

If you do plan to rely on the screen, make sure it's a good one; as large as possible (3in or 75mm diagonal is the benchmark), with a bright, high-resolution display. Conversely, if you want to use the viewfinder, make sure that's a good one too; bright, clear and sensibly placed.

Ultra-zoom cameras

This is a rather nebulous category; in fact it's tempting to lump them in with compacts as a kind of high-end variant. Names like 'bridge camera' seem to be falling out of use, while the term 'prosumer', which is sometimes bandied about, has no clear definition. Alternative names, which seem to have become more widely used are 'long zoom', 'superzoom', or 'ultra-zoom'.

These cameras often look superficially like an SLR, right down to the bump above the lens, but have a non-interchangeable lens and a compact-size sensor. They do tend to have very wide zoom ranges, often running to 500 or 600mm equivalent, sometimes beyond, but they're still limited to 24mm – at best – at the wide-angle end. A 600mm lens for an SLR can cost £6000 and weigh 6kg, so getting one built-in for a few hundred sounds too good to be true.

And arguably it is. These lenses won't deliver the same optical quality as SLR lenses. And although all these cameras now have some form of image stabilisation, it's still almost impossible to hand hold a 600 or 800mm lens. Never mind avoiding camera shake, just keeping your subject centred in the viewfinder can be tricky.

And then consider that these cameras are not vastly smaller or lighter than an entry-level SLR; they certainly won't slip comfortably into the average pocket. And the SLR has the advantages of a big sensor and interchangeable lenses.

It's also interesting to look at these cameras in the light of our five key points for choosing a compact. One telling result is that most of them don't offer a RAW shooting option.

SLR cameras

Of all the main categories of digital camera, the one that still looks most like its 35mm film ancestors is the SLR. There's a reason for this. The 35mm SLR is up there with the bicycle as one of the great humanistic design icons. It brings hand and eye together. As a flexible and versatile camera, especially for hand-held use, it has never been bettered, except possibly by its digital successors.

SLR stands for **Single-Lens Reflex**. Digital SLR is often shortened to DSLR. An SLR is built around a mirror, which diverts the image from the lens into the viewfinder during viewing. The characteristic bulge on top is a pentaprism, which is necessary so you can see the image right-way round and right-side up.

When you take a shot the mirror flips up out of the way before the shutter opens to expose the sensor (or film) and capture the image.

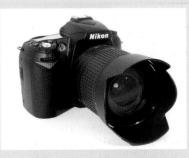

The Nikon D3100, a typical contemporary 'entry-level' digital SLR (Jon)

It can even be argued that the gap between compact and SLR is wider in the digital age than ever before. A 35mm compact used the same film as an SLR, but digital SLRs have much bigger sensors than most compacts. As we've already suggested, this is a very significant difference.

However, not all SLRs are equal in the sensor size stakes, as the table below shows. The majority of current DSLRs have APS-C (DX) size sensors. These are slightly under half the area of a 'full-frame' (FX or FF) sensor, which is the same size as a frame of 35mm film. If the number of pixels is the same, then each pixel on the FX sensor is also twice the size and has twice the light-collecting power. FX size cameras are best for low-light or high-ISO shooting – which can be great for action – and they also give the widest view from any given focal length of lens. However, they are bigger, heavier and (nearly always) more expensive.

At the other end of the scale, the Four Thirds size sensor has little more than a quarter of the area of FX, but it's still nearly ten times larger than a typical compact camera sensor. Most manufacturers seem to view the DX format as the best compromise for most users, but Four Thirds systems are certainly worth considering where weight and bulk are really critical. There's actually not that much difference in the

MAIN SLR SENSOR FORMATS		
Designation	Size in mm (approx)	Crop factor
Full-frame or FX	36 x 24	1:1
APS-C or DX	24 x 16	1.5:1
Foveon	20.7 x 13.8	1.7:1
Four Thirds	18 x 13.5	2:1

weight of camera bodies, but Four Thirds systems can use smaller and lighter lenses. The main manufacturer of Four Thirds SLRs is Olympus. The only manufacturer to use the Foveon sensor is Sigma.

Let's briefly revisit the five key points we identified when looking at compact cameras:

- **RAW Shooting** Always an option on DSLR.
- **Lens range** Interchangeable lenses mean a huge range of focal lengths is available. Crucially, SLRs (especially FX format) can give a wider view than any of the other classes.
- **Sensor size** See table above.
- **Speed of response** Varies, but even lesser SLRs are better than most compacts.
- **Viewfinder** An SLR would not be an SLR without a viewfinder, and it will nearly always be better than any compact. Most SLRs now have the option of Live View on the rear screen as well, which makes handling more awkward in most situations but can be handy when shooting at ground level, overhead, or on a tripod. Some SLRs have a fold-out rear screen, which can be an advantage for Live View or movie shooting but is basically a fragile nuisance the rest of the time.

SLR variants

The SLR is a brilliant design, but that doesn't mean there's no room for improvement. An obvious weakness is that big mirror at the heart of the camera. Every time this flips up it creates noise and vibration. And because the mirror needs room to flip up and down, there's a large void in the middle of every SLR. This makes cameras bulkier than they would otherwise need to be, and pushes the lens further away from the sensor, which limits some of the options available to lens designers.

Recently – in 2009 to be precise – we saw the first camera that could be described as an SLR without a mirror. Instead it has an electronic viewfinder which takes its data directly from the imaging sensor. Electronic viewfinders used to be dreadful, but – just like camera-back screens – they've improved enormously. They aren't yet as sharp or as immediate as an SLR finder but they are still getting better.

As yet the photographic world can't quite agree what to call these cameras. We rather like Electronic Viewfinder – Interchangeable Lens, which creates

Whenever we use the term **'system camera'** in this book, we are including both conventional SLRs and the variants covered in this section.

the acronym EVIL. However, it hasn't yet stuck. You'll also see them called 'compact system cameras' or 'interchangeable lens cameras'. As SLRs are also interchangeable lens cameras, this is not a helpful term.

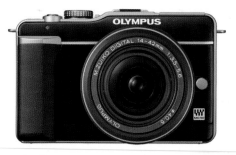

Panasonic and Olympus produce models using a Four Thirds size sensor. Panasonic's cameras look more like traditional SLRs, with a viewfinder bulge on top, but are noticeably slimmer from front to back.

The Olympus PEN E-PL1, one of the new generation of compact system cameras (Photo courtesy of Olympus)

Olympus's PEN series are more compact-like and rely solely on the screen image for viewing, unless you splash out on a separate attachable viewfinder.

Sony's NEX series cameras use APS-C size sensors – the same as the majority of DSLRs – but in a slim, compact-like body. The large sensor, as we know, has many advantages, but it does mean that lenses can't be dramatically smaller than regular DSLR lenses. Viewing is screen-only.

All these cameras promise SLR-like quality and lens choice in a smaller, lighter package. This sounds like a good combination for the outdoor enthusiast, but it's still early days for this whole class of camera. They definitely merit consideration, but they also demand a thorough, hands-on trial before you splash the cash. This is especially true of models with no viewfinder; even if you're used to screen viewing on a compact, it's a different ballgame with the larger, heavier lenses that these cameras use. Using one hand to support underneath the lens is essential, for a start. Also, their continuous Live View means that they will make heavier demands on batteries than a conventional SLR.

Sony have yet another trick up their sleeve with their SLT (Single Lens Translucent) cameras. These look reassuringly similar to a conventional SLR but have a fixed, translucent mirror inside. This allows most of the light to pass through but reflects around 30% up to an array of focus-detection sensors. This means that, unlike any other SLR or 'EVIL' camera, there's no interruption to focusing from mirror or shutter action. This appears to offer obvious advantages for tracking rapid action in particular. On most cameras focusing in Live View (and when shooting movies) is relatively slow; not on an SLT.

The SLT viewfinder looks superficially like an SLR, but it is electronic. The cameras are slightly smaller and lighter than comparable SLRs, but the absence of a moving mirror makes them quieter, less prone to camera shake and potentially faster. They retain all the other handling advantages of an SLR and should be much better with long lenses than the 'EVIL' type. We can't help thinking that this technology could be what most of the world's news and sports photographers, in particular, will be using in a few years time. However, it's not clear, at this early stage, whether SLT cameras totally live up to the promise.

Well, here's the thing. All of these innovations have been rolled out by manufacturers with a relatively small share of the SLR market. Sony may have come from nowhere to third place in this market in a few short years, but the two big beasts – especially in the professional sector – are still Canon and Nikon. And so far, both of the giants have remained resolutely committed to the conventional SLR format. However, it would be extremely surprising if their R&D departments weren't working on new technologies.

CAMERA SETUP

Image quality and size

'Image quality' principally refers to the RAW/JPEG choice, which we've already looked at in some detail. As we've seen, this is a pretty basic decision.

If you shoot JPEG there are usually a couple of extra options: these may be buried in menus but should not be overlooked. Quality settings such as Fine, Normal or Basic refer to the degree of compression applied to the images. More compression means you can cram more images onto a memory card but it does degrade the image – and memory cards are cheap these days. If there's even a slim chance of wanting to make a large print or publish the image then use Fine, or whatever your camera maker calls the best setting. At the other settings some data is thrown away and there's no way to get it back, whereas a Fine image can always be compressed later if you want to email it to someone.

Hampsfell, Cumbria, looking towards the Coniston Fells (Jon)
When you're shooting in the red light of sunset you may not want the camera to 'correct' the white balance

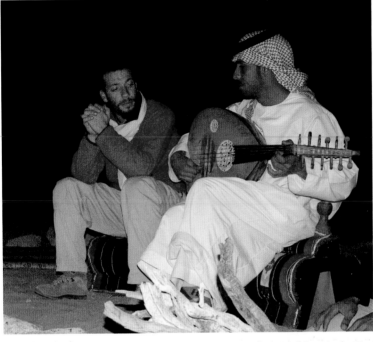

Campfire in Wadi Rum, Jordan (Jon)
Noise is random variation in brightness and colour

There may also be a choice of size settings. Large means the maximum image size possible from that sensor – 12 megapixels or whatever it is. Smaller sizes shrink the whole image to the equivalent of, say, six or three megapixels (this is not the same as trimming or cropping it). Again this is an advantage for email and web use but is essentially irreversible. You can't resize a three-megapixel image back up to 12mp if you decide you do want to make an A3 print after all. Well, you can, but it will look terrible.

White balance

The colour of light – natural and artificial – varies widely. Most of the time our eyes adapt and we barely notice it. By default, almost any digital camera will be set to regulate the white balance automatically and this will probably give natural-looking colours under most conditions. However you may want to take control yourself. Perhaps you generally like a warmer or cooler result than the camera delivers, or perhaps there are specific circumstances where it doesn't quite get it right. When you're shooting in the red light of sunset you may not want the camera to 'correct' these colours (see Chapter 3).

ISO and noise

The concept of ISO sensitivity was introduced in Chapter 1 (p23). Many cameras can regulate it automatically but, as suggested already, this is one of the most important settings of all, so it really pays to understand what it means and at least consider taking direct control.

Ridge above Matho Valley, Ladakh (Chiz)
Manual mode is a good choice for controlling tricky exposures

The ISO setting doesn't just affect the interplay between aperture and shutter speed. It also has a direct impact on the quality of the final image. Increasing the ISO tends to reduce the dynamic range and the intensity of colours, but what's usually most noticeable is an increase in image noise. Noise is random variation in brightness and colour which produces a kind of speckly interference in images. Most cameras have various noise reduction features, and you can also address it when processing images on the computer, but strong noise reduction can make the image softer overall. The range of ISO settings which is genuinely usable depends on your tolerance of noise and how you view the images (large screens or large prints show up faults more readily). Small-sensor cameras suffer much more from noise, so the usable ISO range runs out more quickly. The top limit for decent-size prints from a compact is probably 800 or even 400 ISO, whereas a full-frame SLR will still be delivering acceptable results at 3200 or higher.

Many noise reduction programs (see Chapter 12) allow you to change the colour part of the noise independently from the 'grain' (or luminosity) part – this is useful where you don't want to over-soften a very noisy image – as often it is the colour part of noise that is least appealing.

Other settings

When shooting JPEG, various other image settings are also up for grabs. These can include sharpening, saturation and several other parameters. These are usually rolled up together under some broad heading such as Picture Controls (Nikon), Picture Styles (Canon) or Creative Styles (Sony), but on some cameras you can drill down into these to alter the parameters individually.

Another clutch of controls aim to tackle problems caused by high dynamic range (excessive contrast). These have names like Active D-Lighting (Nikon), Auto Lighting Optimizer (Canon) or Dynamic Range Optimizer (Sony). Again these are usually

rectified automatically by default but many cameras will allow you to intervene if you want more control over the way the final image looks. If you really want ultimate control, don't forget the option to shoot RAW.

CAMERA CONTROLS

Exposure modes

Some exposure modes basically just decide how the camera sets aperture and shutter speed, and perhaps whether or not the flash will operate, leaving you to control other parameters. On digital cameras other modes may hand most or all of the decisions to the camera.

The first group are the traditional modes: Program, Aperture-priority, Shutter-priority and Manual. In Program mode the camera determines both aperture and shutter speed, according to some preset rules. In Shutter-priority you set the shutter speed and the camera then determines aperture to give a correct exposure. In Aperture-priority mode, you set the aperture and the camera then determines shutter speed to give a correct exposure. In Manual mode, the most traditional of all, you set both aperture and shutter speed. All exposure modes regulate aperture and shutter speed. The point about these four modes is they do nothing else: other settings like ISO and White Balance can be changed independently.

Most makers use P, S, A and M symbols to denote these modes. However, for some reason, Canon uses **Tv** instead of S. It's supposed to stand for Time Value, which almost makes sense, but now that many cameras can be connected directly to a TV set to play back pictures, this is bound to cause confusion.

Farleton Fell, Cumbria (Jon)
Landscape mode will favour good depth of field and process the image to give vibrant colour

Most cameras also have a range of other exposure modes. Terminology varies: for convenience we'll call them Scene modes.

These normally pre-determine most camera settings. For example, when you choose Landscape mode, the camera determines aperture and shutter speed in a particular way, but it goes much further. It will probably turn the flash off, for a start, and you may be blocked from activating it manually. Most people rarely use flash when shooting landscapes, but there can be occasions when you do want it to lighten up a dark foreground. Other modes might do the opposite and automatically activate the flash, leaving no easy way to turn it off if you don't want it.

Scene Modes also affect the way the image is processed. For example, Landscape mode usually delivers quite punchy, saturated colours while Portrait mode aims for a softer, more 'natural' (and hopefully more flattering) result. Experimenting with Scene modes can produce remarkably different results – and is a great first step to discovering just how flexible even a simple camera can be.

Focusing

Most cameras focus automatically. SLRs and other system cameras generally also give you the option of focusing manually. But the reality of autofocus (AF) isn't quite as simple as it may seem.

Depth of field, which we've already considered, muddies the water for a start. A lens can only focus at one distance at any one time, but depth of field will sometimes make objects appear sharp even though they are nearer or farther than that distance. So, even if the camera hasn't actually focused exactly where you intended, depth of field sometimes makes up for it.

But that hints at the next question. How does the camera know where you want it to focus? Put it another way; how does the camera know what the subject is?

Chris Radcliffe's hand, Burbage Rocks, Peak District (Chiz)
Even 'people' pictures don't always benefit from Face Recognition technology!

Sometimes it's easy to say. Many cameras now have Face Recognition technology. If they detect one face in their field of view, they'll focus on it. If you're shooting a portrait this is probably exactly what you want but for some other shots it may not be. When shooting a climber you might want some shots to focus on fingers crimping a tiny hold, not on the face at all. If cameras detect more than one face they'll probably focus on the nearest, but again this may or may not be what you want.

The clear implication is that, if you aren't going to use manual focus, it pays to know how the camera decides where its focus point will be. (That's if the camera gives you any choice in the matter. Some compacts may insist that you want to focus on faces every time.) This means looking for what may be called AF-area mode, AF Point Selection, or something of that ilk.

It's important not to confuse these with focus modes, which may have names like Single-shot or Continuous. Some of these are designed to focus on static subjects, some for moving subjects. We'll discuss these more in Chapter 4.

Colour space
Hidden in the menus of most DSLRs is a little setting called colour space. Usually this is set to sRGB. Unless you're sure you need the alternative (AdobeRGB), this is best left alone, as most online/high street printers and all monitors and projectors are not able to display the larger range of colours that AdobeRGB allows. But if you produce your own high-quality prints you may find it useful to change this setting – however, you'll need a good understanding of colour management in this case! We'll talk a little more about colour management in Chapter 12.

Lenses
Don't neglect the lens; it's at least as important to the quality of the image as the camera itself. DSLR cameras have the big advantage of interchangeable lenses, so if your needs change (for example, if you discover you'd like a wider view for landscape shooting) you can accommodate this. On other cameras, you're stuck with what you've got.

Focal length and angle of view
You probably know that a lens like a 28mm gives a relatively wide-angle view while, say, a 200mm lens gives a much narrower view, often suitable for distant subjects. So far so good. But as soon as you try and unpick what the numbers really mean, it gets confusing. Conventional ways of describing lens focal length seem designed to cause confusion.

The lenses of SLR cameras are designated by their actual focal length. Compact cameras have much smaller lenses and their true focal lengths are correspondingly smaller, but they are nearly always described by their 'equivalent' focal length. This is the lens that would give the same picture coverage on a 35mm camera or full-frame DSLR. Sometimes they'll say '35mm equivalent' – so you can even get a lens which is '35mm (35mm equivalent).'

Where it gets really confusing is with other SLR formats, such as the widely-used APS-C. This is just under half the size of 35mm/full-frame and therefore, naturally, gives less picture coverage, or angle of view, from any given lens. The same lens on a Nikon D700 (full-frame) and D7000 (APS-C) will give different results; an 18mm lens on the APS-size camera gives coverage equivalent to 27mm on full-frame (see photos).

Cameras which rely on screen viewing produce a distinctive 'praying mantis' posture. Some of these cameras are so small that it's hard to get a decent two-handed grip, but two hands will always give better support than one.

SLRs in particular are designed for shooting with the viewfinder. This gives an extra point of contact – the photographer's head – and is therefore intrinsically more stable anyway. To get the very best support and access to camera controls, make sure the left hand is cupped underneath the lens, with the thumb and index finger forward.

Good handling, with the left hand supporting the lens. On a very wet day, the camera is in an Aquapac waterproof case. (Jon)

This is really the best way to hand hold any camera, as long as the lens is large enough to allow it. The ergonomic advantages become even clearer when longer lenses are in play.

18mm is commonly found as the wide end of DSLR kit lenses. On an APS-C camera this is 27mm-equivalent, so it gives a slightly less wide view than the 24mm-equivalent found on a few compacts – but on the SLR you can always fit a wider lens. On the compact you're stuck with what you've got.

In this book, when we refer to focal lengths in the general text you can assume it's '35mm equivalent' unless we specifically say otherwise. So if we say 28mm we mean a moderate wide-angle and if we say 14mm we mean a pretty extreme wide-angle. To get a better idea of what this really means, take a look at the daffodil image opposite. This was taken on a full-frame DSLR, so the 12mm lens really is a 12mm (35mm equivalent).

LENS TYPES

Most lenses that you can buy, and nearly all those that are sold as a kit with a camera, are zoom lenses. 'Zoom' means that the lens has a variable focal length. A typical kit lens might be 18–50mm, 18–70mm or even 18–105mm: 18–50 is about a 3x zoom range, 18–105 is about 6x. This is a pretty decent range, which covers many needs, but the interchangeability of SLR lenses gives you a much wider range of options.

While zooms dominate the market, there are still many lenses with fixed focal length, also known as prime lenses, from 14mm wide-angles to 600mm and 800mm telephoto monsters. Prime lenses are simpler to design and build, and can be light and compact, and some critical users still reckon they give better optical quality. However, it can't be denied they are less versatile than zooms.

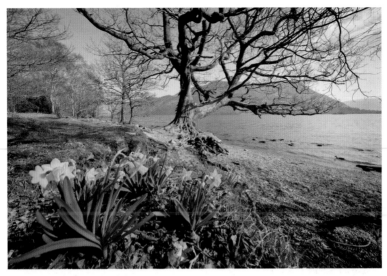

Daffodils beside Ullswater, Lake District (Jon)
A real wide-angle lens (12mm here) can take in both foreground detail and the sweep of a landscape

Apart from focal length, lenses also vary in their maximum aperture. Wide maximum apertures have several advantages: they give a brighter viewfinder image, give extra options for shooting in low light, and allow you to achieve narrower depth

Near Garstang, Lancashire (Jon)
Showing the coverage given by the same lens (48mm) on full-frame and APS-C cameras. The APS-C frame is indicated by the red line

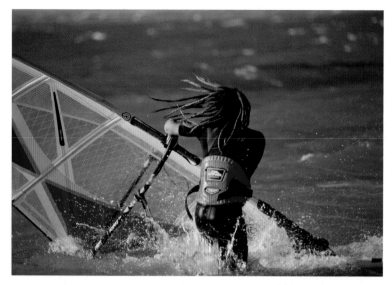

Franco, Cuesta del Viento, Argentina (Chiz)
A long lens (400m here) allows the photographer to fill the frame – and the subject's hair gives a clue how windy it is!

of field. On the other hand, they make lenses bigger, heavier and more expensive. f/2.8 is a wide maximum aperture for a zoom lens, especially if it is maintained throughout the zoom range, but some prime lenses go as wide as f/1.4. Lenses with a wide maximum aperture are sometimes called 'fast' lenses but this is so fraught with potential confusion that we won't use the term. Just watch out if you see a lens described this way: it doesn't necessarily mean – as you might think – that it has a fast focusing action.

The vast majority of lenses sold today are autofocus lenses. Most can also be switched over to focusing manually, and it is occasionally advantageous or even necessary to do so. Lenses with a very wide zoom range are sometimes referred to as superzooms. There's no clear definition of what constitutes a superzoom. The widest range currently available in a single lens is 18–270mm, or 15x. This is impressive but of course there are drawbacks. Superzooms may deliver decent optical quality in mid-range but are often less impressive at the extremes – and the extremes are the reason for buying a superzoom. A particular problem is distortion (straight lines appear curved). This might appear to be more of a problem for the urban photographer than the outdoor type, but can you honestly say you never photograph anything with straight lines in?

Some cameras claim extraordinary zoom ranges thanks to '**digital zoom**'. This is a highly misleading name for what should be called 'in-camera cropping'. As you can always crop digital pictures afterwards, digital zoom is not worth an extra penny. When comparing cameras, look at the 'optical zoom' range.

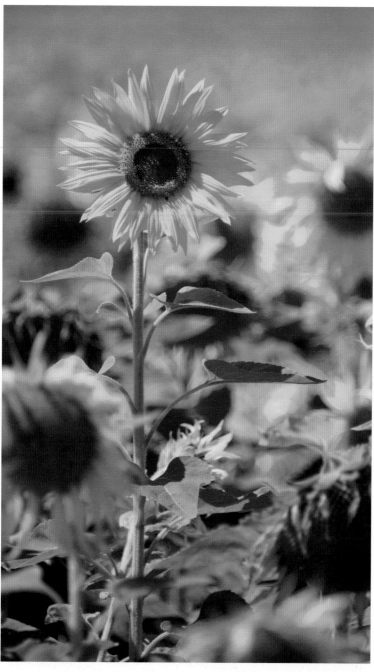

Sunflowers, Beaujolais, France (Chiz)
Wide maximum apertures (here f/5.6 at 400mm) allow you narrower depth of field

Specialist lenses

As well as the regular zoom and prime lenses, there are various specialised types of lens. Mostly we'll mention these in specific chapters where they may be relevant, like macro lenses for close-up work). Other types you might encounter include:

Fish-eye lenses: ultra-wide-angle lenses where distortion is allowed to run wild giving a uniquely curved view of the world.

Perspective control/Tilt and Shift lenses: lenses with a range of movements built in, allowing correction of perspective (like converging verticals when looking up at tall buildings), and very precise control over depth of field.

Image stabilisation

It's hard to know whether to deal with this under lenses or under cameras. This is a range of technologies designed to compensate for the effects of camera shake, allowing you to get sharp images at slower shutter speeds than would be possible without it. With compacts and ultra-zoom cameras it is naturally built-in to the camera but some SLR makers – notably Nikon and Canon – build this technology into the lens instead. This has the obvious advantage that you can retro-fit a stabilised lens to an older camera. This technology goes by many names: image stabilisation, vibration reduction, vibration control, SteadyShot, and so on.

It's generally a good thing, but (there are always buts!) it has limits. You still can't hand hold the camera and get a sharp picture at, say, 1 second shutter speed. Also, stabilisation only compensates for camera movement. It can't do anything about blur caused by a moving subject. It certainly does not mean you can entirely forget about shutter speed. If you are using a stable tripod, it's best switched off – or it will try and compensate for movement that isn't there, and may actually introduce some camera shake!

Black Clough, Forest of Bowland, Lancashire (Jon)
Low light, no tripod: a good case for Image Stabilisation

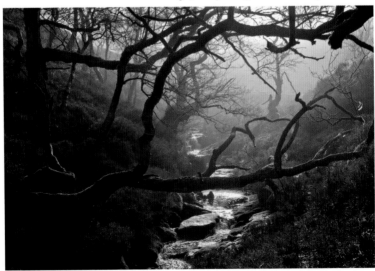

ACCESSORIES

SLRs in particular are system cameras and there are myriads of accessories available for all manner of purposes. We'll mostly deal with these where they're relevant to particular activities. Here we'll just introduce the main categories.

Batteries

Digital cameras need batteries. Batteries run down. Using the screen a lot for Live View, picture review or movie shooting runs them down faster. Carry a spare.

Storage

There's no film but digital images still need to be stored on a physical medium. Some cameras have a small amount of internal storage, but mostly this means memory cards. Memory cards store huge amounts of images incredibly cheaply. Don't skimp. And as they become the repository of irreplaceable images, handle them with care.

With digital you can also back up those irreplaceable shots, and it is crazy not to. This usually means backing up when you transfer images to a computer (see p219), although some pro-level cameras have dual card slots so you can back up instantly. On longer trips and expeditions backing up to a separate device is highly recommended, whether it's a dedicated photo-store or perhaps an iPod or iPad.

Support

Image stabilisation and high ISO settings allow much more freedom for handheld shooting, but there's still an important role for camera support. Tripods give great support and allow you to put the camera exactly where you want it, but there are many other forms of support. The classic beanbag is light, simple, cheap and highly effective. Remote control by cable or infrared allows the camera to be triggered at a distance. This can cut down vibration and also allows you to put yourself in shot when you're out on your own.

Flash

Most cameras have a built-in flash so why is it listed under accessories? This is a big subject and we'll return to it several times, but in a nutshell: built-in flash is small, weak, and produces ugly light; it's pretty awful for portraits and even worse for close-up work. Its one saving grace is that it's handy for fill-in light (see p72), but for most other purposes a separate flash gun is vastly superior, and does not have to be big, heavy or expensive.

Filters

Inbuilt colour correction means digital photography has done away with many filters that were once important. It's still recommended to have a skylight or UV filter on every lens, mostly for physical protection. If it gets scratched a filter is a lot cheaper to replace than a whole lens. The other filter that many photographers, especially landscape photographers, still swear by is the polariser.

Carrying

You have to carry the camera somehow. Round your neck is fine on easy walks – until it rains. In the rucksack it's well protected but inaccessible. The equation between

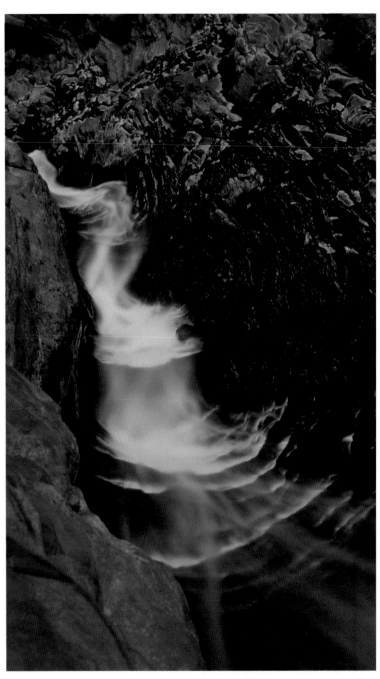

Canyon, Hancock Gorge, Karijini National Park, Australia (Chiz)
Some images (like this one, with a 20s exposure) will always need camera support

accessibility and protection is different for every activity, so the best way of carrying the camera also varies; we'll look at specific considerations for different activities.

Care and cleaning

Much of care is prevention – carrying the camera in the right way, protecting it from impacts, splashes and so on. Changing lenses also requires care, especially in windy, rainy and dusty conditions. Cameras generally don't require a lot of cleaning but when they do, use products designed for the purpose–especially on lenses and LCD screens. And don't, ever, touch the reflex mirror of an SLR in any way.

Changing lenses creates the risk of dust getting into the camera and settling on the sensor. Cleaning the sensor (more strictly, its protective low-pass filter) is a delicate but sometimes necessary operation which must only be done with dedicated swabs and following the instructions carefully.

FINAL THOUGHTS

For Lance Armstrong it was 'Not About the Bike'. For us it's 'Not About the Camera'. A good camera does not make a good photographer – and that's a positive: taking better pictures costs nothing (apart from, possibly, the purchase price of this book!). However, a good camera can help; especially if we define a good camera as a camera that does what you want it to do. From which it seems to follow that knowing (realistically) what you want from a camera is a prerequisite to getting the right one.

However, just for the record, we both use digital SLRs. One of us uses Canon and one of us uses Nikon and – although we watch technological developments with interest – neither of us are planning to change.

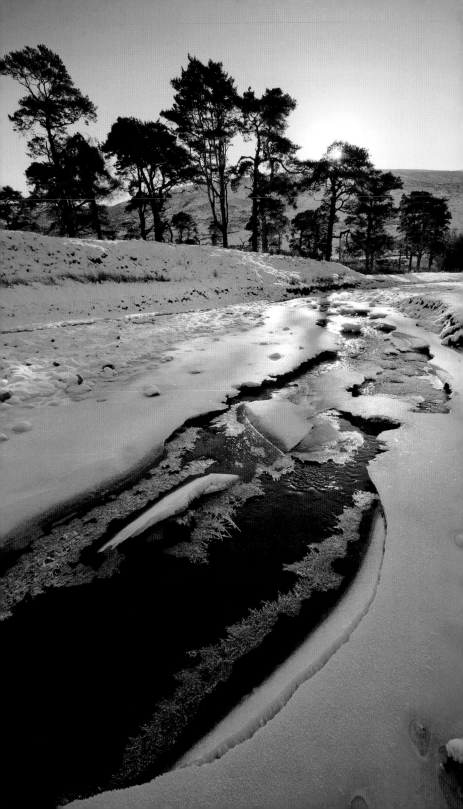

3 PLACES AND PEOPLE

FIRST THOUGHTS

A good photo isn't defined by being perfectly focused and perfectly exposed. It's about feelings. What does it feel like to be in these places, with these people, doing these things? Of course if focusing and exposure are wrong they can ruin the picture, but today's cameras are pretty good at getting them more or less right.

Perhaps all photography is about feelings; photographing places and people certainly is. Technical skill is great if it helps you express your feelings more clearly, but it clearly isn't helpful if fretting about white balance or depth of field gets in the way of those feelings.

PLACES

In any outdoor activity, it's not just what you do but where you do it that's important. Even a short country stroll can take you to places unsuspected by those who never leave the roads. Mountaineers, cavers, sea-kayakers all get to places most people will

Humphrey Head and Morecambe Bay, Cumbria (Jon)
In the outdoors it's not just what you do but where you do it that counts

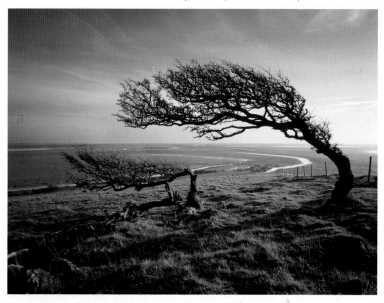

◄ *Marshaw Wyre river, Lancashire (Jon)*
Shot with a wide-angle lens (16mm). The closest ice is in easy touching distance.
Any small shift in position would have significantly changed the framing

never see and may never even have dreamed of. Whether it's to show your less privileged friends, or just for your own memories, you'll surely want pictures that capture the special qualities of these special places.

On the face of it, shooting landscapes should be easy. Landscape doesn't run away when you approach, or start pulling silly faces: it just sits there and waits to be photographed. You don't need expensive specialised gear either: an ordinary camera and an ordinary lens will do fine.

However, shooting landscapes well turns out to be less easy. There are a number of reasons for this. Some of them are technical, but a lot of technically competent pictures still don't really get the message across. Indeed, in their obsessive pursuit of technical excellence some people seem to forget what the picture is actually about.

It is about the place, but places change their face. It's also about time and light, weather and season. Returning to the same place time and again, to photograph it in different moods, can be immensely rewarding.

Seeing the landscape
Landscapes are big and complex. When you're actively involved with landscape, you see much more of this richness than you can from a car window or TV screen. Outdoor activity brings you into close contact with the landscape and makes you much more aware of its detail and texture. A kayaker will be very aware of the way a river flows, of eddies and stoppers and calmer pools. A climber will be very focused on the fine detail of rock, its cracks and holds, the frictional qualities of its texture. A walker or a cyclist will be highly aware of gradients and path or track surfaces.

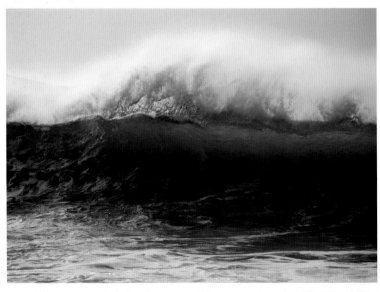

Wave, Isle of Harris (Chiz)
Landscape is rarely completely static – sometimes it's very dynamic indeed!
(shutter speed 1/500s)

Many of these qualities are changeable. A lake which is a perfect mirror in a windless dawn may be all white-capped agitation a few hours later. Landscape does not, after all, 'just sit there'. It changes constantly. There are gross physical changes like landslides and avalanches. Trees fall and rivers change their course.

Complete stillness is a rare and usually short-lived phenomenon. Most landscapes – and most landscape photographs – have movement in them somewhere. Even when there's not a breath of wind, and no running water in sight, the sun moves continually across the sky: if nothing else appears to change, the light always does.

These things naturally affect the way you look at a landscape and the feelings you have about it – and, therefore, what you want to say about it in photographs. As with any photograph, the clearer you are about what you want to say with the shot, the better. 'What a beautiful place' is just a start. What makes it beautiful? What's special about it? Is it inviting or forbidding? Does it awe you with its sheer scale and grandeur or does it seduce you with a quiet, delicate beauty?

Framing the landscape

Perhaps what makes landscape hard is exactly the quality that appears to make it easy: it's just sitting there. It isn't neatly parcelled up into photograph-sized chunks. With a portrait or an action shot it's usually easy to identify what the subject is. Fill the frame with it, get it sharp and correctly exposed (which the camera can help with), and the subject will probably speak for itself.

Landscape photography doesn't work like that. Landscape is all around you. It's a big world, but we're trying to catch it in a small rectangle. That's the challenge. Put it another way: how do you place your subject in the frame if you can't say exactly what your subject is? This returns us to some of the questions raised in Chapter 1. While 'what to point at' may be a no-brainer with action or wildlife, it can be the hardest decision you'll have to make when taking a landscape photograph. In other words, framing is primary and fundamental.

Framing begins with seeing. This means more than just looking in the right direction. It means really being aware of what you're looking at. This sounds very simple, but simple isn't quite the same as easy. It calls for concentration and full attention to what you see, both directly and through the viewfinder.

Many books talk about 'rules of composition', especially the notorious 'Rule of Thirds'. However, in practice, many of the images presented as examples of that rule follow it loosely, if at all. These so-called rules aren't as simple as they seem. Our experience strongly suggests that they aren't that useful either, especially with no clear 'subject' to latch on to (many writers also refer to 'the point of interest', whatever that is) . It seems like more than mere coincidence that 'Rule of Thirds' generates the acronym ROT.

It's pretty hard to think about 'rules' and at the same time stay focused on the feeling and emotion of the moment – many of the greatest photos ever made don't conform to any known rule, and neither does landscape itself.

Bending over backwards to be fair, some people do seem to find such rules helpful. Knowing what they are and trying them out from time to time can do no harm. But don't think of them as rules, and definitely not as laws. A picture is good because it expresses the experience you had in the outdoors, **not** because it conforms to the rules.

Think of these, at best, as suggestions which might sometimes be useful: and beware the short-cut that turns out to be a dead end.

In fact the very word 'composition' is contaminated by this obsession with rules. This is why we're avoiding it as far as possible. The alternative term, 'framing', says exactly what we're doing and doesn't carry anywhere near as much baggage.

We've already dropped a few hints about framing in Chapter 1. The central skill is seeing the whole picture. And it is a skill that anyone can develop, not some mysterious gift given only to a few.

The image on screen or finder is different from the real world because it has two dimensions instead of three. It's also different because it's a rectangle. Long before photography, the vast majority of paintings and drawings were produced on rectangular paper or canvas and often placed in rectangular frames. Today we view many images on screens; whether computer, iPad or iPhone, they're all rectangles. We can trim images to different shapes and present them in other forms, but in practice we rarely do so and it's usually an afterthought. Film or digital, every image starts out as a rectangle. (OK, not every photograph: some fish-eye lenses generate a circular image.)

A rectangle is defined by its edges. If we're trying to frame images consciously, we need to be aware of those edges. Think about them as you try different angles of view. If you use a zoom lens, objects can appear or disappear at the edges of the frame as you zoom in or out: make sure you're aware of them.

Looking at what's contained within those edges is the other side of the coin. Don't forget that the camera can't read your mind and doesn't actually know which bits of the scene you are interested in. It's no good blaming the camera if you get more than you thought you were getting.

Looking at the viewfinder is only part of the process. This can't directly tell you what difference it will make to move back a few metres, or switch to a different lens. You can do this entirely by trial and error, but if you stop to check through the viewfinder after every little adjustment, it'll take forever. Landscape photography isn't supposed to be that slow! This is why looking at the scene directly is just as important as using the viewfinder. In fact, we can all anticipate, to some extent, what will happen when we shift position or change lenses. Step closer to that gap in the trees and we'll see more of the landscape beyond. And the more we do it, the better we get at it.

This is the essence of visualisation. With practice you spend less of your time peering through that fiddly little viewfinder, and much more actually looking directly at the world. Increasingly, you will have a shrewd idea exactly where to stand, and which lens to use, before you ever raise the camera to your eye.

Visualisation means more than just seeing the raw ingredients of the shot. It also means being aware of the differences between the way the camera sees and the way the eye sees. We've already alluded to depth of field, and to the way the camera deals with movement, with colours, and with big differences in brightness.

One of the most important factors remains the 'mental zoom lens.' Physically, the human eye has an almost fixed focal length. It's the brain which can switch almost instantaneously from 'seeing' a wide-angle view to a narrow 'telephoto' one. This ability is very powerful, and very useful to the photographer, as long as you're aware of what's going on.

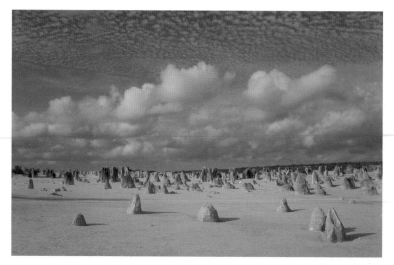

Pinnacles, Namburg National Park, Perth, Western Australia (Chiz)
OK, you tell us, where's the 'subject' in this shot?

Different angles

Landscape photography largely deals with fixed objects. We could move the odd pebble, but not a tree or a mountain. But you can always move the camera.

Switching lenses, or using a zoom, is just one way to change the framing of a shot. Even with the simplest of cameras, with one fixed lens, you can move forward, back, left, right, up and down. Try all of these options, and observe the results carefully.

There is every difference between snapping on a longer lens to take a 'closer' picture of a scene, and actually walking forward into it. If there's a tree fifty metres away and a mountain ten kilometres away, zooming in will enlarge both of them equally within your frame. Walking forward 25 metres makes no difference to the apparent size of the mountain, but makes the tree look much larger. Zooms and telephotos are wonderful things, but they don't replace the need to move.

And as you move, remember the third dimension. Why take every shot from normal eye-level? Scrambling up a boulder or outcrop can expand your view considerably, while getting low draws in more foreground detail. We're outdoor people: who cares about grubby knees?

Foregrounds and panoramas

Many cameras have a 'panoramic' option, which – usually – allows you to 'stitch' several frames together to produce a wider view than the lens can achieve in a single shot.

A good panorama can create a great sense of space. However, we still see a lot of 'panoramas' which apparently do no more than chop off the top and bottom of the picture. This normally cuts out the sky and the foreground, just leaving the middle to far distance. This may satisfy those deluded souls who think you can see it all from a car window, but the active outdoor person is aware of, and cares about, more than just 'the view'. When shooting panoramas, it's usually best to pre-focus on the area you

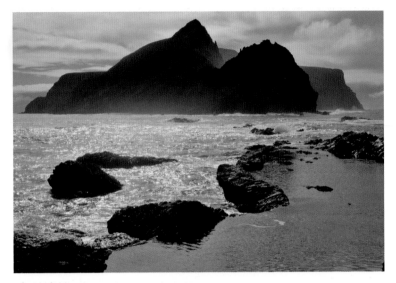

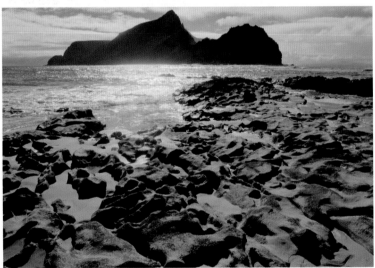

Cabo Calheta, Porto Santo, Madeira Islands (Jon)
Perspective changes with position, but changing the focal length is often the next step

want in sharpest focus, then switch the focus to manual as auto-focus may find alternative points of focus in successive shots.

'Foreground' is not just another bit of photographic jargon, or a goody-bag you can mine to improve your framing. The foreground is where you are. It's where you walk or climb or bike. The foreground is grit under your boot soles, the icy stream you've just crossed, the crystal glinting on the corner of a rock, a bright mound of moss campion. The foreground is what says 'I was there'.

Jeffrey Hill, Lancashire (Jon)
'Foreground' is where you are

To make the most of foregrounds, there's no substitute for a wide-angle lens. (See p43–44 for what constitutes a 'wide-angle' on different camera formats). Wide-angles can encompass both the broad sweep of a landscape and the vital foreground detail. However, they're also pretty good at taking in things you don't want as well as those you do, so think about the whole frame. Keep it simple!

Foregrounds are also a great way to enhance a sense of scale. It's funny, but it's true: if you want a photo of a mountain that gives a sense of its awesome size, filling the picture with it may not be the best way. For most people, especially those with limited experience of mountains, a shot of a peak in isolation, without context, is hard to 'read'.

Including a relatively familiar object, like a tree, helps us make sense of the unfamiliar. Human figures are also ideal for this, because we all know how big – or rather, how small – human beings are. Making the figure really tiny in the frame can be very effective – as long as it's still recognisably human, not just a small black dot.

So how do you ensure that you get strong foregrounds in your pictures? Before you lift the camera, start looking. Flowering plants, interestingly shaped rocks, fence lines, trees, shrubs can all make good foregrounds. But beware – not all foreground objects work equally well! In particular, be wary of random objects such as a tree branch with no connection to the rest of the image: it will usually look more like an annoying distraction. The foreground needs to relate to the background in some way. If you can

Rocks make such good foregrounds that in some circles they are referred to as JCBs – for '**Joe Cornish boulders**' –after Joe Cornish, one of the UK's foremost landscape photographers, who tended to home in on convenient boulders for foreground interest.

Helvellyn, Lake District (Jon)
Even really tiny figures can be very significant in the shot, especially when they appear to be at the focal point

see the trunk of the tree, and the ground in which it's rooted, which perhaps connects to the view beyond, it can work much better than just a branch apparently hovering in mid-air. It's a complicated topic, and what works for one person may not work for another, but it's definitely something to consider.

Some foregrounds are fairly incidental, others may become the dominant element in the shot. To really concentrate on the foreground, you usually need to work at close range and let it fill the frame. Very often the best way to get close is to get low. Sit, kneel, crouch, crawl – do whatever it takes. We take many pictures from a crouching or kneeling position, not because we're lazy – all that crouching and getting up again is harder work than shooting everything from standing eye-level. It's so we can get closer to the figurative eye-level of that butterfly on a thistle, or clump of grass, or hoar-frost encrusted boulder.

Just be aware it can occasionally lead to embarrassment; both of us have had concerned strangers asking if we're alright as they find us lying on the ground; and your so-called friends may find it amusing to pretend they're about to put their boot on your head!

Really wide lenses let you work very close to foreground objects. Even tiny shifts in your camera position can have a big effect on where or how large they appear, while making negligible difference to distant skylines. Get close, get involved, but keep looking at the whole frame.

Middle management

Of course the real world is not divided neatly into 'foreground' and 'background'. An image consisting solely of two disparate segments with no connection between them will often look odd, like a Photoshopped collision of two unrelated images. The bit in

between is easily overlooked, but it's what connects the foreground interest with the wider background landscape.

However, striving to ensure a strong middle-ground in every shot can make the image just too full and complex. The middle-ground can often be hinted at or suggested, while strong lines – rivers, paths, walls, even a line of people or sheep – can keep it simple but set up a clear connection.

FOCUS AND DEPTH OF FIELD

We introduced depth of field on p20. That's a measure of its importance. In all of photography, there's no technical concept that's more vital to grasp. And by tradition, landscape photography – photography of places – aims to maximise depth of field.

This is not an arbitrary diktat. There's sound reasoning behind it. As we've already suggested, when the shot has a clearly defined subject, like a portrait, it may not matter – it may even be a plus – if other elements in the frame are out of focus. But with general landscape views, everything is the subject. (Maybe the word 'subject' is almost as treacherous as that other word, 'composition'.) In this kind of shot, a picture which is sharp throughout matches what we see, and looks more natural.

In TTL viewing the lens is wide open, which gives us the minimum depth of field, but if the picture's taken at a smaller aperture, other objects, both closer and more distant, come into focus. But how do you know what will be in focus? And how do you control it?

Traditionally, every SLR had a depth of field preview button, which manually stopped the lens down to the required aperture. This also made the viewfinder image darker, but it was still helpful in giving at least an indication of the effect on depth of field. These are relatively rare now, but digital photography does give us an instant review instead, and we can zoom in and examine this more closely if we're really concerned about sharpness.

Depth of field is influenced by three main factors.

- **The aperture** Depth of field is smallest at the widest aperture, and increases as you stop down. There's much more depth of field at f/16 than at f/4 (remember, they're fractions). Most cameras have a Landscape mode, one of whose main aims is to set a small aperture. You can also use Aperture-priority for direct control. Just remember that aperture is only one of the factors in play.
- **The focal length of the lens** The wider the angle (in other words, the shorter the focal length), the greater the depth of field. A 20mm lens has much greater depth of field than a 200mm.
- **The distance to the point of focus** Depth of field is greater when you're focused on more distant objects. In real close-up work depth of field is minuscule.

We might assume that an aperture of f/16 or even f/22 would be best. However, due to diffraction, overall sharpness tends to fall off at the smallest apertures. The best compromise between depth of field and sharpest results is often with the lens roughly half way open (eg at f/11 for a lens whose minimum aperture is f/22). At lower ISO ratings this means a slow shutter speed, which in turn means using a tripod or risking camera-shake. Today we have both image stabilisation and the option to turn up the ISO a few notches.

The difference in depth of field is caused by changing the aperture from f/4 to f/8 (Chiz)

Making the most of depth of field

Remember that depth of field extends both behind and in front of the principal point of focus. If you focus on the most distant object in a scene, although depth of field is theoretically greatest, you're only using half of its potential. The fact that more distant objects would be in focus – if there were any – is immaterial. In a typical landscape shot, the most distant part of the scene will be a skyline or horizon. Focusing on this is, as near as makes no difference, focusing on 'infinity'. (Infinity has a somewhat special-ised meaning in optics.) Depth of field theoretically extends beyond infinity, but this isn't much use to anyone except Buzz Lightyear.

You'll often see advice in books and magazines to focus 'a third of the way into the view'. The trouble is that no-one ever explains what they mean by this, probably because they can't. I've never yet found an interpretation that really makes mathematical or optical sense. After all, what is a third of the way from here to infinity?

With some very conventionally framed landscape images, focusing a third of the way up from the bottom of the frame can work, but this too breaks down as soon as you're more imaginative about framing.

It's better to think of the thirds here as an idiom rather than a mathematical formula – roughly equivalent to foreground, middle-ground and background. Focusing towards the far end of the foreground can be a good start to give the widest depth of field for a typical 'big view' shot.

Clearly it would help to focus closer – but how much closer? The answer to this depends on both the aperture and focal length of the lens, so there's no single figure for all circumstances. But there are ways to make a good estimate.

With digital cameras, one approach is to focus on infinity, take a test shot and then examine the playback. Identify the closest distance that's still in focus. Refocus at this distance; depth of field now extends out to infinity and also as close as it's possible to get (without changing aperture, lens or where you're shooting from). Some SLRs have a depth of field preview, which you can use instead of playback to see what's sharp.

Going for maximum depth of field is a convention with a sound basis, but it is only a convention. You're free to ignore it whenever you want.

It's worth remembering why we said that landscape shots need good depth of field. It's to match the way that we see broader views, which gives the impression that everything is in focus. On the other hand, looking at landscape can also engage the 'mental zoom lens'. Small slices of a distant scene, or single prominent objects, can capture our attention. Long lenses help us to take photos which correspond to this kind of seeing.

The selective nature of the 'mental zoom lens' means that the limited depth of field of the long lens isn't necessarily a problem. In fact, being able to isolate the subject by throwing everything else more or less out of focus can be a godsend for this kind of shot. Suppose your attention is caught by a beautiful, shapely tree on a nearby ridge, with a distant hillside beyond. To your eye it stands out clearly, but in the final shot the tree almost merges into the similarly-coloured background of woods on the far side of the valley. Limiting depth of field could allow the tree to stand out sharply against a background in softer focus.

LIGHT ON THE LANDSCAPE

Every photograph depends on light. Landscape photography just reminds us of this fact. Make a few return visits to a favourite location at different times of day and observe how the light changes. Dedicated landscape photographers plan their outings around the light, often working highly unsocial hours as a result.

The received wisdom is that early morning and late evening are the best, if not the only, times for landscape photography. There are reasons for this. Low-angled light at the ends of the day picks out much more of the form and texture of the landscape. The

Echidna Chasm, Purnululu National Park, Western Australia (Chiz)
A small aperture (here f/11) was used to get all the rocks as sharp as possible. This shot also illustrates that midday is sometimes the best time – and for this one the only time, as the light doesn't enter the cave at all except for a short time around midday!

Porto Santo, Madeira Islands (Chiz)
Broken cloud can create fast-changing and dramatic light

colours are often much more interesting, too. The lower the sun, the more its light shifts towards orange or red, while shadows are lit by the deepening blue sky. This creates strong contrasts of colour which can add vibrancy even to relatively mundane scenes (and can't be imitated with filters).

Some books would suggest you might as well pack your camera away while the sun is high. This is all very well for the dedicated landscape photographer, who can plan to be at location X as the sun clears the horizon, and then go home for a late breakfast. It's no help on a trek, when you may have no choice but to pass some of the grandest spots at midday.

Fortunately, sometimes the middle of the day is the best time. Deep valleys and forest clearings may only get sun at these times. A west-facing crag will catch oblique light from around mid-day; evening light, although warmer in colour, hits it face-on, flattening details and structure. Views including shallow water often also are more vibrant when the sun is high and can reflect some of its light off the sea floor.

Besides, we don't always enjoy uninterrupted sunshine. Broken cloud can create fast-changing and dramatic light. Even on the dullest days there can be occasional shafts of sunlight. These effects can come and go very quickly. Sometimes landscape photography is not so leisurely.

Whether or not some books say a particular time is 'best', if you're there and it looks good, why not shoot it? Lighting conditions should never stop you taking a shot, but they will certainly affect how you take it.

Natural light

For virtually all landscape shots, the sun is the light source. Even moonlight is simply reflected sunlight. Lightning and firelight can both make great shots on occasion, but mostly it's about the sun.

North Face of Triglav, Slovenia (Jon)
'Hard' lighting. There's strong lighting to show up the structure of the North Face, but the valley is in deep shadow and the trees are little more than silhouettes

Lone Tree, Lanjaron, Spain (Chiz)
Silhouettes can produce memorable and evocative images

The sun itself doesn't vary much. What makes sunlight interesting and immensely variable is what happens to it in the last few kilometres of its 150,000,000km journey to the surface of the Earth. It gets filtered, diffused, refracted and reflected in endless permutations.

Branches, Derbyshire (Chiz)
Soft light can work beautifully with more intimate aspects of the landscape; here it creates a near-abstract image

Under clear skies, direct sunlight creates strong shadows, but they are never completely black: even a cloudless blue sky throws some light into the shadows. Our eyes adapt constantly, allowing us to see detail in both brighter and darker areas. However the difference in brightness – the dynamic range – can sometimes be more than any sensor can cope with. In the final picture the shadows may appear solid black, or the highlight areas totally burnt out and white – or both. We can sometimes use this to create an effective image, but often the results seem harsh and unpleasant. Photographers refer to this as 'hard' lighting. (This can be hard in the sense of 'difficult' too!) A bright sunny day may be ideal for comfort in the outdoors, but not necessarily the best for photography.

Haze lowers contrast to more manageable levels. Hazy conditions can be very dull for shots with the sun behind or to the side, and shooting into the light may be the photographic salvation of such days, especially when the sun gets lower.

Under an overcast sky, the entire sky effectively becomes one huge light. The light is gentler and shadows are barely noticeable. Unsurprisingly, this is called 'soft' lighting. This makes it much easier to retain good detail throughout a shot, but pictures may seem flat or lifeless.

Soft light doesn't always lend itself to broad landscape views, unless there are very strong shapes involved, but can work beautifully with more intimate aspects. A flower meadow, full of strong shapes and colours, can become a hopeless visual muddle when strong sunlight throws criss-crossing shadows into the mix. Soft light can give a much clearer result here.

Direction of light
Soft light, by its nature, is similar whichever direction you are facing. The harder the light, however, the more your results are affected by the angle you shoot at. You can't quickly change your angle of view to distant objects. If the light's 'wrong' for a distant

Windmill, Porto Santo, Madeira Islands (Jon)
'Against the light' or 'contre-jour' shots can be very striking, but extremely bright areas, even small ones, tend to over-influence the exposure: a couple of test shots ensured the windmill did not appear as a complete silhouette. Masking the sun also reduces flare

peak, only time will change that. But you can easily change your viewing angle for nearer objects. Next time you're confronted with a strikingly-shaped dead tree or highly-textured rock, take a little time to walk round it and see how the light changes.

With the light directly behind you, objects look almost two-dimensional and there are few shadows. Contrast is relatively low. Such frontal lighting can allow you to concentrate on pure colours and shapes. Shadows can still appear – your own, for instance, can be a real nuisance!

Light from the side creates strong shadows, which emphasise three-dimensional forms and textures. Relatively small changes in viewing angle can significantly alter the balance of light and shadow: try it!

Shooting directly towards the sun – 'against the light' or 'contre-jour' is the jargon – involves some of the most variable conditions of all. They can be tricky, but can potentially produce some of the most exciting results you'll ever get. Translucent objects, from clouds to foliage, glow with a seemingly internal light. Solid objects, however, often turn into silhouettes. This can work very well with a leafless tree, less so with a mountain peak. With nearby subjects, a reflector or fill-in flash can turn a silhouette into a semi-silhouette. Midday light tends to be too harsh and can 'burn out' the sky; conversely, the red, orange or yellow morning/evening sky will often give a striking background.

Wild light

Dark clouds may mean that you are about to get drenched, blown around and generally uncomfortable. Oddly, these are often the most memorable bits of the day. Challenging weather often results in abiding memories – and it can be a photographer's dream!

Before the storm actually hits, the contrast between the last patches of bright sunlight and the dim light elsewhere makes the clouds appear much darker than they do when the sun has disappeared completely. That's an effect where the eye actually behaves more like the camera lens than normal, shutting the pupil size down to avoid too much light from the brighter part of the sky overloading the eye. The camera can capture this too – often better than the eye actually saw it!

Once the storm actually hits, good shots may be harder to come by. Besides, cameras really don't like getting soaked, so give it some cover. When the rain eases again, you may find that foliage and flower dripping with fresh raindrops make fantastic close-ups. And there might be a stunning rainbow, so don't pack the camera too inaccessibly – the weather can change very quickly!

When the light's doing wild things, both challenge and reward are at their greatest. Even if contrast doesn't seem excessive, this may be the time to bracket your exposures. If the camera doesn't have automated bracketing it's easily done in Manual mode or by using exposure compensation.

Extremely bright areas, even small ones, tend to over-influence the exposure: obvious examples are when the sun itself is in frame, or when its light is glaring off water. The result is that everything else in the shot looks darker than you wanted; it's underexposed. Therefore you need to give more exposure. In manual, widen the aperture or lengthen the shutter speed. In other modes, select positive exposure compensation.

Small dark areas, even when totally black, don't have the same tendency to pull the exposure out of kilter. However, large dark areas will influence the meter. In this case the question is whether you want them to look dark, or not. When the dark areas dominate the frame, the meter will tend towards an average result. This isn't always

Kent Estuary, Cumbria (Jon)
A splash of sunlight under gathering clouds

PLACES AND PEOPLE

Bay of Fundy, Nova Scotia, Canada (Jon)
Low-angled morning light picks out form and texture. The direct sunlight is very red while the sky-lit shadows are noticeably blue

what you want. For instance, a shaft of sunlight may create a small patch of glowing colour surrounded by gloom. To preserve this effect it's important to keep the dark areas relatively dark. In this case you need to give the scene less exposure than the meter may suggest: use negative exposure compensation.

Flare

Lens flare, or just 'flare', is a hazard when shooting into the light. It results from reflections within the lens and often appears as a string of coloured blobs, aligned as if radiating from the sun. Look out for it in the viewfinder or on playback.

When the sun's actually in the frame, preventive options are limited. Sometimes you can hide the sun behind an object such as a tree. Flare may vanish if the sun is dead centre in the frame.

When the sun isn't in shot, you have more options. A good lens hood is essential, but few lens hoods provide full protection, especially with zoom lenses – you'd really need a zooming lens hood too. You can provide further shading with a piece of card, a map, or even your hand. Unless the camera's on a tripod, or you've got an assistant, this requires one-handed shooting.

The colour of magic

Colour doesn't just belong to objects. Light itself changes colour. Sometimes it's easy to see, like the warm orange or red light of sunrise and sunset. You can even see different colours of light at the same time. Shadows aren't just darker than sunlit areas, they're also a different colour. If the sky's blue, so is the light in the shadow areas.

Other variations are subtler and less obvious to the eye. Under overcast conditions, the colour of the light is essentially uniform and the brain is easily tricked into

How do you know when the exposure really is right? Looking at the playback image on the back of the camera is all very well, but it can be hard to see in bright sunlight, and merely changing the screen brightness can make an image look lighter or darker even though the shot itself hasn't changed.

A far more objective way of judging the exposure is with the histogram. On many cameras this is automatically displayed as one of the available playback screens for each shot. On others you may have to delve into menus to make it visible.

'Histogram' may sound technical, but it's just a very simple graph of the range of tones in the image, with the darkest to the left and lightest to the right. A 'good' histogram usually shows across the whole width of the graph, but doesn't spill beyond its bounds: this indicates 'clipping' – areas which are pure black or pure white with no detail recorded. And this is where you may need to start thinking about one of the options here for dealing with high contrast.

As an alternative, many cameras can also display a flashing warning when highlight clipping is present.

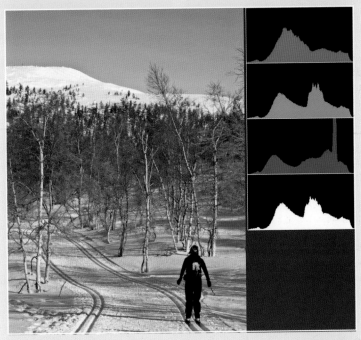

The histogram (Jon)
This illustration is taken from NikonView software but the histogram display on the camera back will be similar, although some cameras will only show the single summary histogram (white), not the individual red, green and blue colour channels.

3

PLACES AND PEOPLE

Grize Dale, Lancashire (Jon)
The same shot with and without fill-in flash

seeing it as 'normal', but in fact it is often distinctly cold (blue), which is generally perceived as unattractive. Fortunately, the white balance control of digital cameras can compensate for the coldness.

Sometimes we want to 'correct' colours and sometimes we may not. If we're shooting a portrait we probably will want to warm up those blue-shifted hues, to avoid the victim – sorry, subject – appearing ill or even dead. But if we're shooting a melancholy winter wood the cold hues may create an eerily effective mood. Either by manually setting the White Balance in-camera, or by shooting RAW and adjusting later, we have the choice.

The question of contrast

We've already alluded to the problems posed by hard lighting conditions, which can create contrast or dynamic range beyond the range of any sensor (and way beyond what film can cope with). The annoying thing is that such conditions are frequently very exciting for photography.

The best sensors – inevitably, they are on DSLRs – now have terrific dynamic range capacity, but even these will be outfaced at times in really exciting natural light. Compact cameras fall well behind.

There are many ways of dealing with extreme contrast, but all start with being aware of it. If you squint when you turn towards the light, or need to take your sunglasses off when you go into the shade, this suggests the light is hard. And don't discount the 'test shot'. Image playback has extra value in tricky conditions, and studying the histogram pays dividends.

There are various options for dealing with high contrast but all have their limitations.

Graduated filters. You can get these in all sorts of hues but a 'grey' graduated filter (known as 'grey grad', or more properly, Neutral Density graduated or ND grad) selectively darkens part of a scene without distorting colours. These are usually employed to darken a bright sky relative to the foreground. The problem is that the transition of the filter is a straight line even though the boundary in the scene may be far from straight. These days the grey grad seems like a bit of a blunt instrument compared to what can be done in software (post-processing) afterwards

Reflectors or Fill-in flash. These throw extra light into dark areas, but only over a very short range. A reflector (which can be as simple as an unfolded map) lets you see the effect before you shoot: flash can be assessed on playback.

Reframing. Sometimes you can just 'lose' a troublesome area by adjusting your viewpoint or shooting angle. This may be the best way of dealing with a large block of black shadow. If the sky's very much brighter than the foreground, it may appear virtually white in the picture. There's little joy in this, so try reframing with the horizon high in the frame.

Exposure bracketing. Bracketing – taking multiple shots at different exposure levels – is not a specifically digital technique, but what digital does allow you to do is to combine the separate images afterwards, perhaps taking the highlight areas from one, mid-tones from a second and shadows from a third. This can create images covering a far wider dynamic range than is otherwise possible (see p226). Many cameras have an automatic exposure bracketing feature and some can even merge the images for you. A tripod or beanbag helps to ensure that the separate images all line up perfectly.

HARDWARE FOR LANDSCAPE PHOTOGRAPHY

You can use just about any camera for landscape photography, and almost any lens will suit some shots, but a wide-angle lens is really a necessity – 'stitching' images is only a partial substitute. A longer lens may help to isolate small or distant features, but remember that many can be picked out simply by walking closer to them. Large-sensor

Black Clough, Forest of Bowland (Jon)
A 1.3 sec exposure definitely needs a tripod or some other very solid camera support

cameras give the widest view, and also score at dealing with high dynamic range, but smaller sensors do make it easier to achieve really great depth of field.

Even so, depth of field demands small apertures, which can lead to slow shutter speeds. However, today's cameras (especially those with larger sensors) can maintain excellent quality at high ISOs; coupled with image stabilisation this makes hand holding a real possibility much more of the time. It's no longer possible to say that landscape photography absolutely demands a tripod. However, some shots, such as those where a long exposure is deliberately used to blur movement (usually with waterfalls) still do.

There is, however, another reason for using a tripod: it slows you down. Using a tripod is a good way to make yourself think – the antithesis of 'point and shoot'. If you have to unpack a tripod, you'll want to be sure the shot is worth taking, and then to think carefully about how best to tackle it. When you're travelling through the outdoors you may not want to carry the extra weight, or have time to set up a tripod for every shot (especially if travelling with non-photographers), but you can still do the thinking part. Thinking shouldn't slow you down too much, and it certainly doesn't weigh anything!

LANDSCAPE WITH FIGURES

Figures can give a sense of scale and accentuate that feeling of 'being there'. Even a very tiny figure can sometimes make a crucial difference to the meaning of a shot. As the figures become larger, it becomes harder to define what is a landscape shot and what is an activity or action picture. But, quite honestly, who cares about these artificial distinctions, apart from a few photography wonks?

Where you place the figure in the frame is important, especially when it's relatively large. A central figure is usually more dominant than a same-sized figure near the edge

Cathedral Gorge, Purnululu National Park, Western Australia (Chiz)
Figures can give a sense of scale and accentuate that feeling of 'being there'

Paul Heaton in the Cat and Fiddle, Derbyshire (Jon)
You can take photos in pretty low light, especially if you set a high ISO speed (1250 in this
case). Lit solely by the pub window on a very dull day, this shot of singer and cyclist Paul
Heaton was originally taken for Cycling Plus *magazine*

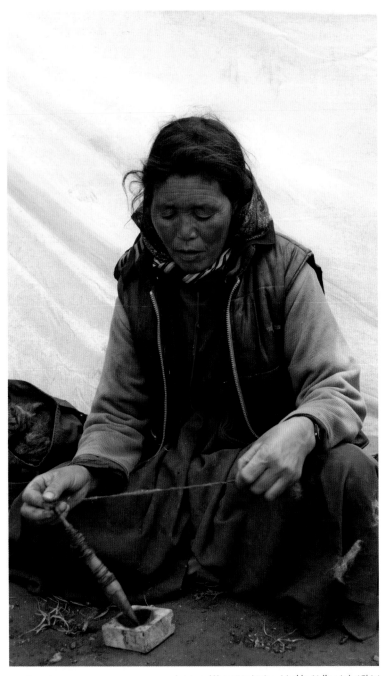

Woman spinning, Markha Valley, Leh (Chiz)
Attractive and revealing moments can occur when someone is otherwise absorbed

of the frame. A central figure can 'block' the view beyond. For those 'summit view' shots it's usually better to have the figure(s) well to the side and probably looking into the frame. If they're looking the other way the viewer will wonder what's out of shot that's more interesting!

When moving figures are involved, it's usually preferable to have them moving into the frame rather than out of it. Some pundits will tell you it's better if they're moving from left to right because this is the way we read. However, other cultures read from right to left, so there's nothing hard-wired into the human brain that makes us prefer one direction or the other. Besides, in the real, outdoor world you can't always choose which way your participants will be moving. But it does help if they're looking around at the scenery rather than down at their feet.

Figures in the landscape

At some point, as you get up close and personal, 'Landscape with figures' morphs into 'Figures in the landscape' and on into 'Portrait'. Of course, many pictures of people, especially in the outdoors, are also 'action' shots, with specific requirements that we'll deal with in later chapters. But the 'pure' portrait deserves some consideration. For most of us, people are part of the outdoors experience and should be part of the photographic record of that experience. Even if you walk alone you may want to include yourself in a few shots, to record how you felt, to give a sense of scale, or just to say 'I was there'. Thank heavens for the self-timer.

Globally, most photographs are pictures of people, and most cameras are designed with this in mind, so they ought to do a pretty good job at it. Face recognition technology, present in more and more cameras, means that the camera will preferentially focus on human faces. Of all areas, then, this could be one where you can safely leave everything up to the camera – and concentrate on your people-skills instead. Good portraits require sympathy and engagement with the subject. Perhaps even the word 'subject' should be avoided. People are not subjects, just people.

Unless you're on a solo trek in a deserted wilderness, other people are a major part of the outdoor experience, and they naturally fall into two main categories; the people you go with and the people you meet on the way. Photographically there's no difference but a different personal approach may be required, particularly when dealing with other cultures. An obvious example: in many parts of the world photographers – especially male photographers – need to be careful about photographing women, and in some cases should not even attempt it.

It's not worth being sneaky about it. If you ask politely, and accept a refusal, no-one should be offended. If you try and sneak a shot and get caught, at the very least it's a breach of trust and sours relations; occasionally the consequences could be much worse. Local guides are usually helpful and can act as interpreters, but language need not be a barrier. There are very few people who don't recognise a camera and nearly everyone understands 'OK?' as well.

The drawback with this open, upfront approach is that most people are likely to pose and grin helpfully at the camera. In most cultures children learn at an early age that this seems to be expected. This is unfortunate when you're after a more natural effect, but usually the best approach is take the shot anyway and then take a few more as the person relaxes. 'Sacrificing' the first shot or two is no loss, at least on a digital camera. With a digital camera, too, you can show people what they look like on the

Garry Reed, Hadrian's Wall (Jon)
Strong light works for some portraits (but be prepared to use a bit of fill-in flash)

LCD screen. Such sharing builds trust and friendship, but it can become a drain on batteries.

Most cameras now have a Portrait mode. This does several things, all of which you can emulate if operating manually. For a start, the camera sets a relatively wide aperture to limit depth of field (see p20), helping subjects stand out from their background. The camera may employ Face Recognition technology to select the focus point automatically. And (for JPEGs anyway), it will process the image with relatively low contrast and gentler colours.

Also – and here's the unfortunate part – it will almost certainly activate the flash automatically if the camera thinks light levels are too low. But built-in flash is rubbish for portraits. It is small, which makes the light harsh. It is sited very close to the lens, which makes the light frontal and flat. And it often creates the dreaded 'red-eye'.

'Red-eye' is caused by light bouncing back off blood vessels in the retina. Many cameras have a 'red-eye reduction mode' which uses a series of pre-flashes to cause the pupils to contract. Of course this creates a delay and kills any chance of spontaneity, while doing precisely nothing to improve the overall lighting. Red-eye reduction is a prime example of a feature that sounds like a good idea but really, really isn't. Turn

it off and use software red-eye removal later instead. If Portrait mode insists on red-eye reduction, then ditch Portrait mode.

Small flash units are also low-powered, with a range of only a few metres. This often leads to the person's face being illuminated while the background goes black, leaving no clue as to whether the shot was taken in Kathmandu or Keswick.

For better portraits, the first rule is: avoid flash at all costs. You can take photos in pretty low light, especially if you set a high ISO speed. A small increase in image 'noise' is generally a price worth paying. If a slow shutter speed is required, you can minimise camera shake by bracing on a rock, table or other solid object – but the subject will need to keep still. Unless you catch them in very contemplative mood, or possibly asleep, this sacrifices the spontaneous element. A simpler way of avoiding the use of flash is, of course, to shoot in daylight. This also gives you a range of options to shoot everything from full-on action shots to static, posed ones.

Posed shots are all very well but in the outdoors we'll often prefer something more natural and relaxed. Stops on the trail for food and drink provide handy opportunities and, while it may be inadvisable to take sneaky shots of strangers, you can get prior consent to try and grab candid shots of your friends. Attractive and revealing moments

Pico Veleta, Sierra Nevada, Spain (Chiz)
Action shots can be portraits too

Young monk, Phyang Monastery, Ladakh (Chiz)
Although you can't see it in the shot, he was under a shady canopy, which gave lovely soft lighting to his face

can occur when someone is otherwise absorbed: preparing a meal, admiring a flower or sorting climbing gear before an ascent.

The virtues of this kind of shot, showing people in context and doing what they came for, can be combined with a bit of eye-contact by framing up a shot of this type and then calling the person's name. Shoot as soon as they look towards you, before any stiffness creeps in, and the result can be a great semi-candid portrait.

The nature of the light does affect people pictures. If you shoot with the sun directly behind you, then you are asking people to look straight into it, which is uncomfortable and often makes them squint. Light from the side is easier to cope with and gives stronger 'modelling' on the features, which can produce powerful portraits. The sun directly behind the subject can give a backlit halo on the hair but throws their face into shadow. A low-power burst of flash gives 'fill-in' light: this is the best argument for on-camera flash. An alternative is to use a reflector to bounce light onto the face. A white T-shirt will do very well, but takes us into the realms of the posed shot. Sometimes other light-coloured surfaces, like limestone rocks, present themselves naturally.

The softer light of an overcast day is often easier and kinder for people pictures. This is a win–win situation as it gives you something to do with the camera when there's little incentive to take landscape shots.

FINAL THOUGHTS

A good photograph is not a good photograph because it conforms to the Rule of Thirds or any such 'rule'. It is a good photograph because it makes its point clearly; because it tells the story you wanted it to tell. From time to time you probably see a picture that makes you go 'wow!' It's highly unlikely that this will ever be because that shot is a great example of the Rule of Thirds. In fact with a real 'wow' shot that's probably the last thing you'll think about.

It follows that the starting point for a 'wow' shot is not a rule, or technique, but a feeling. The starting point is a place that makes you go 'wow', or for that matter, 'ugh!' And if your photograph makes other people respond in the same way, it's a success. In the end, which is the greater accolade to a photograph? 'What a great shot,' or simply, 'what a beautiful place.'

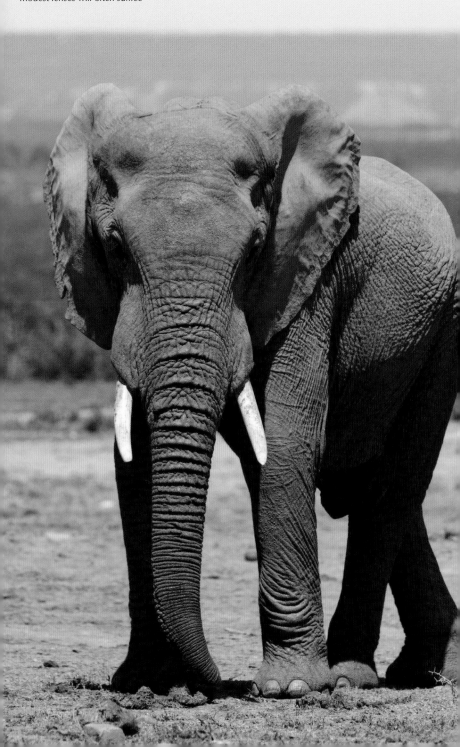

African elephant, Addo National Park, Eastern Cape, South Africa (Chiz)
This shot was taken on a 400mm lens, but elephants are large and can come surprisingly close; more modest lenses will often suffice

4 WILDLIFE AND NATURE

FIRST THOUGHTS

Outdoor folk enjoy far more encounters with wildlife than their unenlightened brethren. For most of us, this is a big part of the appeal of the outdoors, and one reason why pursuits like climbing, kayaking and the rest have a far deeper appeal than mere 'hobbies'.

But many of these encounters are easily overlooked: the sparrow that almost hops into your car as you get out for the start of a walk, the spider's web glistening with dew in the early-morning light, the rosebay willowherb or harebells lining a former railway, even the ravens cawing as they wheel over the mountain tops. These are all very commonplace to the outdoor person but may be unfamiliar to the unenlightened, and all are worthy subjects that can make great photos.

Of course, some encounters are extremely fleeting, but many subjects are more or less static. Flowers are not noted for running away as you approach. They do move about in the wind, but at least you can take your time and maybe wait for a lull. Fungi don't even wobble in the breeze, unless it's an absolute gale, and neither do pebbles or driftwood.

At the other end of the spectrum, we've all missed something that a companion has seen, just through being a few strides behind at the time, or because we'd glanced in the wrong direction. You can't eliminate the element of luck, but you can be prepared. Which usually means having a long lens fitted to the camera and ready to hand (close encounters, after all, often aren't quite close enough when viewed through a lens).

However, it has to be recognised that the majority of good images of wildlife, even familiar British species, are taken by seriously dedicated wildlife photographers, professional and amateur. These are people so dedicated that they are willing to hike all day with a 600mm lens on one shoulder, or to sit in a cramped hide from dawn until dusk, if that's what it takes. Any of us may get lucky once in a while, but those who get lucky regularly achieve it through pure dedication, knowing the habits and habitats of the creatures, and – usually – having some specialised (and expensive!) kit.

This may be all very well for short periods, if there's a really good chance of a sighting at a particular spot, but most people won't want to walk all day with a camera and hefty lens round their neck or slung at their hip. Still less run, climb or cycle. And if the long lens isn't ready when that snow leopard finally appears, what do you do? Start digging around in your rucksack? For the professional, missing that shot might be a tragedy. For you, missing the encounter in the vain attempt to get a shot could be far worse. In fairness, a snow leopard is so rare that most people would be glad just to see signs that it had been there, let alone a chance to capture an image of it.

There's a fundamental choice. You will have a far better chance of getting good wildlife images if that is the sole purpose to your walk/cycle/kayak, but then – for that

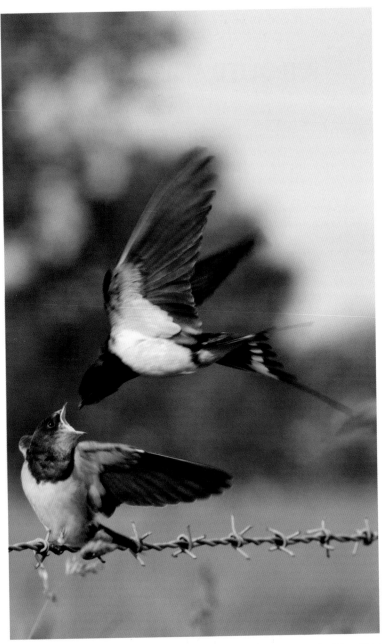

Swallows (Hirundo rustica), Staffordshire (Chiz)
Although the juvenile swallows were very helpful in staying on one perch for several minutes,
the difficulty of capturing the moment of feeding was not to be underestimated, as only the
briefest of tweets from the adolescent chicks preceded mother's speedy arrival with food

time at least – you have become a dedicated wildlife photographer. You're no longer an outdoors enthusiast enjoying the wilderness, and taking some images that communicate your feelings about the experience. The dedicated wildlife photographer requires time that the outdoor enthusiast simply won't wait around for. And the dedicated wildlife photographer will want to use kit that the outdoor enthusiast will find a serious encumbrance to enjoyment of their outdoor activity.

Really dedicated wildlife and nature photography is outside the scope of this book, but don't be too dismayed. There are many relatively easy wildlife and nature subjects, where good images can still be captured with fairly basic equipment. And, more importantly, images that you can be proud to show, and which help you explain why you enjoy the natural world so much. And the more time you spend in that natural world, the more chances you have to get lucky.

Ethical and legal issues

Photographing wildlife presents profound ethical issues. We shouldn't have to explain this to folks who already have a deep appreciation of the outdoor environment. But it can't hurt to restate that no image is worth the life of the creature, or any other creature that may get 'in the way'. And that means not disturbing their homes or their habitat either.

Many species are also protected by law. In the UK, for instance, over 80 species of birds may not be photographed at or near the nest without a special licence – even if you just happen across the nest on a walk or a climb. These include species as familiar as the hen harrier. Disturbance can cause them to abandon the nest and any eggs in it, or expose its location to predators; and that can be a year's breeding attempt wasted. And when the creature is on an endangered list, that's a serious issue.

Even where species aren't protected by law (for example the meadow pipit, which is one of Britain's commonest birds), it's still not acceptable to trample on its eggs, even

Four-spotted chaser dragonfly (Libellula quadrimaculata) (Jon)
Dragonflies rarely stay still for long: this shot took some persistence (and a 300mm lens)

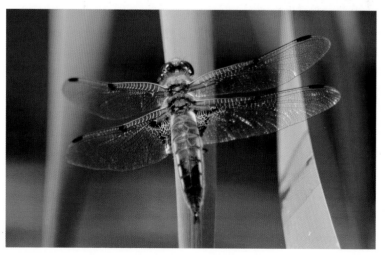

for the sake of the best shot of a snowy owl ever taken. The welfare of creatures and their habitat is more important than anyone's images.

To put it in context: how would you like it if a strange gigantic creature dumped the Hubble telescope in front of your home, destroying the village shop and pub in the process? That's the human-scale equivalent of what a careless photographer could be doing to the wildlife around them.

HARDWARE FOR WILDLIFE PHOTOGRAPHY

Wildlife photography is inevitably often gear-heavy, because so many of its subjects are either small, or far away. In either case, there comes a point at which decent results are unattainable without specialist gear – and the small and the distant each require quite different specialist gear.

Still, for us mere mortals, digital has brought some surprising advantages to afford-able equipment. A compact camera with a good macro setting can be a surprisingly good option for very close-up shots. Also, cropped-sensor DSLR cameras (which is most of them) give the apparent effect of increasing the focal length of your lens. A 200mm lens mounted on a typical DSLR gives the same frame-filling ability as a 300mm lens would on a full-frame camera.

Hardware for distant subjects

Distant subjects demand long lenses. That much is obvious. However, what do we mean by 'long', or indeed 'distant'?

Lenses such as 135 or 200mm, which seem long enough in many situations, sud-denly seem feeble in a wildlife context. These lenses correspond to the 'mental zoom lens' previously discussed: they allow you to pick out a relatively small part of the

Saltwater crocodile (Crocodylus porosus), Kakadu, Northern Territory, Australia (Chiz)
Distant or dangerous subjects demand long lenses (to get this shot I used a 400mm lens from a boat designed to get close to such creatures!)

entire scene, just as your brain can do. Such lenses produce images which still feel quite natural, but when it comes to wildlife, the effect can be paradoxical. That buzzard which seems so close can actually seem further away when you look through the lens.

The largest bird you'll ever see wild in Britain is the white-tailed sea eagle, which can have a wing-span of 2.5m. With a 200mm lens on a typical DSLR, the fully extended wings would fill the frame at a distance of about 10m. It's not that rare to see sea eagles in some parts of the Hebrides, but you'll be very lucky to get that close to one, even for a moment. With smaller birds you'll need to be even closer.

Even a 400mm lens doesn't compare with a half-decent pair of binoculars. Some wildlife subjects really do demand extreme lengths: 600 or 800mm, or even longer. These have very specialised uses; they are also extremely expensive, very heavy, and need some serious support. All in all, hardly practical when you're on the move, let alone trying to combine photography with other activities.

> **Digiscoping** – attaching a camera to the eyepiece of a telescope or spotting scope – usually works best with the small lens of a compact camera. DSLR lenses are just too wide to fit the eyepiece of most telescopes.
>
> While this can be a fantastically cheap way to get astronomical (sorry!) zoom-lengths, the quality of the image will invariably be affected by both the quality of the telescope you are using, and the small sensor area of the compact camera.

Most of the lenses used by the specialists are fixed focal length ones, but that doesn't mean they're cheap. A 500mm prime lens will cost nearly £5000, if not more, and the only makers in this bracket are Canon, Nikon and Sigma. There's a wider choice in 300mm f/2.8 lenses but a typical price is still several grand, and the weight is well over 2kg. Second-hand may be a cost-cutting option, but such lenses are fairly rare. And some older lenses may provide limited functions (eg manual focus only) or not work at all with digital cameras.

Such long prime lenses are standard equipment for the dedicated wildlife photographer, and they're behind many of the stunning shots you'll see, but they're beyond the means even of most non-specialist pros. The closest we're likely to get is hiring one for a special job once in a blue moon. And even if money was no object, you'd still have to carry the darn thing – as well as the hefty tripod (or just possibly a top-notch monopod) needed to support it.

The longest lens most people will own, or want to lug around, will be in the 200 to 300mm range, often as part of the range of a zoom lens. Some of these lenses are surprisingly light, compact, and affordable. Their main drawback is that they are slow, with an aperture of f/5.6 or even f/6.3 at the long end. This can make focusing difficult, both auto-focus and manual – although for manual focusing a lot depends on the quality of your viewfinder.

In truth, there are some subjects where no lens is ever going to be long enough – photographing bearded tits just 5–6m away at Leighton Moss RSPB, an effective lens of 560mm still seemed inadequate.

In recent years the superzoom that covers everything from wide-angle to long(ish) zoom has become a popular option. While the image quality may not meet the most critical standards, the more casual photographer will probably find the trade-off well worth it for the light weight and for not having to carry a second lens in the hills. And, at £200–£400, the price isn't bad for what you get.

Moving up a step in image quality (and price, and weight!), you may decide that the wide-angle shots are best covered with a separate lens. If so, the 70/75–300mm zoom is a very popular choice, giving many wildlife shooting opportunities without breaking the bank – or your back! There's a bewildering array in this category (Sigma alone has three different 70–300mm lenses), but it's a truism that you get what you pay for. More expensive models are more likely to feature specialist lens coatings (to reduce flare), faster and quieter autofocus, and image stabilisation. A wider maximum aperture helps with focusing, both auto and manual, especially at the 300mm end. As always, check the reviews and try and test a real copy of the lens before you buy.

If you're really serious about wildlife photography, the next step up the ladder would include lenses like Canon's 100–400mm, Nikon's 80–400mm or Sigma's 120–400mm, or a 300mm f/4 prime lens. The price is somewhere between £800 and £2000; weight is1.3–1.6kg.

If this all sounds scarily expensive, and intimidatingly heavy, a lightweight and inexpensive solution is to use a teleconverter. A 2x converter, fitted between lens and camera body, doubles the focal length of the lens. However, it's not without its downsides.

First, there's usually some loss of image quality, although it may still compare favourably with options such as superzooms.

Second, not all teleconverters will work with the lens you'd like to attach to: check carefully with the retailer or manufacturer before splashing the cash.

Third, you may lose autofocus. Some teleconverters simply don't support it. It also often happens because converters let in less light to the sensor, (which reduces the effective maximum aperture). For example, with a 2x converter your 70–300mm f/4–5.6 lens becomes a 140–600mm f/8–11. However, most cameras' AF systems only work at maximum apertures f/5.6, or at best f/8. This is one reason why teleconverters are usually paired with prime lenses.

Using long lenses

Long lenses are heavy, and therefore harder to hold. They also magnify every wobble of your hands. A common rule of thumb states that the minimum shutter speed required for sharp images is 1/length of the lens, but in practice it's worth allowing a bit more speed, suggesting that with a 300mm lens you really need 1/500sec, and with a 400mm lens 1/1000sec, to have a reasonable chance of hand holding successfully. And that's a reasonable chance, not a guarantee!

Whatever the shutter speed, it's vital to hold the camera and lens properly (see p44). If you have exceptionally steady hands, and good technique, you may sometimes get away with a slower shutter speed than the formula suggests. Conversely, when your hands are not so steady – possibly the morning after a good night out – these guidelines may seem wildly optimistic. A buffeting wind can make it virtually impossible to hand hold a 300+ lens at any shutter speed. It can be hard enough just keeping the subject in the frame.

Chiz Dakin, Leighton Moss, Lancashire (Jon)
It's vital to hold the camera and lens properly

This all suggests using a tripod, but there are several reasons why this isn't always practical. Tripods slow you down, which is no bad thing with contemplative landscape photography but hopeless when you're trying to react to animals or birds that appear for brief moments – unless you can predict where these appearances may occur, like a bird with a regular perch.

You can't use just use any tripod either; long lenses need them sturdy, especially when there's a breeze. If the wind's strong enough to make hand holding tricky, it's going to test the stability of your tripod. Sturdy tripods are not light, and when you've already got a chunky lens to carry, this can be bad news.

With this in mind, image stabilisation (IS for Canon users, VR for Nikonistas, OS on Sigma lenses) is a real boon, especially for the longer lenses. IS can offer between two and four stops gain on the lowest speed you can normally hand hold at. It's now built-in to most longer lenses (zoom or prime), but check the specifications. Nikon's 300mm f/4 is one example of an otherwise excellent but elderly design with no VR.

Monopods are both lighter and nimbler than their tripod cousins. So is a beanbag, which is exactly what its name suggests. This only needs to weigh 200–300g and can cost virtually nothing. A couple of ziplock sandwich bags filled with small polystyrene beads is a good home-made option! You can improvise a pretty effective substitute with hats, gloves, and other bits and bobs – things you're probably carrying anyway – packed fairly firmly into a small stuff-sack.

Hardware for close-up subjects

Small subjects and distant ones present a similar problem: without the right lens they can be so small in the frame you can barely see them. But there the resemblance ends. With distant subjects you can get the impression of being close by using a long lens. With small subjects you have to be close, and you need a lens that works when you are. The limitation with most 'normal' lenses is that the minimum focusing distance is too long.

Camera using beanbag for support (Chiz)

You might still plump for a longish lens because it will magnify the small subject more, but this can easily be offset by a greater minimum focus distance. Will a 24mm lens or a 135mm lens be best for photographing a smaller subject? Can't say, but it's easy to find out.

Take a selection of familiar objects of varying size: coins, credit card, postcard, your copy of this book. Try each lens in turn, set it to its minimum distance and then move to and fro until the image is sharp (switch off autofocus – it's easier, honestly!).

Scarce swallowtail (Iphiclides podalirius), St Martin de Londres, France (Chiz)
With small subjects you have to be close, and you need a lens
that works when you are (here 24-105mm)

With zoom lenses, try at both ends of the zoom range. You'll quickly see which lens gives the largest image. In a few minutes you've established not only which lens to use, but also the smallest subject-size which yields a frame-filling shot and how close you need to be to get it. Incidentally, you've also sampled a useful focusing technique.

The humble digital compact should not be overlooked for macro shooting in the outdoors. Some offer really close-focusing macro capability. Some will even focus on something as close as 1cm away – which is getting into seriously specialist territory for the DSLR! Just remember to set the **macro setting** first (the symbol usually looks a bit like a flower with three petals), and don't forget to cancel it once you've finished – or you'll be wondering why the camera refuses to focus on that distant landscape!

Many lenses, especially zooms, claim to offer 'macro' capability. The term is often used loosely, meaning nothing more than an ability to focus, well, quite close. Sometimes it means that at one end of the zoom range you can switch the lens into Macro mode and focus rather closer. However, to be strictly accurate, macro capability means at least 1:1 reproduction.

1:1 means that the image on the sensor is the same size as the object being photographed. On a typical DSLR, the sensor size is around 24 x 16mm, coincidentally close to the size of the SD cards most such cameras use to record images. In other words, you can take a sharp, frame-filling shot of an SD card-sized object.

Gorse blossom (Ulex europaeus) (Jon)
The tiny flowers are seen here at close to 1:1 reproduction. This required a calm day as any movement of the flowers would have ruined the focus

Cuckoo-flower (Cardamine pratensis) *(Jon)*
Clusters of flowers can make good subjects if the lens won't allow you to get close enough to individual blooms

No ordinary zoom lens can do this. The best most 'macro' zooms can do is 1:4, which roughly fills the frame with an image of a credit card. Many prime lenses, especially 'standard' 50mm lenses, can equal this without making any hyped-up claims to 'macro' capabilities.

Still, 1:4 reproduction is enough for many purposes. It allows impressive shots of many types of flower, for example, as well as many creatures that might sit still long enough to be photographed (toads, to name but one). If you want to photograph things much smaller than this – smaller flowers, individual crystals in rock, insects – then you need true macro capability.

There are several ways to achieve this.

- Extension tubes fit between the lens and camera body, and the more sophisticated (but expensive) types will retain all the camera's functions such as metering and focusing. These can be combined very effectively with a moderately long lens to give a much closer focusing distance.
- Close-up lenses are small supplementary lenses, attached to the front of the lens like a filter. Again, there's no loss of automatic functions. Convenience, low weight and bulk, make close-up lenses appealing to the outdoor user, but sharpness can be quite variable, especially at the edges of the image.
- The final option is a dedicated macro lens. This will give at least 1:1 reproduction. True macro lenses are nearly always prime lenses and appear in various focal lengths from around 50 to 200mm; around 100mm is most common. The best length depends on the kind of subject you're interested in. Longer ones are better for mobile subjects, as extra distance gives less chance of disturbance. A macro lens will serve perfectly well for shooting normal subjects, (albeit with slow auto-focus!) so a 50mm macro can double as a standard lens, for instance.

Underlining how close you can get with a macro lens, with a 50mm macro it is often necessary to remove the lens hood, as it can shadow the subject or even make contact with it.

INTO ACTION

Using long lenses

Long lenses demand high shutter speeds, unless used on a really rigid tripod. We've already mentioned the 1/shutter speed guideline; go even faster for a better success rate. Shooting creatures in motion may dictate high shutter speeds too. There are several approaches to achieving high shutter speeds; surprisingly, the obvious choice – Shutter-priority mode – is not always the best.

Using Aperture-priority mode. This is usually the preferred option for relatively static wildlife shots, partly because depth of field is too important to ignore. Quite simply, images that don't have enough of the creature in focus rarely work.

There is another reason too. If you use Shutter-priority mode with the speed set to 1/2000sec, the camera may be close to widest aperture from the off. If the light subsequently drops, the camera has no leeway to set a wider aperture for this shutter speed.

> If depth of field really is minimal and you can see no way around it, make sure you get the creature's eyes in focus! The brain will forgive softness elsewhere far more readily.

You may get error warnings, but you may also get markedly under-exposed shots. If you start in Aperture-priority mode, the camera will allow the shutter speed to drop as the light falls. Of course, you may then begin to face problems with camera shake: low light can be a problem whichever way round! (You'll rarely be close enough for flash to come into play.).

Using Shutter-priority mode. This is often preferred for any shots where you want to capture motion in a specific way, perhaps by panning, or freezing the motion. (For

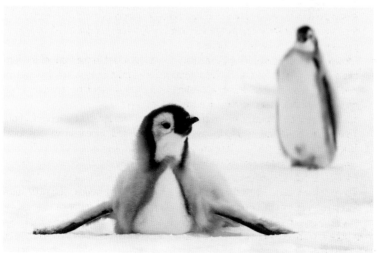

Emperor penguin chicks (Aptenodytes forsteri), Antarctica (Chiz)
Depth of field is too important to ignore. Here the far chick is kept intentionally in soft focus
(aperture f/6.3 at 200mm)

4

WILDLIFE AND NATURE

more on these, see Chapter 7). In these cases you must have direct control over the shutter speed and depth of field may become a secondary factor.

Ramping up the ISO. This could be considered an adjunct to the use of Shutter- or Aperture-priority but, as one of the greatest advantages of shooting digitally, it deserves greater prominence. Most DSLRs now produce very acceptable results anywhere up to ISO1600, while some – especially those with larger sensors – can produce totally useable images at 3200, 6400, or even a staggering 12800. These benefits are usually maximised when you shoot RAW and process with noise-busting software such as that in Lightroom 3.

Focusing modes for wildlife photography

Choosing where you want the camera to focus is crucial to getting the image you want (see p42) Always be aware that if you allow the camera to choose which AF point to use, it will usually select the nearest object which coincides with one or more of the focus sensors. Selecting the focus point manually gives more control.

Having selected the focus point, we need to tell the camera if the subject is likely to move or not. Different manufacturers give different names to the autofocus modes, but it should never be too hard to work out which is which.

Rock hyrax/dassie (Procavia capensis), Betty's Beach, Western Cape, South Africa (Chiz)
Make sure you get the creature's eyes in focus!

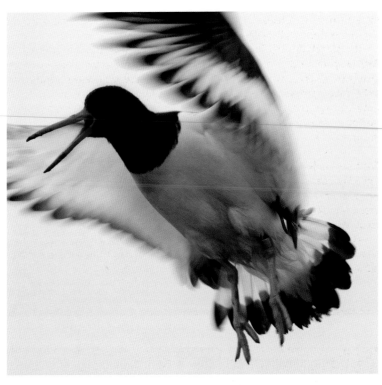

Oystercatcher (Haematopus ostralegus*), Gothenburg, Sweden (Chiz)*
The body is pretty sharp but the wings are blurred (aperture f/22, shutter 1/250s, ISO 400)
showing the angry movement as it dive-bombs me for getting a bit closer than it was happy
with! (I'm not sure who was more surprised when it flew out very unexpectedly!)

One-shot mode. This is the mode you'll normally use for static subjects. It can also be used for moving subjects by pre-focusing on a specific point, then waiting for the creature to walk into that spot. If no focus sensor covers the spot you wish to focus on, shift the camera until you can focus there, then keep your finger half-pressing the shutter button; this will lock the focus and you can then re-frame the shot.

Continuous focus (often called something like 'Servo' or Tracking) is useful for creatures which are moving. Once the AF finds its target, it holds onto that subject and continuously updates the focus distance. It's ideal for tracking fast-moving creatures that are running in a fairly predictable direction, and works best when the subject is a reasonable size. The system can sometimes take half a second or so to lock-on to a subject, so there are times when it makes more sense to switch it off and focus manually – even on a panning shot!

Subjects moving through undergrowth or trees can easily confuse the autofocus sensor as to what it should be focusing on. In such cases **manual focus** may be the only method that works. Small to medium-size birds against a bright sky can also easily fool the sensor.

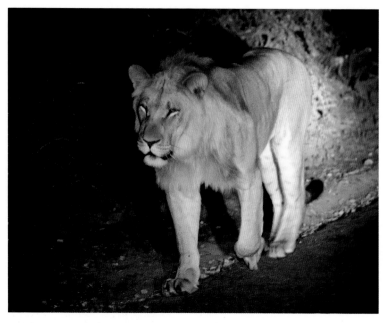

Young lion (Panthera leo), *Addo National Park, Eastern Cape, South Africa* (Chiz)
On a night-time game drive in South Africa, we were privileged to see three young lions come right past our vehicle. In the poor light I set the ISO to a mind-boggling 25600. Initially I wasn't impressed: noise appeared to make the picture unusable. But when I ran the image through Lightroom 3's noise reduction, a lovely sharp, well-focused image emerged, while leaving perceptible grain that actually added to the atmosphere of the shot. For me it was one of the defining images of the trip

Framing tips for wildlife and nature photography

A few simple techniques aid framing of wildlife and nature images.

- If the subject is moving, leave room for it to move into – this helps emphasise the feeling of motion. And, in general, try and have it moving into the frame, rather than out of it – otherwise the viewer's brain will be trying to work out what is more interesting outside the frame!

- Filling the frame (more or less) can give the subject more impact, but if the creature is relatively large or close, be wary of cutting off legs, heads or tails. If you can no longer fit the whole creature in the frame, framing to include just its head and shoulders is a good option – anything else tends to look visually awkward.

- When shooting a group of subjects, try to leave at least a small amount of space around the group; as far as possible aim to avoid chopping any creature in half.

- With shorter length lenses, try and think in terms of an 'environmental portrait' – showing the creature in its habitat, rather than just the creature being small in the frame.

- Shooting at the creature's eye-level usually gives most impact. This may mean you need to crouch, kneel or lie on the ground. This is equally true for flowers and fungi – don't shoot down on them, at least not by default.

- Check your background; this wants to be as clear and unfussy as possible. This is one reason for using wide apertures; the shallow depth of field blurs out clutter that can't be removed in any other way. Many people would say this can make or break a wildlife image.
- Side-lighting or backlighting can work wonders – but if shooting into the sun beware of flare (see p69).
- Where the creature is moving, make sure your shutter speed is high enough to freeze the motion, or alternatively, slow enough to give a really strong blur if that's the effect you want. What rarely works is the in-between shot that's neither properly frozen, nor properly motion blurred!

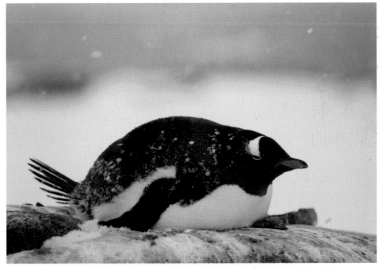

Nesting Gentoo penguin (Pygoscelis papua), *Antarctica (Chiz)*
One-shot is the best AF setting here – she's not going anywhere while brooding her clutch of eggs!

Stalking

Where do you draw the line between stalking and just walking quietly? People who walk alone have far more, and closer, encounters with wildlife than those who walk in groups – although lone walkers who talk to themselves might do less well than a group of Trappist monks. It follows that you can improve your chances still more by taking a leaf or two from the stalker's book.

Just to complicate life, you can't stalk the same way in every case. Mammals and birds pose different challenges. Birds generally have very good eyesight and pretty good hearing, but relatively poor sense of smell. Most birds – owls being the obvious exception – have their eyes set on the sides of their head, giving them a very wide visual field. When stalking birds, the prime requirement is to stay out of sight, the next to be as nearly silent as possible.

Most mammals have a sense of smell far keener than our own. This makes it essential to approach from downwind – a lesser consideration when stalking birds. Mammals typically also have excellent hearing. Sight may be less important, but it

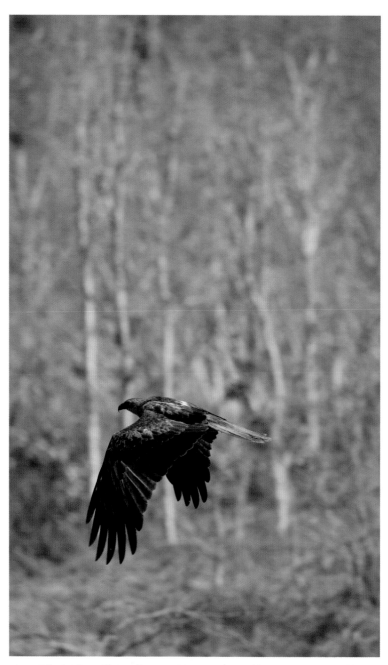

*Whistling kite (*Milvus sphenurus*), Fogg Dam Conservation Reserve, Northern Territory, Australia (Chiz)*
Continuous focus is usually the best AF setting for moving creatures

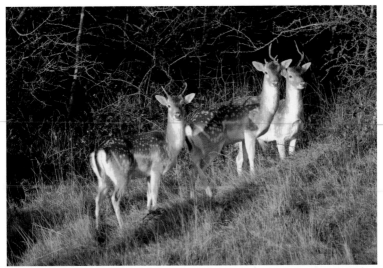

Fallow deer (Dama dama), Lancashire (Jon)
'Stalking' as such isn't always necessary: when you walk quietly (especially alone) you're likely to encounter much more wildlife

still pays to be inconspicuous. Skittish creatures may flee at sudden movement, especially of bright colours, and they notice movement on the skyline more quickly than anything else.

Successful stalking requires careful preparation. A hat that shades your face will make you less conspicuous. Some stalkers cover their faces with a scarf or balaclava. A midge-hood is also a possibility. Anything shiny can be a dead giveaway, so specialists may tape over metallic parts of the camera or use a camouflaged sleeve or cover. Don't let the sun shine on the lens. There's little you can do about your own scent, but staying cool is better than sweating heavily – and don't add to it artificially with aftershave or deodorant! A harder choice could be whether or not to wear insect repellent: if it's an absolute necessity, look for types made from natural ingredients.

After the downwind approach, the essence of stalking is silence. In fact it's oddly like climbing – each foot placement requires careful thought and execution – and can be equally absorbing.

If you think you may have attracted attention, freeze. If you've been spotted, you may be lucky and get away with it if you move off sideways without looking at your quarry. It may conclude you haven't seen it. It'll still be a while before you can try getting closer again.

With all the skill and luck in the world, you still may not have much time. You can't afford to waste it fiddling with the camera. It needs to be ready for action. If and when you do get close enough, the one remaining thing on your mind should be smoothly and silently getting into a suitable shooting position.

With some creatures, you may find an almost opposite technique more effective: we could call this anti-stalking. When you first sight a creature or group, look at the direction they are moving. Then skirt around, get well ahead and sit or crouch to wait

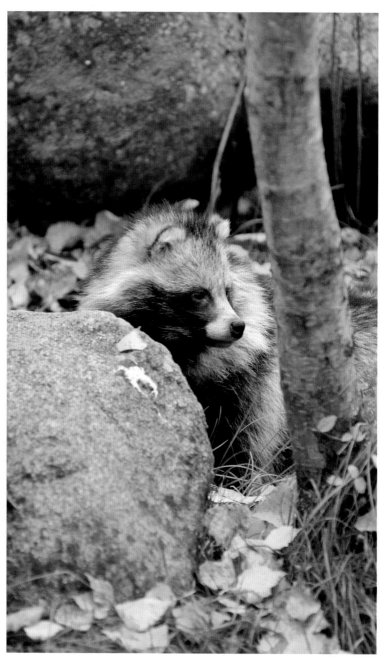

Wolverine (gulo gulo), Finland (Jon)
If you can't fill the frame with the creature, think about the context and what is meant by
'environmental portrait'

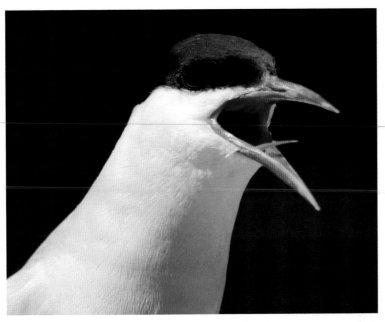

Arctic tern (Sterna paradisaea), Farne Islands (Chiz)
Shooting at the creature's eye-level usually gives most impact

patiently for them to catch up. Oddly enough, 'hiding in plain sight' works best – attempting to blend in too much only makes them suspicious. Far better to sit quietly, look uninterested (don't look directly at them), and slowly bring the camera to hand. With a bit of luck they may pass very close to you – usually far closer than you would get by trying to approach them directly!

Always remember the ethical and legal issues. If a creature keeps moving off before you can get close enough, you're probably disturbing it. You'll also only be getting shots of its behind, so it's not worth hassling it anyway! And never let the chance of a good shot lead you into disregarding your own safety. Since stalking means looking closely where you're putting your feet, it shouldn't lead you into a fall, but there are other dangers. In the UK context, you're more of a danger to wildlife than the other way around, but this isn't necessarily so in other parts of the world. If you can get a good shot of a grizzly bear with a 300mm lens you may already be too close, and far from thinking about how to get closer you should be thinking about getting further away!

You may get closer to many creatures on horseback, or on a bike, than you can on foot. People in boats, especially kayaks, often get closer encounters too. It's a sad comment on our species that 'biped' equals 'danger'.

Hides

You may casually find public hides or other concealment such as shooting blinds. Rocks or bushes may provide natural cover. Setting up your own hide, however, is strictly for the specialist.

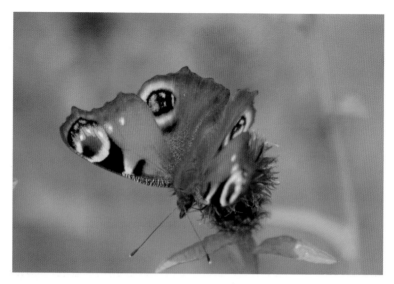

Peacock butterfly (Vanessa io), Cumbria (Jon)
Slender depth of field reduces background distraction

On the other hand, a tent is much like a hide and may give you some great opportunities. This may influence where and how you pitch, not just wild camping, but even on some valley sites. In other respects it may be delightful to have the evening or morning sun shining in through the tent entrance, but if you want to be inconspicuous it's best to keep the interior in shade as much as possible.

Seed-head of borage (Borago officinalis) (Jon)
In real close-up photography, depth of field is minuscule (the seed-head is about 3cm long)

SHOOTING CLOSE-UPS

The main technical concerns are, as ever, focusing and exposure. But there's another issue which often arises first, and that is finding the subject. The credit-card-sized things that you might shoot with a 1:4 macro will usually be perfectly obvious as you travel through the outdoors – and the slower you travel, the more you'll see. However, 1:1 type subjects may take more searching.

Photographing them gets a bit more involved too. It's probably best suited to the solitary walker, but can fit in well on longer trips when you're spending time at camp-sites. A tripod may be useful for accurate focusing on static subjects, but very small subjects can be mobile too. 'Stalking' butterflies can be one of the most maddening occupations known to man, although preferable to being stalked by midges. A tripod is all but useless in this situation.

Focusing

In real close-up photography, depth of field is minuscule, even at small apertures like f/16 or f/22. And at 1:1 or greater magnification, depth of field seems virtually non-existent. This isn't a problem with flat subjects, like your SD card or credit card, provided you shoot perpendicular to them; the same applies to natural, relatively flat subjects like lichen on a rock or the spread wings of a butterfly. However, most macro subjects in the outdoors are definitely three-dimensional. The issue soon ceases to be keeping 'the subject' sharp. It's more likely to be, which bit of the subject is sharp?

This makes autofocus less useful for close-up work than you might expect. You can't expect the crucial bit of the subject to line up with a focus sensor every time. Even the large numbers of sensors in pro SLRs won't always lock on to the right point. When the subject itself is in constant motion you can't even lock focus and reframe. Most flowers, for instance, are in almost continuous gentle motion. The slightest breeze, or sometimes even your own breath, is all they need.

Manual focusing really does score in close-up work. The usual things, like a good viewfinder, make it easier, and true macro lenses typically have maximum apertures around f/2.8, which is much better than the f/5.6 of many 'macro' zooms.

To obtain the largest possible image of a small subject you want to get as close as you can. We've already mentioned a useful refinement of manual focusing technique, which amounts to a form of pre-focusing: setting the lens to its minimum focusing distance and then moving the camera to bring the image into sharp focus. If the exposure allows you to hand hold this is relatively easy, especially if you can brace your elbows on something to minimise further movement once you find the right distance. With a tripod it can be quite a fiddle: a monopod or a beanbag can be an excellent compromise.

With moving subjects there's a further refinement. When flowers wave in the wind their movement is rarely completely random; they often oscillate along a fairly regular path. You can pre-focus at a point on this path and wait for the image to come into focus. The mid-point is where the flower will be moving fastest, whereas at either end there will be an instant of stillness. However, since the flower's movement isn't completely regular, it won't stop at exactly the same point every time. It takes patience, good reactions, and an element of luck.

Specialist flower photographers often erect windbreaks, even complete transparent or translucent tents, to shield subjects from the breeze; many flower shots are

WILDLIFE AND NATURE

Fungi on gorse, Cumbria (Jon)
A reflector can be handy to lighten hard shadows

actually done in a greenhouse or studio. Without such facilities, we can only be realistic. A calm day is obviously best, and some flowers wobble more than others. Violets, with their drooping flower-stems, are worse than most.

Exposure

If autofocus is of dubious value in close-up work, automatic exposure is much more helpful. It won't work with a reversing ring or basic extension tubes, but should work happily with more sophisticated tubes, close-up lenses, or macro lenses.

When using Manual exposure mode, there's one pitfall to be aware of. Many lenses get physically longer when focused very close. This can alter the effective focal length and aperture, which lets in less light than you'd expect. This effect is even more marked with extension tubes. This is no problem if the lens/tube combination allows normal metering and you take your meter reading with the lens already focused at the shooting distance. It's more difficult if you have to meter manually. The effect is moderate at 1:4 but much more pronounced at true 1:1 macro. At least with digital it's easy to check whether you've got the exposure correct and adjust it as necessary.

In all these situations the effective aperture is smaller than the figure shown on the lens barrel. A slower shutter speed will be required than for a distant shot in the same lighting conditions. This increases the risks of blur from both camera shake and subject movement.

Close-up photography is full of trade-offs like this. While you might want a small aperture to maximise depth of field, you may have to compromise to get a workable shutter speed. If you shoot in Programme or Aperture-priority mode, keep a close eye on the shutter speed that's being set. Just as with long lenses, never forget that raising the ISO can be your 'Get Out of Jail Free' card.

Using flash and reflectors

Hard shadows created by strong light can also be confusing in close-up images. But using on-camera flash to even out the shadows rarely works – close-up work cruelly exposes all the limitations of on-camera flash. It comes from the wrong direction; being straight on to the subject provides very harsh, flat and unflattering light. It can also give very unfriendly 'lens' shadows, or even miss the subject entirely at very close distances. At least nine times out of ten, it's better to turn off the flash and use your 'Get Out of Jail Free' card instead.

However, carrying an external flash gun has obvious drawbacks (such as weight, bulk, time) for the average outdoor photographer. And if you are willing to carry the extra kit, then using either a wireless remote control or sync cable allows you to place it so that it provides much more flattering side-lighting.

Another tip for controlling the light is to use a reflector, which can be something as simple as an unfolded map, or sheet of white paper or card. This is useful both when shooting with flash and in strong sunlight, which can create very high contrast in small

Don't rule out bringing back some (ethically collected) leaves, nuts or berries to photograph on the dining-room table. This may well be the place to play with flash guns, tripod and all sorts of other accessories.

Water lily (Nymphaea violacea), Butterfly Springs, Northern Territory, Australia (Chiz) (aka – how to scare a camera!). The dark colour of the water was gained wading in to neck level to capture this shot of a beautiful flower in the shady part of the springs.

subjects, especially at an acute angle. The great advantage over flash is that you can clearly see the effect before you shoot.

FINAL THOUGHTS

More than most areas of photography, photographing wildlife forces you to accept some limitations. Truly frame-filling shots of most wild animals and birds are hard to get. Some subjects are much more approachable, and every now and then you may get lucky, but consistent success in wildlife photography demands both a lot of skill and at least some specialised equipment. Beyond a certain point it is no longer just one element of the outdoor experience but has to become the dominant part.

The same might be said of sports photography, but what sets the best wildlife photographers apart is patience, dedication, and deep knowledge and understanding of their subject. You can make a decent job of photographing most sports without being an expert in the sport – although some knowledge certainly helps – but you'll never be a wildlife photographer without knowing a lot about wildlife; in some cases you'll never even see the subject!

Of course taking photos is also a great way to learn about wildlife, so you can get better at two things together. But if we don't have the time or patience, we have to keep our ambitions in check. While the 'twitchers' may spend all their time pursuing rarities, for the rest of us wildlife and close-up photography is mostly about the commonplace. There is no better way to remind ourselves that common plants, animals and birds are often as beautiful as rare ones.

Don't forget though – a little learning can be a dangerous thing – not so much for you as for the animals and birds you're pursuing, as well as other species that may get 'in the way'. If in doubt, back off. You don't need that shot. Your life doesn't depend on it. Theirs might.

4

WILDLIFE AND NATURE

Bernie Carter, Wolfhole Crag, Forest of Bowland (Jon)
A padded camera pouch on a dedicated waistbelt (like this one from Think Tank Photo) keeps the camera both secure and accessible

5 WALKING AND RUNNING

FIRST THOUGHTS

In outdoor photography you'll sometimes be a participant and sometimes a spectator. It's perfectly possible, for example, to photograph outcrop-climbing or bouldering without taking part in the climbing yourself. In cycling, as you usually have to stop and get off the bike before shooting, you become a spectator at least for those moments. In walking the distinction is more blurred. It's very rare that most people need to take images of walking without being part of that same walk; one exception might be a charity walk in which a friend or colleague is participating. Even professionals capturing images from a walking festival for a tourist board will often cover the same route as the walking group – although often it's a case of run-stop-run rather than steady walking!

But speed things up, and things change. Many runners won't carry a camera at all, or at best the integrated one on their phone, or the tiniest of compacts. And at the instant they stop to take an image – are they still a participant? Perhaps, perhaps not. It's far more likely that the best images will be taken by a spectator who is there to see the runners go past, and enjoy the atmosphere, but isn't actually running themselves.

Fell End, Hampsfell, Cumbria (Jon)
Walking brings its share of magic moments

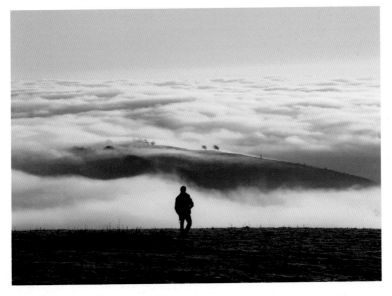

HARDWARE FOR WALKING AND RUNNING

The lighter you can travel, the less you'll feel weighed down and the more you're likely to enjoy it. But there's a balance to be struck – a hovering kestrel or a really beautiful flower may have you wishing for a lens you had been happy enough to leave behind.

We each make our own personal compromise over what to take and what not to take. A compact camera will be light and pocketable and will probably do a fair job on general shots in good light, but a DSLR will be much better for action and low light without adding more than 400g overall.

A basic setup would include a lightweight DSLR with fully-charged battery and general purpose zoom (say 18–70mm), a beanbag (or hat/gloves as a stand-in) and perhaps spare memory card(s). Accessories such as a lens cleaning cloth, grey grad and polarising filters, and a simple rainguard (see p195) weigh little and can be immensely helpful.

If you think you may want a longer lens, then a 70–200mm or 70–300mm zoom is a good and often relatively lightweight choice, but it all adds up. Some days you may regret not carrying it, some days you may wish you hadn't bothered!

Tripods, 400mm and macro lenses are all things you may occasionally wish for. However, any or all of these probably mean that the walk is more about the photography than a walk for its own sake.

Dedicated photographers may find it hard to leave the tripod behind, but it boils down to which is more important – a perfect image, or a good image reflective of an enjoyable walk. The equation will change according to the nature of the walk, who your companions are, or how you feel on the day! Remember, however, that a beanbag can support a camera just as effectively as a tripod but is far easier to carry. And the value of a tripod often lies in making you think more carefully about the shot rather than any inimitable ability to keep the camera rock-steady.

If simply carrying the camera on its neck-strap is ever a viable option, it's when you're walking – at least in fine weather. Even so, a heavy camera bouncing against chest or belly can become irritating after a while. It also exposes the camera to a high risk of knocks as soon as you start negotiating gates, stiles, or scrambling sections. A padded camera bag – on its own waistbelt or the rucksack's – provides better protection while remaining accessible.

I prefer to replace the maker's neck-strap on the camera with one that offers greater comfort and redistributes the weight more widely, and usually keep the camera slung diagonally across my body. This keeps it enough out of the way when 'just' walking, and easily accessible when needed. In poor weather, I either tuck it under my waterproof jacket (it's surprising what will fit – just!) if the rain is light or short-lived, or stow it in a padded camera bag near the top of the main body of my rucksack.

(Chiz)

When carrying additional gear, we'll both normally choose to use a regular walking rucksack (instead of a specialised photographic backpack) for the simple reason that it's far better at holding all the other things we need on a walk – spare layers, food and drink, even crampons and an ice axe if on a winter walk. The downside is that

takes longer to haul the camera out if we've stowed it for some reason, like torrential rain or awkward scrambling.

Longer lenses live in a padded case in the rucksack until needed; smaller accessories go in a rucksack or clothing pocket. Items like rainsleeves and beanbags act as good padding on the bottom of the rucksack, and the hassle-factor of accessibility is only an occasional issue for these.

When running, if you do contemplate carrying anything but a very light camera, then how you carry it becomes critical. A camera bouncing around is going to be a mighty annoyance, and the vibration may not do the camera any good either. It needs both a really good padded case and a way of minimising the bounce factor. Some may find that a secure chest-harness (like the one from Think Tank) is the best solution, although this probably works better for males than females.

MAKE THE CONNECTION

When out walking, what do we most want to bring back as good memories – and hence good images? Whether it's the awesome landscape, or the folks we were with, it often boils down to the 'I was there' factor. The scale of that huge mountain whose summit you reached; the scary drop on the narrow eroded path where you inch past holding your breath; the simple feeling of shedding the modern trappings of life and getting into the fresh air in the local woods or fields. And more than just 'I was there, passing through...' but 'I was really connected to this place'.

Anyone who can afford a plane ticket can enjoy the view from above the clouds. But when you look down from a mountain-top, one that you've struggled and sweated to reach, you look down on the clouds in a very different way. From the plane, the

Chiz Dakin, Chilling, Ladakh (Chiz)
The 'I was there' factor: that drop is made all the scarier by the scale of the walker at the far end

view is detached and remote; from the mountain it is personal and connected. 'On top of the world' but still very much part of it.

Pure close-up shots can certainly make the connection. However, we also want to reflect our wider surroundings. A shot of a few granite crystals is not, by itself, going to say much about the grandeur of Yosemite. But equally, plain views don't say anything personal about your experience there. Where's the connection in a shot that anyone in a tour bus could have snapped? It's about as personal as a blank postcard!

One way to make the connection is to put yourself, or your companions, in the picture. This automatically says 'I was there', and may also convey what you were doing while you were there. The bit where Sam decided to take the harder route directly up the boulders – or where Jo wasn't sure about scree-running down! If you're on your own, this becomes more awkward, but not impossible: most cameras have a self-timer. You can usually find somewhere to set the camera – on a flat rock, perhaps. If it needs levelling, or tilting up a bit, use spare gloves, hats, a couple of thin stones, or whatever's to hand. Check the framing (using Live View if it's awkward to see the viewfinder), and check again after the first shot to be sure you stood in the right place.

If the timer doesn't allow enough time to get in position, especially on awkward ground), a wireless remote control may be the answer. These can be fairly inexpensive, costing between £15 and £50, but some very cheap models have extremely poor ratings, so do some research first. Increasing cost usually increases reliability and

Chiz Dakin, Paso de los Lobos, Sierra Nevada, Spain (Chiz)
Personal and connected – but with rough terrain, a remote control would have made this shot much easier to get!

Stepping stones, Cheedale, Peak District (Chiz)
A 10-second self-timer delay was barely long enough to get into position on slippery limestone stepping stones!

operating distance from the camera. It's worth thinking about the working range you may want. You can usually reach 10m within the 10 seconds most camera timers give you. An advertised range of 100m may in practice give more like 60m, especially in woodland – but this is still more than enough for your average walking shot, if you're aiming to be anything more than a small black dot on the horizon.

And where you're trying to get your companions in the picture, it's worth considering a little what you want the image to say. The best shots look natural, rather than posed. That doesn't mean you can't direct people. If you need them to move clear of a boulder to be more visible, or not overlapping each other so much – ask them to move! Few people can anticipate exactly what you want when they can't even see what you're seeing.

Where is the walker?
With many shots what you're really trying to say is 'we were there'. Putting the group bang in the centre of the image and showing little of the landscape rather misses the point. As does the group being so far away from you that they become anonymous dots in the landscape. This can still be an interesting image in its own right, but it's no longer making that direct connection between us and the landscape.

'We were there' usually implies a shot that shows both your companions and the view they can see. If you're setting up such a shot, try and get the people side-on to the camera: the back of people rarely looks as good as their faces (and expressions!). Classic examples of such shots include standing on isolated pinnacles or rocks (or even trig points), with a valley below; or at a viewpoint overlooking a waterfall. Sometimes it's as simple as putting them offset from centre in the foreground with the forest trail snaking out behind them in a pleasant curve.

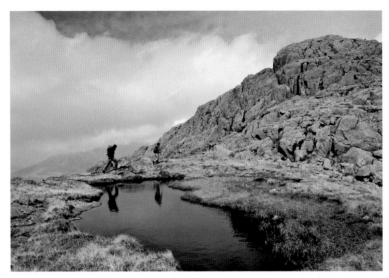

Little Stand, Lake District (Jon)
The positioning of the figures was critical to ensure that both appeared in reflection

When taking shots of walking groups, I'll often run ahead with a long lens. I'm usually looking for a bit of trail with interesting foliage on at least one side, preferably overhead too. Other natural frames such as rock arches, or overhangs can also be useful. I'm also looking either for a bend to add depth to the image, or somewhere I can get well off to the side of the trail.

Sometimes I'll go for wide depth of field to get the whole group in focus. At other times reduced depth of field works well, with focus on either the lead walker or second in line, although I usually don't want the ends of the group to blur too much. This also means that the background is suggested rather than shown in every detail; this works a treat when the background is uncomfortably cluttered. (Chiz)

INTO ACTION

Of course, static posed shots have a great tendency to look static and posed. But we don't just go walking so we can stop and look at the view. We walk for the sake of walking too. And this would imply that we want to take action shots, not just static ones. Walking action is slow compared to most other pursuits, which should make it relatively easy to capture, but there are still a few things to think about.

First, it's usually better to get ahead so you can shoot your companions coming towards you. Allow plenty of time – probably more than you might imagine! – to get into position with the shot framed up before they reach the crucial point. On easy ground, you can be checking the camera settings while you are moving ahead, but this may be inadvisable on steep or exposed terrain. You can, of course, ask your companions to slow down or stop if necessary, but doing this too often won't make you particularly popular.

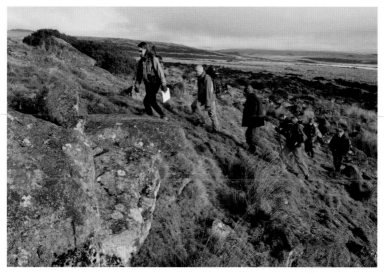

Crossing Dartmoor (Jon)
Shots of walking groups require the photographer to cover more ground than anyone else!

It takes a little experience to recognise the best spots to catch the action, especially when combining it with a view behind. Stiles, rock-steps or bends in the path can all add interest. On rough ground, walkers are more likely to be looking down at the ground rather than gazing around at the view. Don't be afraid to call out and encourage them to glance up momentarily – at least with your own group. Shouting at total strangers is not recommended!

Near Boot, Eskdale, Lake District (Jon)
Keep looking for the best spots to catch the action

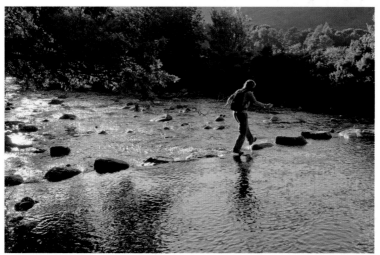

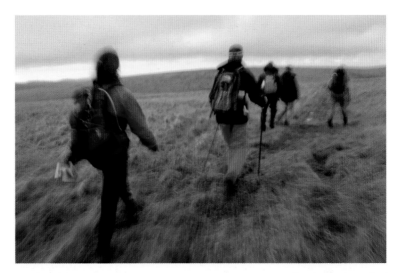

Crossing Dartmoor (Jon)
Deliberate motion blur can make an effective shot

How action is recorded depends on the shutter speed, and naturally the best way to control shutter speed is through Shutter-priority mode. With walkers, relatively low shutter speeds will still give reasonably sharp, frozen images. 1/125sec is about the minimum: 1/60 often reveals the beginnings of blur especially in hands and feet. 'Frozen' shots can still look dynamic because of the body language of the walker(s). When shooting one individual, timing the shot just before the leading foot hits the ground often gives the most dynamic impression. As most walking groups don't tend to march in step, you can't expect to do this for larger numbers – although you could still try it for the leading figure.

If low light forces you to use a slow shutter speed but you'd prefer not to see motion blur, you could ask your subjects to walk in slow motion – or even start walking slowly, then freeze when they reach a prearranged mark like a pebble or a flower a few metres later.

Trying to get people to do this without hamming things up, or grinning inanely at the camera, is rather harder – this requires good communication and an understanding of what you are trying to achieve – and probably an agreement from you that you won't interrupt their walk this way too often!

Slower shutter speeds will produce more blur, at least with people walking at normal speed. Stiles, scrambling sections and so on may slow them down. Deliberate motion blur can make an effective shot. Experiment to see what works for you; 1/15sec is a good starting point. One problem is that you are also likely to see camera-shake, which blurs not just the walker(s) but everything else in the picture. If the camera or

lens has image stabilisation then you can experiment more confidently with slow shutter speeds and expect the walkers to appear more or less blurred while their surroundings are still sharp. This sort of shot is rarely seen in walking coverage but that's all the more reason to give it a go.

RUNNING

There's generally a sharp distinction between taking images as a participating walker and becoming a photographic spectator of running. Running is often viewed in terms of training or competition, so other aspects become secondary; most runners travel light, stop relatively infrequently, and rarely carry much of a camera. Photography by participants is rare, but on the other hand, runners make ideal photographic subjects, especially at muddy fell races!

Runner near Salwick, Lancashire (Jon)
Nothing in this shot is pin-sharp, but it's clear that the torso moves around much less than the feet

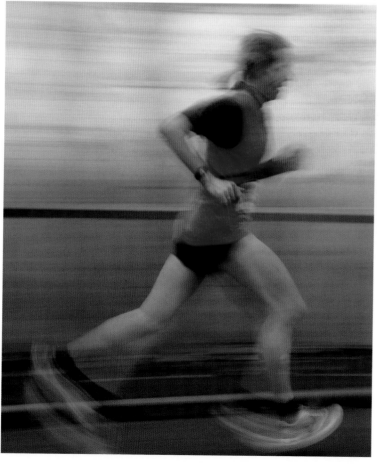

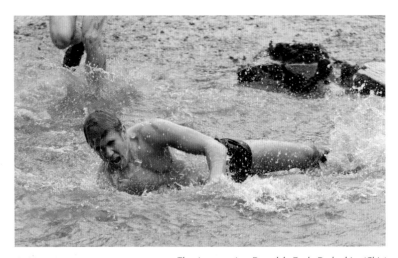

The river crossing, Dovedale Dash, Derbyshire (Chiz)
A fast shutter speed (1/500 sec) freezes the action, including the splash. It was probably pretty
freezing for the runner too!

If you are one of the rare runners who carries a camera – of any sort! – then most of the tips for walking are applicable, sometimes with extra force; if you're running with others, then you'll almost certainly need to have stopped yourself (if only briefly!) to photograph your companions, and this may require a double effort to get far enough ahead.

Motion and expression

While runners travel more slowly than cyclists, there's more body movement. Mountain bikers on a descent may hardly move arms and legs at all, except in subtle shifts of weight, while runners' arms and legs are in constant motion. Much of what's said in Chapter 7 about speed and technique is equally applicable to running, including the key choice of whether to freeze the motion or embrace blur. And on some fell-running descents the speeds will be pretty high!

Panning shots of runners are a challenge; slower speed of travel points to a slower shutter speed for background blur, but this will result in greater blur of the pumping heads, arms and legs. It's a good idea to experiment to see what works for you, especially in terms of shutter speed. You can pack a lot of experimentation into a short time as a spectator-photographer at a running event with, perhaps, hundreds of competitors.

A classic subject for great cross-country and fell-running images is the water crossing – whether splashing through a stream, or jumping across a narrower channel. Usually this is tackled by freezing the action, so that the splash is captured crystal-sharp in mid-'explosion' with the runner pounding through it. Some unusual shots may be got by using motion blur techniques, but it's very hit-or-miss, with all too many attempts producing little more than a blurred runner in a grey soup! That said, when one does work, it tends to be rather more striking for its rarity value.

Faces tell tales too. The agony of a steep uphill, a mud-splattered face, the elation of the winner, the relief of every finisher – all make for powerful expressions, and thus for interesting images.

To capture facial expressions, you will often need a longer lens, ideally over 100mm; a zoom lens gives more flexibility. (It's not always possible to move closer, especially at races!). The longer lens is useful even at shorter distances, as it tends to blur out the background, focusing attention on the individual runner and their expression. This is especially important where the background is cluttered, or full of other runners.

At the end of the race (Chiz)
Faces tell tales too

To minimise depth of field in this way, you will usually use Aperture-priority with a wide aperture, eg f/2.8 or f/4. Before using any lens at its widest aperture, however, check that it is actually sharp at its widest setting; some lenses are quite soft wide open, and may need to be closed down a notch or two to greatly improve sharpness. Check, too, that you have sufficient depth of field at a given distance and amount of zoom to get enough of the runner's face and/or body in focus. Sometimes you may need to set a narrower aperture, like f/8 or f/11.

FINAL THOUGHTS

Walking and running have a common base – the human being moving over the landscape under their own leg-power – but provide very different opportunities for the photographer (participant or spectator), and place different restrictions on what the participating photographer is likely to enjoy carrying in terms of equipment. But both provide good opportunities for getting shots which show how you connected with the landscape – the emotions of any companions you were with, and the exhilaration that being out in the elements can bring.

Reuben Dakin on Meall Greigh, Ben Lawers, Scotland (Chiz)
The walker adds a sense of scale to this image, with late winter sunshine adding a golden glow above the inversion in the Tay Valley below

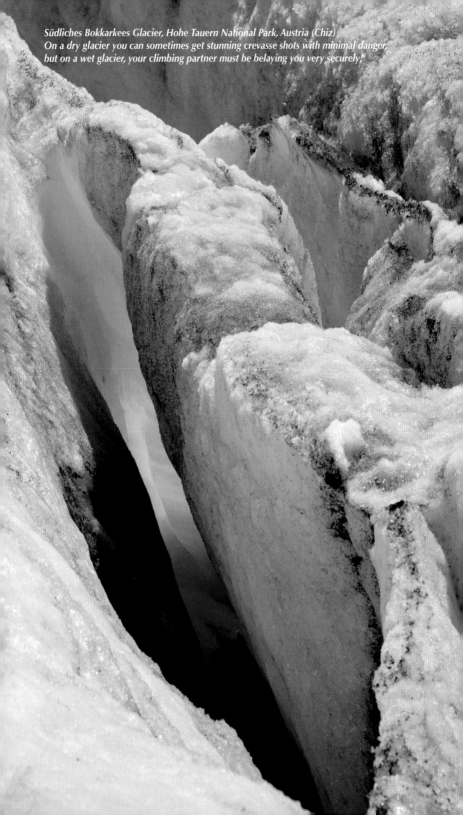

Südliches Bokkarkees Glacier, Hohe Tauern National Park, Austria (Chiz)
On a dry glacier you can sometimes get stunning crevasse shots with minimal danger,
but on a wet glacier, your climbing partner must be belaying you very securely!

6 ROPED SPORTS: CLIMBING, ABSEILING AND MOUNTAINEERING

FIRST THOUGHTS

Much of this chapter deals with sports that some will consider extreme. And certainly, some of the conditions that the photographer is likely to encounter may well be extreme: the mountaineering photographer may face howling snowstorms, sub-zero conditions and even rocks falling from above. Even the crag-climbing photographer who only ventures out on days of good weather will have to cope with intermittent rain, snow, wind and chalk dust – particularly the latter if they venture indoors to a climbing wall! For more on such hazards, see Chapter 11.

In sport climbing and bouldering, hardly anyone carries a camera. Photography here is the preserve of the spectator – although sometimes you may need to be a pretty good climber to get to the best positions. Conversely, in Alpine mountaineering and the Greater Ranges, at least above the hut or base camp, there are no mere spectators – occasional exceptions like the Eigerwand and Aiguille du Midi apart. Although caving may be regarded as a roped sport, it's extreme enough photographically that we deal with this in Chapter 11.

Tody's Wall, Froggatt Edge, Peak District (Jon)
A ledge reached by easy scrambling gave a level view of the crux of the climb

HARDWARE FOR ROPED SPORTS

Climbing and mountaineering have relatively little requirement for high-spec cameras and lenses. You can often get relatively close to the action and, when you can't, the dramatic architecture of crags and mountain faces often allows highly effective shots even with the climber quite small in the frame. Massive long lenses might be a valued add-on to the professional's kit but most of us can manage fine without them. The action that you'll be photographing is also, for the most part, comparatively slow. How to carry the camera can be a far more vexed question than the actual choice of camera gear.

That's not to say that all cameras are created equal, and in relatively easy situations like outcrop climbing and bouldering the extra quality and control of a system camera will score; but when weight and bulk are more critical, as on hard multi-pitch rock-climbs, a decent compact, used intelligently, can still deliver great results.

While really long lenses may fall firmly into the category of optional extras, wide-angles don't. A genuinely wide-angle lens allows greater freedom when you can get close to the action, as well as a better chance of doing justice to the architecture of the crag and the grandeur of the mountain landscape. We'd always choose an 18–50mm zoom, for instance, over the apparently greater range of a 24–120mm.

Having said that the action in climbing is relatively slow, there are certainly exceptions, especially in bouldering and sport climbing, but also sometimes on hard trad routes. Dynamic moves can make great images and the fast shutter response of a DSLR makes it much easier to capture them.

When you're in 'spectator' mode, as is normal with bouldering and sport climbing, how to carry the camera isn't usually a big issue. It can go in the rucksack with

Heading for Lsykamm from Quintino Sella Hut, Italy (Chiz)
A classic shot of a climbing team – but you need either to move aside or photograph someone else's team to get it

whatever other gear you're bringing. Or, if the approach to the climbing venue is just a walk, the camera can ride on a neck-strap or in a pouch at your hip.

When you're actually climbing with the camera, the issue becomes more critical. On multi-pitch rock climbs and snow/ice routes you may well carry a rucksack anyway. This makes the camera less accessible, but as you'll normally only be photographing from stances this isn't particularly problematic. When arriving at a stance, secure yourself first, then remove the rucksack and clip it to the belay, then secure the camera before taking it out of the sack.

On typical British rock-climbs of, say, one to four pitches, many people prefer not to carry a rucksack. Carrying the camera by its neck-strap is rarely a good idea. Even if you shove it round your back out of the way it can get tangled with your gear, and all too easily slide round to the front at precisely the wrong moment. This can spoil your balance, and also makes the camera itself very vulnerable to knocks. A padded pouch is the sensible answer, either on a separate waistbelt or attached to your harness. A separate belt allows the camera to be slid round out of the way when you're actually climbing. Round your back means it won't get in the way, except on traditional chimney pitches, when it can easily be slipped to one side.

> If there's a chance of taking a significant fall, there's no 100% safe way to carry the camera. Are you sure you want to? Maybe your second should be doing the carrying?

Dropping the camera could be costly for you, but it's a lethal missile for anyone underneath. Don't do it. You can clip the camera strap to a gear loop or sling, or replace it altogether with climbing cord or tape. If carrying the camera on a waist-belt, be very sure the fastening's secure! For maximum security, keep the strap clipped to a sling or otherwise secured even when the camera's in its pouch.

CLIMBING AND BOULDERING

Climbing offers many opportunities for 'spectator' photography. Many crags, especially shorter outcrops, offer easily-reached vantage points and a variety of shooting angles. It isn't necessary to be a climber yourself, although this does give more options. Whether a climber or not, if you're shooting from the top, don't get so involved that you forget where you are. There are several recorded cases of photographers absentmindedly stepping into space! A few slings or a short length of rope will often allow you to belay yourself so you can get that view over the edge without risking a plummet, (but if you're not already a climber, this should only be attempted after learning how to do it safely!)

An understanding of climbing does help a lot – knowing where the route goes and what the climber may do next helps in visualising the shot, and sorting the framing and settings in advance. Which might be very different if you suspect your climber is likely to gain some air-time (action shot) than if they're about to lean back and contemplate the moves ahead (thoughtful portrait shot)!

With sport climbs in particular, the repetition and rehearsal that goes into many routes may give you lots of chances to photograph 'the move'. But it's always a good idea to be prepared for the unexpected, whether an unscheduled fall, or a swift 'flash' ascent.

The least interesting shots are usually those of a climber's bum directly above the photographer. This is the great problem with shooting as part of a climbing team – you're usually looking either straight up or straight down, at the soles of the leader's

Sally Dipple, Burbage North, Peak District (Chiz)
Details such as a climber placing a cam in a crack reveal less obvious aspects of the sport.
Shooting from above was the only way to get this shot!

feet or the top of the second's head. Wait for those moments when the leader looks down or the second looks up, and for sideways moves. Your eyes should light up when the route includes a diagonal pitch or a traverse. And why confine yourself to photographing your own team? You'll often get better angles photographing people on nearby routes.

When it's a team of two, photography is further limited by the need to belay your partner. In fact, you have to question if you should be taking the shot at all – safety comes first! Belaying while the other climber is moving is really a two-handed process. You may be able to release one hand from the live rope when the climber is static, perhaps placing or removing a piece of gear or contemplating the next moves. You won't get action shots of the crucial moves but you can still capture the atmosphere and setting of the pitch. This almost invariably means grabbing the shot quickly. Shooting one-handed naturally increases the risk of camera shake: VR lenses help, but keeping the shutter speed high is still a good idea.

A snatched shot like this doesn't mean that it's taken without thought; you can be thinking constantly about the best places to grab a shot, how you'd like to frame it, and so on. Decisions about exposure, maybe even about focusing, can be taken even further in advance, once you're tied on and ready at the belay but before your partner starts climbing. Where you position yourself on a stance must always be dictated by safe and effective belaying, but with this proviso you may want to think about your position in relation to photographic angles too.

While a threesome is slower, it greatly increases the photographic opportunities. You could even rotate leads, and take turns with the camera, giving everyone a share of the limelight. If stances are small, and even more crowded with the larger team, your shooting angles may be very limited, but occasional larger ledges may allow you some freedom of movement to gain better angles. You may even be able to set up an ab rope

The Rakes, Hutton Roof, Cumbria (Jon)
Many crags lie at an angle across a slope, making it easy to shoot on a level with the climber

to dangle off and get some 'close to the action' shots. But always make sure the other members of the team are happy with this first, as some climbers are very unhappy trying to lead with people above them!

On outcrops, or at the start of longer routes, it's remarkable how often you can shoot from the ground. Many crags lie at an angle across a slope, so by walking up a bit you can look across a section of the crag. Even a few steps sideways along the base of the route can make for a much more pleasing angle than looking straight up at of the soles of the leader's feet.

Bouldering even allows you to take pictures when you're on your own, if your camera has a self-timer. A tripod gives the greatest flexibility in choosing camera positions, but it's a burden if the bouldering site is at the end of a lengthy walk, and many climbers may prefer to use a beanbag and whatever nearby rock will support the camera.

Make sure focus and exposure are correct before getting into position. Many self-timers have a fixed ten-second delay, which doesn't give you a lot of time to get established on the rock. If you can adjust the time-lag you'll have more options, but you could also find yourself hanging around in a strenuous position for longer than you really like. It may take a few attempts to get the timing right.

If you really want some shots of yourself bouldering (perhaps to study your technique?), consider shooting video instead. You can usually extract single frames from the clip, although they'll have much lower resolution than 'proper' photos. (See Appendix 1.)

Drew Moore, Little Stand, Lake District (Jon)
Unroped scrambling may allow more opportunities to shoot from the side, but take care

Tody's Wall, Froggatt Edge (Jon)
Many of the best shots will occur naturally when a climber's at their limit. No posing now!

A cheap remote control system will allow you to get into position without rushing. Once in position, a small hand-held transmitter will set off the shot. Depending on your camera and remote, you may even be able to start a burst of shots a second or so apart – allowing you to make the hard move with both hands free and unencumbered! However, neither approach allows the precise timing that's needed to capture truly dynamic moves. This really takes two people, and often three: one to climb, one to act as 'spotter', one to take the shots.

When shooting bouldering you can often work very close in. A wide-angle lens lets you do this, and this can enhance the sometimes extravagant body-positions that boulderers adopt. But before you do this make sure that the climber is happy with it and also that you have a good sense what their next move is likely to be. You don't want to get kicked in the lens by someone throwing a heel-hook!

Talk to your climbers

Communication is vital. They may be the best climbers around, but if they don't know what you want, you may not get the shots you want. A climber in a straight up and down position doesn't look very exciting – if they can climb in a more dynamic way, it looks more interesting photographically (and they may even find it improves their grade!). If they need a bit of encouragement on this, laybacking or bridging up a corner can make the shot seem more dynamic. Leaning out from the crag to survey the route above also adds interest. Carrying on from this idea, even just the simple action of lifting a foot as if in mid-move or taking a hand off the crag to reach for chalk gives more visual excitement than just standing around – even if it's on micro-holds.

Knowing the climber's capabilities gives you a sense of what you can reasonably ask them to do without compromising their safety. No shot is worth causing a fall – and if you do make them fall you may find them reluctant to pose for you again!

Many of the best shots will occur naturally when a climber's at their limit rather than posing – but make sure they're still happy to be photographed. Some people may find that the mere presence of the camera creates a niggle at the back of the mind which disrupts the pure concentration they need. Don't put undue pressure on anyone who feels that the camera will make them less safe, or just spoil their enjoyment. Ask gently if they'd be happier if you back off and use a longer lens, or go and shoot someone else who's happy to be in the limelight.

Flash ascent

Even on a bright sunny day, some routes will always have sections in the shade. And these sections may or may not contain the crux of the route. If they do, then you may consider using flash to lighten up the shot. But first of all consider whether by raising the ISO you can get the shot successfully without flash. This works well if the entire shot is in shade – as it might be in a deep gully – unless you're already at the limit for your camera. Compacts may struggle to produce decent results above 800 ISO even after tweaking with a noise reduction program, but large-sensor cameras can probably stretch to ISO1600, 6400 or even further.

Boosting the ISO works less well if there's a bright background, like looking out of the gully to the sunlit hillside on the other side of the valley. Here, without flash, you may have to choose between shooting the climber as a silhouette against a normal-looking background, or a well-exposed climber with a very washed-out background. Only by using flash do you have a chance of balancing the two.

But before firing up the flash, speak to your climber as to whether they will be OK with this. If they're not, then don't use it. An alternative which has recently arisen is the development of LED-based video lights. One or more of these lightweight continuous lights may be sufficient to brighten up the shot sufficiently at close quarters without causing surprise to the leader from a flash at the crux move. If the gully's that gloomy they may welcome the extra light anyway!

The value of flash is not limited to deep gullies. More commonly, and surprisingly to many, it's often most useful on bright sunny days. A bit of fill-in flash can reduce the harshness of the highly contrasty shadows that mid-day and mid-summer bright sunlight often creates. Always remember that fill-in flash is as it says – it should not be so powerful that it takes over from the sun as the main light on the climber – but should be just enough to allow some detail to be seen in an otherwise deep black, impenetrable shadow. Built-in flash is usually pretty useless as the main/only light for climbing shots but it can work just fine for fill-in.

It's been said many times that the difference between an amateur and a professional is that the professional uses **flash** when the sun's shining, not when it's dull, while the amateur does it the other way around.

Abseiling

Abseiling is something that every professional climbing photographer has to be comfortable with, as it's often the only way to get the perfect shooting angle. To shoot from an ab rope you need to be confident in your ability to set up secure anchors, to abseil in complete control, and to lock off the rope at the desired position. Locking off is usually easy enough with dedicated abseil devices but if abseiling on a more basic device such

Drew Moore, Little Stand, Lake District (Jon)
When shooting bouldering you can often work very close to the climber. The built-in flash was used for fill-in here

as a Figure-8 or Tuber you can also lock off by looping the rope several times around your thigh or tying an overhand knot of rope (in the dead rope below the belay device) through a crab attached to your harness on the belay loop. You also need to be able, after taking the shots, either to reascend to the top (by prusiking or jumaring), or continue the abseil safely to the ground. Most climbers know at least the rudiments of abseiling but may be much more vague about prusiking or jumaring. Don't attempt it until you know what you're doing and be aware that prusiking up a rope can put extra strain on the anchors and cause more wear where the rope runs over the edge of the crag. If you contemplate doing a lot of photography from an ab rope then consider buying a dedicated, non-stretchy rope specially for the job as this makes the abseil itself more comfortable and also saves wear and tear on the climbing rope. It should be second nature on an ab anyhow, but it's always a good idea for safety to tie a knot at the bottom end of the ab rope – especially if using a short rope that you intend to prusik back up!

Shooting from an ab rope also demands that you carry the camera and any other gear in a suitable way. Make sure there are no loose trailing straps that could catch in the abseil device. The best choice is usually a pouch or belt-pack that can be slid

Alan Hinkes, Scout Crag, Langdale, Lake District (Chiz)
Shooting from an abseil rope allows you to get closer to the action from above

round to the rear while abseiling and then brought to the front when you're locked off in position. Just as with other climbing photography, take a belt-and-braces approach to ensuring that you can't drop any of your gear.

Needless to say, you should have the agreement of the climber(s) before photographing them from an abseil rope. A camera clicking, and possibly flashing away from a few metres' distance is something that professional climbers have to get used to but will be a new and possibly disturbing experience for recreational climbers. On popular crags and outcrops you should also consider where the ab rope may run as you won't win many friends by blocking off other popular routes. And make sure it doesn't trail down into your shot either!

One of the scariest experiences of my life was when I agreed to take some photographs of climbers on Third World at Warton Main Quarry in Lancashire. I belayed from a tree at the top of the crag, abseiled into position in the middle of a 40m high slab, locked off and got ready to shoot. But before the lead climber had got anywhere near my level I felt myself slowly sinking …

My immediate vision was of the tree slowly uprooting itself from the shallow soil at the top of the crag. Almost before I could think I had climbed 5 or 6m (5a in trainers – couldn't do that normally!) to a small ledge where I balanced nervously until the climbers had completed the route and could check the belay for me.

The tree was fine. We concluded that the movement I had felt was due to the rope digging in to a sandy bank in front of the tree. Even so, it was a while before I attempted another abseil shoot! (Jon)

Abseiling as the subject of the photographs is almost exclusively a spectator sport as far as the photographer is concerned – regardless of whether you are returning from the summit of an Alpine mountain, or doing sport abseiling off a high bridge. As each participant will normally do the abseil individually, your main shots will be of others abseiling, while you are free of the main abseil rope.

Photographing from above can be good for capturing facial expressions of terror as the participant sets off, but after a few metres you may require cooperation from the participant to look up on demand to get a good shot.

Some abseils offer opportunities to shoot from the side and these will provide the best opportunities for getting good interesting shots of the participants. However, it's fairly rare to find sloping ground that can be scrambled alongside an abseil. To get good side shots, it's more common that you will need to set up your own abseil rope a few metres off to the side of the main abseil. Obviously you should always check in advance that this is a) practical (there may only be one available anchor point – especially on sport abseils) and b) acceptable to the others who are abseiling. This is particularly important if you are trying to photograph a group of novice abseilers on a sport route, where you should also get the leader's agreement. As such abseils are often undertaken for charity or as a team-building-type exercise, participants will often be eager to have a memento of the occasion. Be aware, also, that you may find that you're not legally allowed to set up your own ab rope without a permit, particularly on man-made structures such as old railway bridges.

Mountaineering

Mountaineering takes both the challenges and the rewards of rock-climbing and makes them bigger and more complex. Easy mountain routes/sections may be more akin to walking or scrambling but harder mountaineering can pose all the technical and practical challenges that you meet in rock-climbing photography plus a few more, like

Mala Mojstrovka, Julian Alps, Slovenia (Jon)
Small figures can be very effective, especially when outlined against the sky. It all helps link the climber to the setting

Above the Gnifetti hut, Monte Rosa, Italy (Chiz)
A wide-angle lens (24mm) takes in the scale

trying to shoot with thick gloves on or when festooned with slings that have frozen and turned almost as stiff as iron. In such situations you need to be both a very competent climber and to feel very much at home with your camera gear and techniques before you can contemplate wrestling with a bulky SLR. And perhaps a tough, weather-resistant compact would be a more suitable choice. Slipped into a pocket of your outer jacket (and permanently secured by a lanyard or bungee cord) such a camera can be ready to shoot in seconds and is also easy to use one-handed.

But then you try and change a setting and find that you can't work any of those tiny buttons with your gloves on. Or you leave the hut three hours before dawn and you know that the camera can't shoot an image worth a damn at anything above ISO 800. Or you're high on the ridge a few hours later and you aren't sure if the compact can really cope with the incredible range of brightness from dazzling snowfields on the south flank to deep shadows on the north side. And you can't help starting to wonder if maybe it would have been worth bringing the SLR after all…

There is no easy solution to this conundrum. It's personal and individual; how do you balance the superior image quality and extra control of the SLR against the undeniable penalties of weight and bulk? However, just as you probably honed your climbing skills on British rock and winter climbs before heading off to the Alps or Greater Ranges, you can do the same with your camera. Take every opportunity to familiarise yourself with its handling and controls. If it is a compact and you know you're not going to fiddle with menus on the climb, try and make absolutely sure you're using the best settings before you start. Try, also, to have a good sense of what the camera can and can't do.

Photographically, remember that mountaineering, even more than domestic rock-climbing, is about the places and the people as much as it is about the action. Bouldering shots may be all about the moves and the body shapes, but these are usually less obvious when climbers are bundled up in several layers of fleece. In mountaineering photography, look for the shots that link the climber to the setting. It's helpful that mountaineering routes rarely follow a pure straight line – the theoretical direttissima

is a rare beast, especially at the grades most of us operate in. Most routes will include traverses or diagonal pitches and many will include ridge-sections too. A final snow-covered arête below a summit with stunning views into valleys below can be a great place for images, and often gives better images than shots straight from the summit. All provide great opportunities for photos that show both climber(s) and setting. But everything we've already said about balancing photography with your own safety and that of your companions applies with equal or greater force in the mountains. And never stop to take an image where there is a real risk of cornice/snowbridge collapse, avalanche, or rock/serac fall – move to safety then take the image! If your partner is willing (and the conditions permit), it can be possible to get some stunning shots of crevasses by being belayed on the edge of them, but this should not be attempted by the inexperienced glacier traveller – it is highly dangerous if you get it wrong! Conversely, don't even try and do this without a willing and secure belay(er)!

Images with climber(s) really small in the frame can be extremely effective but they need a little extra to make them work their best. Think contrast: dark figures in a patch of sunlight or brightly-clad climbers on a vast wall of grey rock or wide snowy plateau.

And think, too, about all the elements that make up the mountaineering experience. It certainly isn't just about the technicalities of the crux pitch or the view from the summit. There's the wait in the valley while clouds blanket the peaks; the anxious study of weather reports, maps and guidebooks; the train or cable-car to the starting point; the 'comforts' of huts, campsites and bivouacs.

Of course, mountaineering often involves dealing with extreme conditions, of which there's more in Chapter 11, while for the additional complexities of expedition life, see also Chapter 10.

Frundenhorn, Bernese Oberland, Switzerland (Chiz)
Looking down on another party gives a real sense of the scale

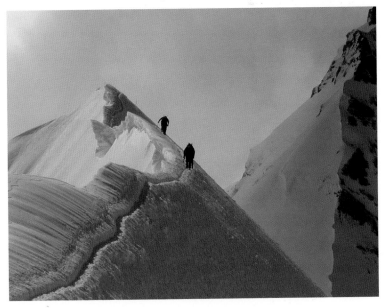

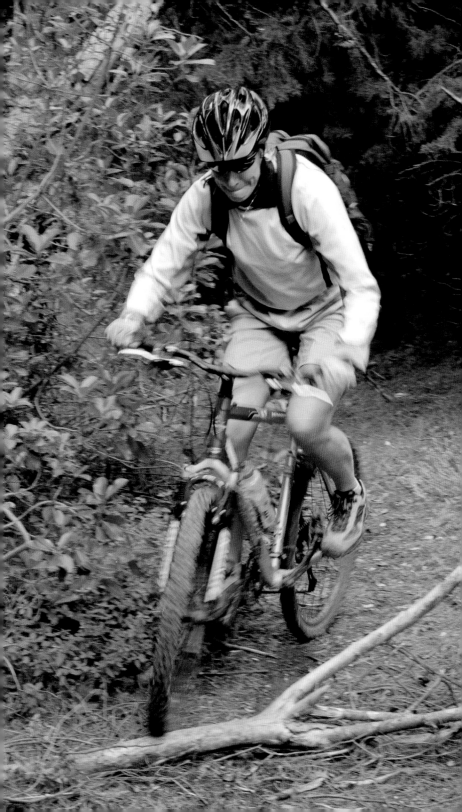

7 WHEEL SPORTS

FIRST THOUGHTS

Let's hear it for cycling photographers. They have a tough job and the best set a fantastic standard. Cycling is a tough sport to photograph for two main reasons. One, you usually need to stop to take pictures. There are exceptions to this rule, but the spectator/participant divide is a lot sharper for cyclists than it generally is for walkers. Two, cycling is fast: few outdoor pursuits happen at such speeds. Yes, downhill skiing, and yes, maybe, kite-surfing, but neither of these regularly involves taking off into the wilds for several hours or days carrying all the photographic kit you may need.

Now here's a dirty secret: a lot of road cycling photography is done by people in cars or on motorbikes. This is obviously necessary to cover road racing, and it takes a lot of skill and nerve to shoot with heavy lenses from the pillion of a motorbike dangling just ahead of a ravening Tour peloton. You might be surprised how much 'recreational' cycling photography is also done with motorised aid, as it can be the only practical way to keep leap-frogging ahead of the riders, especially on long rides, sportives and so on.

Of course in mountain biking this is often impossible – thank goodness! Part of the beauty of mountain biking is that it takes you to places where cars and motorbikes can't go. The road cycling photographer does not necessarily have to be a cyclist, but

Tom Sparks, West Highland Way, Scotland (Jon)
This is a long way from the road. The all-round MTB photographer also has to be an MTB-er

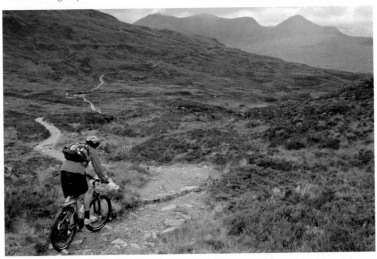

◄ *Adele Blakeborough, the King's Land, Athens, Greece (Jon)*
Facial expression can emphasise the point – whether it's concentration, suffering, or just having fun!

135

any all-round mountain bike photographer also has to be a mountain bike rider. Of course, most readers of this book will be interested in photographing their own rides, on- or off-road. That's what it's all about.

HARDWARE

Professional mountain bike photography can involve riding long and/or technical trails with a heavy backpack of gear. Naturally, pros are going to carry an SLR camera (maybe even two), for the sake of image quality, fast response and the ability to use a wide range of lenses. Many of the images you see in the magazines are taken with one or more remote flash units, too.

If your main aim in riding is to have fun, there's clearly a line to be drawn. If your companions are keen to see some really great shots from your bike exploits then they may (may!) be persuaded to share some of the load-carrying duty too. But still, someone is going to have to carry the camera.

And let's repeat: cycling is fast. Even on recreational rides, cyclists move three to five times faster than walkers. On downhills you can double this, and on some of the descents in the big tours you can possibly double it again. And while this may suggest that photography is easiest on climbs, you're going to want to take pictures on the descents as well.

So, cycling is fast, which rather suggests that the camera needs to be fast too. It's not so much a matter of blasting off eight or ten frames a second; the real issue is how fast the camera responds when you press the shutter button. The shutter-lag of the average digital compact camera is nowhere near as agonising as it was a few years ago, but they are still slower than SLRs and other system cameras, and the speed of cycling means this difference will be acutely felt.

In addition to shutter-response, the ability of the focusing system to track and follow moving subjects is also generally superior in system cameras. There are ways round this – even manual focusing has a place – but it's hard to avoid the conclusion that for cycling photography SLRs and other system cameras reign supreme.

This is unwelcome news, as light weight and pocketability are definitely more than welcome in a biking camera. It doesn't mean that you can't shoot cycling with a compact, but it does probably mean that you have to be a lot smarter about it. Shooting on climbs will be favoured; when mountain biking you might shoot at tight switchbacks or technical obstacles which slow the riders down. Catching a downhiller or freerider at the peak of a jump is going to be a very hit-or-miss business with a compact.

The good news (yes, there is some) is that there's no overwhelming need for hefty, costly out-of-the-ordinary lenses. There is a heck of a lot that can be done with the most average of lenses. A wide-angle is a big help as there's often limited scope to stand back from the edge of the road or trail. You're going to have to shoot close in but 18mm (on a typical SLR) will work in most situations. It's very likely you have that already. Of course a bagful of additional lenses and external flash guns will give you loads of extra options, but who's going to carry it?

Even if all you've got is a modest SLR and 18–70mm lens, how you carry it when cycling is fairly critical. The balance between protection and accessibility is a fine one. All cameras are susceptible to vibration, so some decent padding is essential, on- or off-road. In fact, on anything other than really smooth roads, carrying the camera on

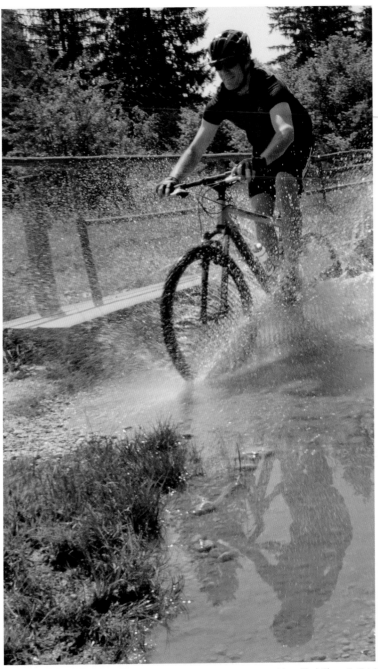

Near Bled, Slovenia (Jon)
Significant shutter-lag works against the precise timing needed for shots like this

Reuben Dakin, Peak District (Chiz)
The framing of the rider with the overhanging trees was pre-planned. Continuous focusing
mode was used to track and follow the moving subject

the bike, whether in a pannier, saddlebag or bar-bag, is only to be considered with very good padding.

At the same time, you want your camera to be accessible. Clambering off the bike every time you want to take a picture is hassle enough, without having to extricate the camera from a pile of dirty washing in a pannier.

For both reasons, the camera is best carried on your body. You act as a suspension system, so cameras suffer much less rattling. It's also the most accessible place. But carrying the camera on a neck-strap is asking for trouble, although you might risk it on a gentle cycle-path. A compact, even in a case, will readily fit in a pocket. Bulkier SLR's need a separate pouch. You might sling this on a waist-belt, but we've always found this uncomfortable.

Instead both of us find the best solution is to carry the camera on our chests. Chest harnesses are usually fine for walking or upright, Dutch-style cycling, but rarely hold the pouch close enough to the chest when you're bent over in a sportive rider's tuck or hanging off the back of the saddle on a mountain bike descent. 'Camera banging on thighs' is desperately annoying for the rider and not good for the camera.

> I've had good results by ditching the harness and linking the pouch to my backpack with four short lengths of bungee cord. This system has needed some fine tuning but now works well. The camera is well protected, even in some falls, and about as accessible as it's ever going to be. I still may transfer it to the backpack before a really steep MTB descent, although this may say as much about the limits of my riding skill as about the limits of the carrying system. (Jon)

Jon Sparks, Lancashire (photo: Bernie Carter)
Carrying the camera on the chest is one possible solution

If this approach does not appeal, the next most accessible place is clearly in a bar-bag. However an SLR plus pouch or other padding will pretty well monopolise your average bar-bag. Bar-bags are also less favoured for off-road riding, in which case you may have to load the camera in your backpack. If it stays at the top it can be relatively accessible, but those extra few seconds can still feel like a long time. A separate stormproof SLR pouch with waist/shoulder straps such as the one by Aquapac can be the best compromise here, but a quick-access zip on a rucksac like Decathlon's Forclaz40Air can also make a big difference to the speed of access.

INTO ACTION

Speed is the big issue. This certainly means we need to think about certain special techniques and camera settings, but it has another, possibly bigger, implication too. On the bike you're travelling quickly, but you have to stop to take pictures. When walking, you might just break stride for a moment or two, but on the bike it means jamming on the brakes, pulling in to the side of the road or trail, getting off the bike and laying it or leaning it somewhere – and it also means getting back up to speed again afterwards, which is also more strenuous than it is when walking.

The first consequence of this is that you probably don't want to do this too often. However, the natural breaks where everyone in the group may stop (road junctions, tea shops) aren't necessarily the places where you'll get the best pictures. If taking pictures means making extra stops, you want to make them count. So you may not stop that often, but you need to keep thinking about stopping.

This requires the ability to recognise great picture opportunities. You can develop this in various ways. One is by studying photos that inspire you. You'll never emulate all of them because you don't have a fish-eye lens and you won't be on the back of a motorbike just ahead of the pro peloton – but that still leaves a lot of great shots taken

Reuben Dakin, Welsh Coast Cycle Tour (Chiz)
Running repairs are part of the experience, and natural breaks make good opportunities for images

'McMoab', 7stanes, Kirroughtree, Scotland (Jon)
Mountain-biking creates a wide range of picture opportunities

with more simple resources. Look at the locations that make great shots: it could be a hairpin on a road descent, a tricky drop-off on a mountain bike trail, or it could just be a place where the road or trail winds through a special bit of scenery.

Stopping to photograph a great view is straightforward enough, although it can still leave you playing catch-up. It's when you want shots of your riding buddies that things get more complex. You (and they) don't want to see their rear ends in every shot. So this probably means that you'll have to sprint ahead – well ahead – before stopping to take some shots as they approach and ride past. And then you have to put the camera away and sprint again to catch up. You can look on it as training. Or you could just ask them to slow down a bit! Communication with your riding partners is vital.

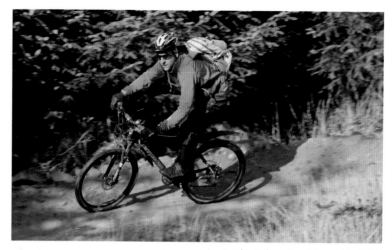

Jon Sparks, Gisburn Forest, Lancashire (Chiz)
Riders are often acting as models under direction

Many of the professional shots you see and admire don't just happen. There can be a lot of planning involved. With racing photos there's no second chance and photographers may ride or drive the whole route beforehand to scout out the best shooting spots. Away from racing, the riders are often acting as models under direction. They may space themselves out so the photographer can capture them individually or they may ride in close formation for a group shot, but it isn't just left to chance. Often they'll ride sections of road or trail several times to get the shot just right.

How far you can replicate this with your riding mates is a matter for negotiation. They may not mind repeating fun bits of trail (Chiz could ride Coed y Brenin's Dream Time all day long) but won't be so keen to do a nasty climb over again. But if you don't ask, it certainly won't happen. Of course on popular routes, such as the main mountain bike trail centres, there are usually plenty of other people about. If you're happy to photograph riders in general, rather than a specific person or group, just hang around for a few minutes.

Assuming that your 'models' are the people you're riding with and that you don't want to keep them hanging around more than necessary, then try to streamline the whole process. Watch top cyclo-cross riders if you want to see how to dismount quickly, but more to the point, try and avoid unnecessary fumbling with the camera. When you leave the café or the previous stop, make sure the camera's stowed so that it's easily accessible, and make sure as far as possible that the settings are appropriate for the most likely scenario at the next stop.

When you do stop, take a second or two to check your settings are still appropriate. If you've moved from open country into the forest, for example, you may need to increase the ISO rating. And then, since stops are precious, think about ways to get more than one shot out of it. For example, zoom the lens to its longest and take some head-on shots of the riders approaching, then zoom out, take a couple of steps back off the trail and take some panning shots as they pass. That's two very different shots for the price of one.

Speed and technique

How do you represent movement in a still image? Obviously, a prime factor is the speed of the movement. However, speed is relative rather than absolute. With cycling photography the subject is relatively small and we are often shooting from close to. This means that, even at non-racing speeds, they move rapidly across the field of view.

That's if you keep the camera still, of course: however, if you move the camera to follow the rider, keeping them centred in the viewfinder can still be tricky. Riders moving directly towards or away from the camera are easier to keep in frame; you could say that their relative speed is slower.

It's no surprise that shutter speed is a key control in determining how movement will appear in the image. However, because relative speed varies, the 'right' shutter speed is also a variable. This means that 'sports' or 'action' modes are crude tools at best. These aim to keep the shutter speed as fast as possible. Sometimes, however, the shutter speed set will be faster than necessary; a slower speed might freeze the movement and allow you to use a smaller aperture to improve depth of field. Conversely, if you actually want to see some blur, the selected speed will probably be far too fast.

The natural alternative, which most cameras have, is Shutter-priority mode. This is usually indicated by 'S' or 'Tv' on the control dial. In Shutter-priority you select the shutter speed and the camera sets the aperture accordingly. This is your best bet to ensure satisfactory exposure while remaining in charge of the crucial variable.

HEAD SHOTS

Both of us have occasionally shot one-handed while riding – the picture on p144 is an example. In good conscience we hesitate to recommend this to anyone else; you certainly need to be a decent bike-handler and pick your moment carefully.

A helmet-mounted camera is a much safer option. This mostly lends itself to shooting video, so there's a bit more about it in Appendix 2. When shooting stills, the key issue is how to trigger the camera at the right moment. A cable-release or wireless remote seems the obvious solution but it's hard to use either of these while maintaining a good grip on the bar, and if your hands are in shot one of them may look odd.

WHEEL SPORTS

Movement and shutter speed

What is the 'right' shutter speed? It would be nice to give a simple answer but the real answer is 'it depends'. It depends how close you are to the rider(s), how fast they are moving, and whether they are moving across your view or directly towards you – among other factors! However, part of the beauty of digital is that you can get a quick check on the result from your first shot. If it's not what you wanted, it should give you plenty of clues as to what you need to change. Then you can get a much better result by getting the rider to do it again, or shooting the next rider, or simply filing the knowledge for next time you face a similar shot.

Practice obviously counts. Studying the images again when you get them on a big screen will help. But rather than suggesting you begin in a complete vacuum, here are a few hints to get you going:

Reuben Dakin, Coast to Coast Cycle Route, Northumberland (Chiz)
This shot was taken while riding, resting the camera on my head for additional stability. A
shutter speed of 1/13 sec creates some blur, especially at the edges of the image.

For most cycling action, 1/250sec is usually a minimum shutter speed to give a good chance of freezing movement. When the riders are travelling fast or you're really close, it usually pays to jump up to 1/500sec, 1/1000sec or even faster. There is a place for much slower shutter speeds, but that's when you decide to accept that a degree of blur can create an effective shot.

In many situations, the light levels won't allow a shutter speed like 1/500sec or 1/1000sec to be used unless you set a fairly high ISO rating. Lenses with a wide maximum aperture (say, f/2.8 or wider) will give you more room for manoeuvre here (that's why they're sometimes called 'fast' lenses).

In these situations, SLRs and other system cameras are highly preferable. Their larger sensors give better results at higher ISOs, and the range of ISO settings that you can choose from is usually much wider. There's also much more chance that you will have, or can get, a lens with a wide maximum aperture. And shifting shutter speeds in Shutter-priority mode is usually something you can do with a simple turn of a command dial: on many compacts it's much more fiddly, if possible at all.

However, if you only have a compact or you're not prepared to carry anything heavier on a long tough ride, don't despair. You can still get good shots, but you will need to understand the limitations of the camera and work within them. For example, simply stepping back and not trying to shoot so close to the rider gives you a bit more leeway on the shutter speed. This will also include a bit more of the background or setting, which isn't necessarily a bad thing.

To freeze, or not to freeze
The idea of using these faster shutter speeds is generally to freeze the action; to record everything in crisp detail without any sign of blur from motion. This means, however,

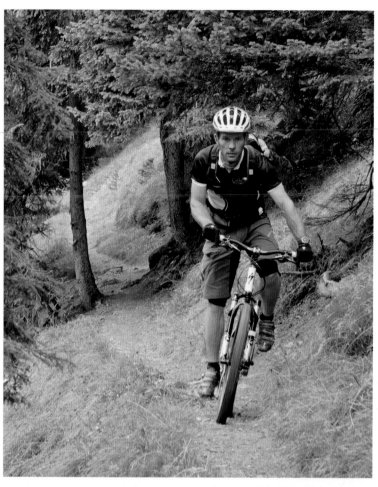

Above Davos, Switzerland (Jon)
Body posture can give a dynamic feeling even when all movement is frozen

that we need other clues to tell us that the subject is moving, and perhaps also how fast. Of course, we assume that someone on a bike, with both feet on the pedals, is in motion: most of us can't do a track-stand. But if the point is to show that a rider is travelling at speed, we need a bit more than that. Body posture can help when a rider's working hard; perhaps in a low tuck in a time trial or out of the saddle on a climb. Facial expression can emphasise the point.

On the road, bends are also good: a rider leaning into the curve looks more dynamic than sitting up along the straights. Mountain biking creates extra opportunities as there may be many spots where riders will have one or both wheels off the ground. Riding a technical trail section ahead of your companions helps you identify such spots.

However, freezing the action isn't the only option. Blur, or partial blur, can also give a very strong sense of motion. In particular, there is the perennial standby of the panning shot.

Panning

The basic idea of the panning shot is to follow a moving subject so that it remains basically sharp, while the background becomes blurred by the movement of the camera. This is easiest when the subject is moving across your field of view, at a roughly constant distance from the camera. It's also easier if you aren't too close, so you don't have to pan too fast. A moderate telephoto lens usually works well; on many cameras the long end of the zoom range will put you in the ballpark.

The point about standing back is simply that the panning movement you have to make becomes slower. It's easier to keep the rider centred in the lens, and your movement will also be smoother. You can take panning shots from close range with a wide-angle lens and sometimes there's no choice: many mountain bike trails run through forest with limited space either side. Close-in panning takes more practice, that's all.

To get a reasonably sharp image of the rider you shouldn't drop the shutter speed too low, but on the other hand, the slower it is the more pronounced the background blur will become. On riders travelling fast (roads, smooth trails, and of course descents) 1/125sec can be a reasonable compromise. As you stretch out to 1/60 or 1/30sec, the background blur will be more obvious but the image of the rider may also lose a little sharpness. On slower sections (climbs and technical features) you need the slower shutter speeds to get any visible background blur, but the riders will be moving around on the bike more and so they too will appear more blurred.

On a compact camera, if you can't control the shutter speed directly, don't use Sports mode for panning shots. Try Landscape or Portrait instead as these will set slower shutter speeds.

Preston Evening Time Trial Series (Jon)
The classic panning shot; the rider is essentially sharp, apart from slight blur in the feet, while the background is blurred by the speed

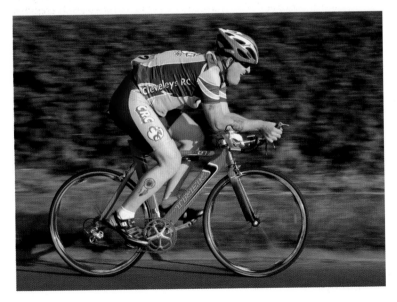

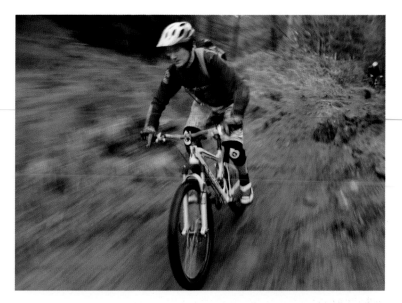

Grizedale Mountain Bikes staff member, Grizedale Forest, Cumbria (Chiz)
Zooming the lens in mid-shot can give a great feeling of motion

Blur

Which leads on to the option of an even more blurred result. Well, why not? Go wild and hand hold at 1/8sec and see everything start to blur. This is an unpredictable technique and all too often the results are just a mishmash, fit for nothing but deletion. However, it can also produce really striking and unusual images. It will probably take a lot of trial and a great deal of error before you start to get even vaguely consistent results, but if it appeals, go for it.

An obvious question is, how can you distinguish a blurred subject from a blurred background? There needs to be some form of contrast between them, such as a clear difference in colour, or if the subject's in sunlight and the background's in shadow.

It's also possible to combine both blurred and sharp images. The panning shot already does this in one way, but you can add another refinement. By mixing a slowish shutter speed with a burst of flash you can have both a sharp image and a hint of motion blur. Because flash has a limited range, you'll need to get fairly close to your subject. It's more than usually important to ensure that your subject knows what you're doing, and doesn't object. An unexpected flash at close quarters could be extremely annoying, not to say painful, for a mountain biker negotiating a tricky obstacle!

In fact many of the images you see in cycling and mountain-biking magazines and websites use flash. Often one or two external flash units are placed to the side of the trail and triggered wirelessly by the flash on the camera. This is almost certainly taking things too far if you want to ride for fun, but may be worth thinking about if there are at least three of you and you have a camera and flash gun which support wireless operation. It requires three people because you need one to ride, one to take the picture and one to hold the external flash gun – unless you want to lug along a lighting stand (or very lightweight tripod) as well!

7

WHEEL SPORTS

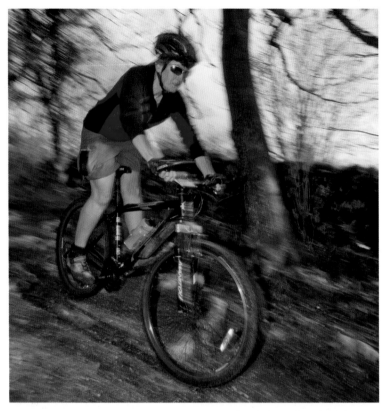

Bernie Carter, Warton Crag, Lancashire (Jon)
Mixing a slowish shutter speed with a burst of flash combines motion blur with sharp detail

If this is too much then you're probably reliant on the built-in flash on your camera. That's OK: built-in flash is often terrible as the main light for a shot but gives much better results when it's just part of the mix with daylight. Even the tiny flash on a compact can work surprisingly well. But get close to the action: the flash simply won't reach more than a few metres.

Focusing

The prevalence of fast movement creates extra challenges for focusing systems too. Yet again, SLRs and system cameras generally have more sophisticated systems which are much better at tracking moving subjects. On cameras where you can switch between the viewfinder and the rear screen (Live View) it's often the case that Live View focusing is much slower and isn't really up to the task with rapid action.

Different cameras have different focusing options so there's little alternative to perusing the maker's manual to try and discern what settings look best for high-speed action. Panning shots can make focusing much less challenging, as the rider is usually at a fairly constant distance from the camera. Compacts have a better chance of keeping up here.

Many of the professionals still swear by manual focusing, at least for some shots. This may seem to require finely honed skills and reflexes but it isn't always so. As just suggested, panning shots could be relatively easy, and there is also the time-honoured technique of pre-focusing. The name is fairly self-explanatory: you focus on a particular spot and wait for the subject to reach it.

You can pre-focus with an autofocus system, if there's a focus lock – often this just means maintaining half-pressure on the shutter release. Some compacts may allow this. The point of pre-focusing is not just that it can give consistent results when autofocus seems unpredictable. It also encourages you to think about exactly when and where you want to take the shot: as a road-rider passes the apex of a hairpin, for example, or a mountain-biker launches over a drop-off. Pre-focusing focuses the mind as well as the lens.

FINAL THOUGHTS

A good camera is one that gets used. If it's too heavy, or too much trouble to carry, it isn't a good camera. Whereas a simple camera that goes everywhere with you and gets pulled out frequently is a good camera – especially if you use it within its limitations. And this also means that carrying the camera in the right way can make it better.

By the same token, the simple willingness to put your brakes on and stop from time to time will make you a better photographer. Not every shot you take will be a winner. But the one sure way to miss out is not to try.

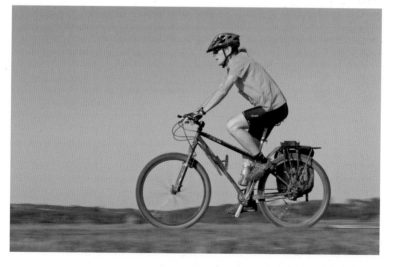

Reuben Dakin, Carsington Water, Derbyshire (Chiz)
Panning shots can make focusing much less challenging, as the rider is usually at a fairly constant distance from the camera. Compacts have a better chance of keeping up here. But getting a sharp shot still requires accurate tracking of the rider

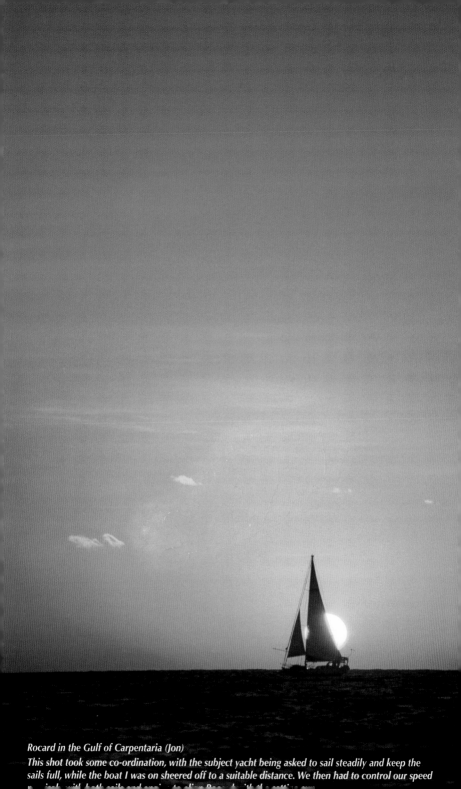

Rocard in the Gulf of Carpentaria (Jon)
This shot took some co-ordination, with the subject yacht being asked to sail steadily and keep the sails full, while the boat I was on sheered off to a suitable distance. We then had to control our speed

8 ON THE WATER

FIRST THOUGHTS

Any outdoor activity can involve getting wet. In some cases, like gill scrambling and canyoning, it's pretty much part of the package. But obviously activities which are based on or in the water involve the most sustained exposure to wet conditions. There's still a basic difference between just getting wet and actually going underwater. And there's also a big difference between a capsize, or shallow immersion, and diving to more than a couple of metres.

There's also something that is always more important than the camera – you! Always be sure that you're well within your capabilities in the activity you are doing before you start to play with photography as well. Concentration needed for taking images is concentration not directed towards your safety, so be sure that the conditions you're going out in aren't too rough for your skills, and be prepared to drop the camera quickly if necessary in an emergency. It's also a good idea NOT to wear the camera's neck strap around your neck while on the water. If you capsize there is a risk that it may get tangled and suffocate you. Far better to have a short strap (or shortened neck strap) wrapped a few times around your lower arm while shooting to give the best compromise between not dropping the camera and personal safety in the event of a capsize.

Windsurfers at Newgale, Pembrokeshire (Chiz)
All electronics, and cameras especially, are far less tolerant of salt-water than fresh water

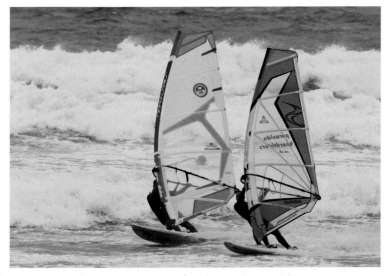

HARDWARE ON THE WATER

Sailing, kayaking, windsurfing and so on don't always entail getting totally soaked. However, a capsize can put you under water. This is very bad news if the camera's not ready for it! If you're quite sure you're not going to capsize, then the advice in Chapter 11 for shooting in the rain should suffice. In exceptionally calm conditions you may be able to dispense with any precautions, especially if you have a friend doing the hard work of steering, paddling, managing the sails etc. But think carefully about this. When there is water around there may be no dry place to put the camera between shots – how often are the bottom-boards of a dinghy or the inside of a kayak bone-dry? And don't forget the inevitable drips and splashes that lapping waves, raising a paddle high or a wet flapping sail will give. You may not notice them, but your camera will!

All electronics, and cameras especially, are far less tolerant of salt-water than fresh water. Tales abound of repair centres declaring cameras exposed to salty conditions as 'being used outside operating conditions' (a handy excuse not to honour the warranty). Even if you expect to keep completely dry, airborne salt spray can still be a problem for the camera, even in relatively small quantities.

Filters are very useful on land, but may be one thing too many to worry about on the water. But if you only take one filter with you, make sure it's a polariser. Not only is this one of the very few filters whose effect can't be replicated in digital post-processing, but it's often the only available method of reducing unwanted reflections on the water and on wet reflective surfaces (such as the hull of your boat or kayak!). If you have plenty of time, a grey grad may also be of use for landscape shots. Tripods are generally a waste of space while actually on the water, as no tripod can counteract the motion of the ocean! But they may be worthwhile for shore landings, or if the boat is so huge that ocean motion is less of an issue than holding the 400mm lens steady in a howling gale, or if you want to shoot self-portraits or video, à la Ellen MacArthur. But unless you can secure the tripod so it doesn't tip overboard, a small camera/camcorder mounted on a suction clamp such as a MonsterPod may be a more secure option for such shots.

Protecting your camera

There are a few different options available for protecting your camera on and at the water's surface.

- Use a dry bag or wrap in a waterproof jacket between shots to protect the camera from water within the boat or kayak. This won't protect your camera if a sudden gust of wind or sharp-sided wave sends a wall of water at you mid-shot, but it should provide fair to good protection from splashes and on-board water for the rest of the time. Beware that a capsize still may drown your camera.

> Beware – many 'dry bags' are not designed for keeping things dry when faced with complete submersion.

- Use a waterproof compact camera. This may be the best option for some water-sports enthusiasts who value light weight and easy access (without faffing with housings or bags) as a priority over image quality. But the limitations of compact cameras apply. Many waterproof cameras suffer worse image quality than standard compact cameras and frequently have very limited options for taking control of the shutter and aperture settings. Bizarrely the warranties of such cameras can

also exclude water damage, which several users have reported occurs rather more easily than one would expect. After use, all such cameras should be rinsed in a fresh water bath to minimise the risks of salt ingress.

- Use a waterproof housing for your compact camera. Dedicated waterproof housings are available for many compact cameras and are usually relatively inexpensive (compared to dedicated SLR housings!), averaging £200+.
- If you expect to be using flash or taking the camera more than a few metres underwater, options 2 and 3 may be your only affordable options. Rigid plastic housings can suffer badly from condensation, especially when used at the surface on a warm sunny day, so make sure you pack lots of fresh silica gel. Another tip to reduce condensation is to hide the camera under something dark, such as a loose spraydeck or jacket, when not in use – this will often help the condensation clear by the time you come to take the next shot.
- SLR waterproofing options for the water's surface: Aquapac and ewa-marine make very useful waterproof housings to fit a variety of DSLR cameras (see Chapter 9, p170 for more information).
- For longer trips, especially overnighters, a sturdy protective box (Peli Case or equivalent) may be the best way to transport additional camera gear, such as the longer lens, that is only likely to be used on land. Just remember to shut the purge valve on older models before loading into the boat!

An Aquapac SLR housing suitable for surface and shallow-water use (Chiz)

KAYAKING (SEA AND RIVER)

Kayaking is an activity where both participant and spectator options will give good but very different results. The photographer has a choice between them, being rather forced by the nature of the activity down one route or the other.

Shooting from the water

Photographers who are also participating will have to make compromises on keeping the camera dry yet accessible, and understand that in a kayak (or dinghy) your viewpoint is

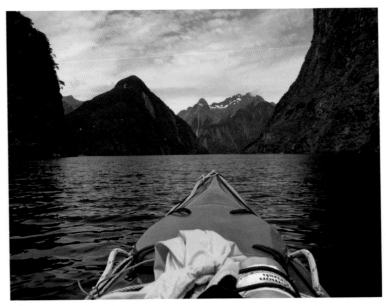

Doubtful Sound, New Zealand (Chiz)
The viewpoint is very close to water level, but including the kayak in the shot conveys a connection to the environment

very close to water level. You can only really vary this perspective by getting out of the kayak – on an accessible cliff, island, or bridge. (It's an unwritten rule that standing up in a kayak causes all sorts of problems – and often results in a dunking!)

Whatever you're shooting on water, one of the most important things to get right is the **angle of the horizon.** When viewing the images afterwards, the brain very quickly notices that the sea shouldn't really be trying to drain out of Druridge Bay towards The Netherlands! Getting it right in the original shot is always the best option, but if this seems too difficult, frame the image more loosely so that when you straighten it in software afterwards you don't end up cropping anything important out of the shot.

The horizon can be very close, cutting off the base of distant hills. If you're not careful all your shots may consist of little more than water and sky. The best scenic shots are usually taken pretty close to shore – possibly far enough that you can see the landscape rather than an individual rock, but not so far that the landscape vanishes into huge expanses of sea and sky.

Being fairly close to your subject also applies to people and wildlife – when showing the images to those who weren't there, it rather misses the point to have to get the microscope out to show that you really were kayaking with grey seals or whales. If you can't get closer, then enjoy the moment, rather than concentrating on an impossible shot!

Similarly with people shots: think about facial expressions and paddling action: you know you'll need to be close for these. Putting part of your own kayak in the shot can be a visual clue to the viewer that you were there, and really close to the action at the time.

Get used to shooting without looking through the viewfinder or at the screen. The combination of waterproof housing and LCD screen in sunlight makes it very hard to use Live View (or equivalent), but the viewfinder isn't always much easier to use when the camera's in a housing. Although it takes time and practice to be able to reliably frame the image without screen or finder, it saves a surprising amount of time – which can make the difference between getting the shot of your mate in mid-capsize, or just the bottom of his kayak afterwards! Time saved also reduces the need to catch up after stopping to take pictures – never a bad move for personal safety on the water!

Shooting a kayak against a dark cliff or dark-leaved foliage usually means the camera will expose for the background, resulting in a very over-exposed subject. Setting exposure compensation to −1 is a good starting point in such circumstances – but don't forget to reset it afterwards!

When looking to capture images of your mates on the water, don't forget the issue of hats. Most kayakers wear some form of headgear – a helmet for serious whitewater paddling or a beanie or sunhat on the ocean. Any sort of brim will often cause the person's face to be in shade. Asking them to remove the hat often isn't practical – either for reasons of safety (white water) or because it has given them a serious case of hat-hair! It is usually better to use a small amount of fill-in flash to lighten the shadows – but warn them first, and don't overcook it – the flash isn't meant to replace the sun as the main lighting.

Always consider safety first. It's obvious, but it's easy to forget when an image grabs your eye. Don't try to shoot if concentrating on photography could put you or your companions in danger. If current or wind is drifting you towards a rocky shore, or between closely moored boats, you'll probably need much more time (and therefore distance) than you think to get the shots. Even the fastest snap takes time to get. (You are doing that 'think' bit before the point and the shoot aren't you?) And when you're wanting to get that vitally important shot of your mate concentrating really hard as they try to pilot the kayak through dumping surf on a rocky passage below a cliff, it'll take more time to get yourself in the best position and ensure the camera's on the best possible settings for the shot. You'll also need to co-ordinate carefully with your mates if they are not to paddle out of range while you get the camera out and compose the shot.

Your paddle is your lifeline – always stow it securely and safely before taking a picture. If you are out on your own, a paddle leash could be a wise investment – a simple length of deck-cord bungee, with a loop at one end (for tying around the paddle shaft) and a toggle at the other (for placing under the deck-line) is all that's needed. This can get in the way while paddling: usually it is best to keep it coiled under the deck-line and just attach to the paddle when you stop, despite the extra faff-time this involves. Be careful to plan your shots so that you don't risk being left behind, especially if you are not one of the strongest paddlers in the group. A waterproof compact or housing may be the best option for speed of access and to reduce faff factor to a minimum. This might sound trivial, but it's surprising – and sometimes quite scary! – how even a slow group can disappear into the wide blue yonder while you're absorbed in photography.

Wildlife shots from the water

A kayak can be a very quiet and unobtrusive way of getting much closer to shoreline wildlife than you will ever achieve on foot. Especially by exploiting the current or wind to drift you towards the creature in question, you will often get far closer than otherwise, reducing the 'need' for extra long, extortionately expensive lenses. The usual ethics of wildlife photography apply, as laid out in Chapter 4.

Watch out for herons and other birds perched on tree trunks by the shore or riverbank; quiet paddling can also lead to surprisingly close shots. However, herons in particular often act as a general sentry for the area – so if you send one squawking from their perch, you can be sure everything else in the vicinity will be scuttling for cover if it's not already out of sight!

It usually takes a lot of luck and patience to get good shots of otters and other aquatic mammals. Even when families are known to live nearby, they are very shy creatures, and may well disappear before you get near them, especially if this isn't an area you frequently paddle.

Reen Pier, Co Cork, Ireland (Chiz)
Wildlife shots are sometimes more accessible from the water – but beware disturbing the 'guard-heron' who will squawk a warning to any other wildlife. It may be helpful to get someone else (Jim of Atlantic Sea Kayaks here) to paddle from the back of a double kayak

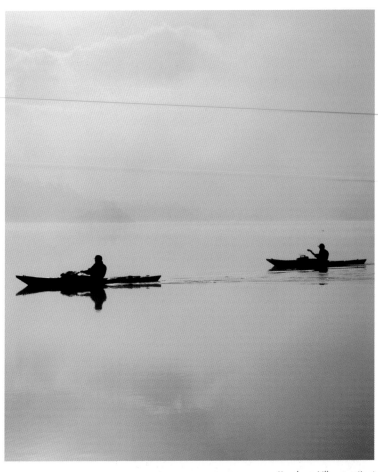

Kayakers, Ullswater (Jon)
Leaving the water, even just to stand on the shore, creates a significantly higher viewpoint

Spectator images

When you climb out of the kayak for a few minutes to shoot from a river-bank or skerry, you become a spectator – at least temporarily. This is a great way to get a different perspective on your paddling companions, but make sure they know what you're planning or you may find they're halfway down the river by the time you're in position!

A higher viewpoint allows shots of the wider landscape with a paddler in the foreground, and may make the water appear a quite different colour. Sometimes you may choose to exclude the sky altogether.

Photographing from the land gives a lot more freedom to bring out the longer lenses and larger cameras. Standing on a river bank, sea shore or cliff above the sea can allow the use of stabilising platforms (rocks, trees, monopods, tripods) to enable slow shutter speed shots of moving kayaks to be taken. This can be particularly effective for whitewater or slalom river kayak shots – especially where the kayak is rotating

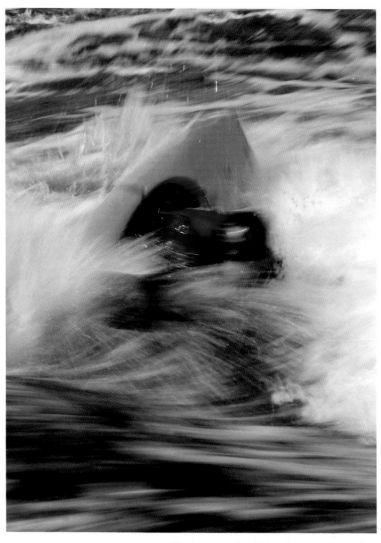

Kayaker pirouetting, Holme Pierrepoint, Nottingham
Slowing the shutter speed to 1/15 sec can make interesting semi-abstract shots – but it's a
fairly hit-or-miss technique!

fast in the water around an obstacle, or fairly stationary within fast-flowing water. As with all action sports, the speed, direction and closeness of the subject to the camera will determine the ideal shutter speed to freeze or motion blur the subject. Nearer, faster and more 'across' movement all need faster shutter speeds.

Safety may seem a lesser concern, and you won't (usually!) have to worry about capsizing, but always be aware of your surroundings – if you are standing at the top of a cliff make sure you don't get so caught up in the photography that you unintentionally

step forward onto thin air! Likewise, if balancing on slippery rocks at the water's edge. If you are photographing at the coast a rain-cover and UV or clear protector filter will help to protect the camera and lens from salt spray.

A monopod gives far more flexibility of movement when tracking fast-moving kayakers close to the camera than a tripod but more stabilisation than IS/VR alone provides. It also helps support the weight of bigger lenses: your arms will soon thank you for this!

It's important to consider what the participant is about to do next. There is no substitute for understanding how a kayaker will react to the water around them. If there is a channel close to shore behind some rocks, they may well be about to explore that, but if they're a relative novice, they may stay well clear of the shoreline. Knowing what they are likely to do next, and where they may head to, is key for getting in position ahead of them, ideally in time to change camera settings if needed.

SAILING

Many of the techniques relating to kayaking are just as applicable to sailing. Small dinghies in particular probably have similar risks of capsize, with all the implied issues for keeping the camera safe and dry.

However, there are several significant differences. Open cockpits mean that any gear in loose (even if waterproof) bags needs to be securely attached if it isn't to drop to the bottom of the sea in a capsize. If the boat has storage lockers, gear can be stowed, but then it's not readily accessible for that once-in-a-lifetime shot, so this is best reserved for additional kit that's only required for on-shore excursions.

The larger the sailing boat, the further from shore it will sail to keep itself safe from running aground or being washed onto rocks. This limits the chances of some of the really close-range shots of shoreline or wildlife. And the larger the boat, the more chance that all participants are on the same boat, rather than spread across several craft, meaning that action shots will be predominantly 'in-boat'.

The smaller the boat, the greater the value of a wide-angle lens (it's hard to step back from your subject when your hand's got to stay on the tiller!). If you are braving the SLR in the boat, a 10–20mm or even fish-eye lens can give really dramatic results, but a wide zoom of 24–27mm will be a good compromise.

Larger boats give more options for viewpoints, and really large boats such as ferries or icebreakers can give several storeys' worth of height gain over the sea. Really adventurous photographers may find some good angles from atop a mast – if the skipper is happy for you to go up there!

SURF- AND WIND-SPORTS

Both windsurfing and kite-surfing require high winds and will typically involve shooting from a sandy beach. Surfing doesn't need high winds, but shots will still typically be taken from a beach. This means the photographer will have both airborne sand and salt spray to content with. Cameras and lenses with good weather sealing will cope better, but for those with limited weather sealing it would be especially advisable to protect camera and lens with a cover such as the simple rainsleeve – or a plastic bag with a hole for the lens and elastic bands to secure it. If such a covering isn't available, all kit should be wiped down with a damp cloth immediately afterwards to remove salt spray. In fact this is a sensible precaution anyway.

Bridget Carter hoisting sail on Peer Gynt II (Jon)
Bigger boats do allow relatively dry shooting

Kite-surfing at Yyteri, Finland (Jon)
Photographing surf- and wind-sports will typically involve shooting from a sandy beach

Zoom lenses should be zoomed as little as possible to reduce the risk of salt spray or very fine sand being ingested into the inner workings of the lens, and a filter (UV/clear protective/polariser) helps increase weatherproofing at the front of the lens.

Changing lenses on the beach is ill-advised – if a different lens is needed it is best to retreat to the relative safety of a vehicle, beach hut or beachside café for this operation. Sand and digital sensors do not mix – a scratched sensor usually means a written-off camera (from personal experience).

Photographing any water-based surf or wind sport as a participant will require a totally different set-up from beach-side photography. The best option is usually a light and inexpensive camera, protected in a waterproof housing.

For windsurfing, one option may be to mount the camera at the end of the boom for self-portraits (one-direction only!). For video, the preferred option in many outdoor sports is to attach a lightweight camera onto a helmet – and this may be an option for a lightweight still camera too, but then you have the problem of how to tell it when to capture the shot! Neither of these solutions is ideal. My preferred method is to attach a lightweight waterproof compact camera to the boom by a secure bungee while not in use, then to stop in the water and remove the camera to shoot those around me. You may well find that you become a natural gybe-mark for other windsurfers, so a camera with a reasonably wide-angle lens is preferable. Carrying an SLR in a waterproof housing on your back is ill-advised due to the skimming-stone effect if you land backwards on the water at speed – the water can feel as hard as concrete and no camera appreciates this! Likewise for carrying it on the front – due to the ever-present risk of a high-speed catapult.

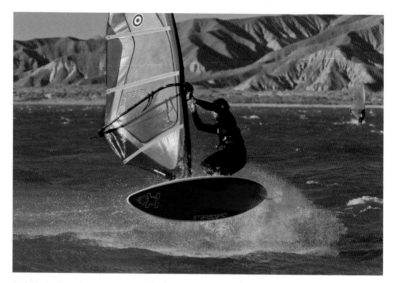

Franco, Cuesta del Viento, Argentina (Chiz)
A long lens, SLR and perhaps tripod are needed to capture even moderately distant action,
such as this jump (shutter speed 1/800sec here)

For kite-surfing, similar problems apply, but there are fewer options for where to hold (or mount) a camera. The best option probably really is a helmet-mounted video camera. A small waterproof compact tucked into a (zipped up!) pocket could be used while taking it easy in the water.

Adrian Diaz, Cuesta del Viento, Argentina (Chiz)
Head-on action shots are hard to get, but you can get some great 'environmental portrait' shots

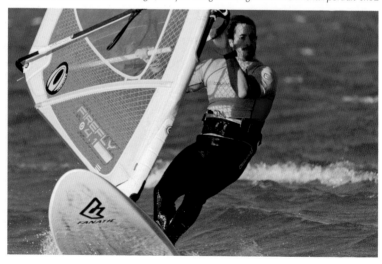

Spectating

For all three sports, the boundary between spectator and participant blurs somewhat if you enter the water – even as 'just' a photographer. Then you are a swimming participant at least, and part of Chapter 9 relating to snorkelling and near-the-surface underwater use is also worth reading. You also need to be confident that other water users as well as those you are photographing will see you and avoid you!

One obvious option is to shoot from a boat; often a club rescue boat is a useful platform if the boat-driver and club are amenable. With reduced risk of submersion, you might risk your SLR equipment for a better shot. Splash and spray will be a hazard and a camera rain-jacket is a vital precaution. Forget about tripods and even monopods in bouncy RIBs: photographers should rely on high shutter speed and/or panning.

On dry land, whether on a break between sessions on the water or as the main point of your visit, a different array of equipment may be called into play. A sturdy tripod, SLR and long lens won't hinder enjoyment of the sport, and can be carried in the vehicle used to transport the surfing equipment – just make sure that there is a dry space for it on the return journey! A sturdy tripod is ideally set up on a slightly raised point above the current waterline, safe from advancing tides – but not too high up. As with many action sports, if you can keep the viewpoint at roughly chest level, then this really puts the action 'right in your face' for greatest impact. As tripod stability is affected by the wind, then a position below the dune-line can give some protection from the worst of the wind, especially those with an off-shore component.

Professionals specialising in water-sports tend to use long (eg 600mm) prime lenses mounted on studio-weight tripods. With these, frame-filling panned shots at 1/50sec can give a spectacular impression of speed – but such lenses are outside the realities of most other photographers, even more generalist professionals.

A couple of related key factors in windsurfing photography are the angle of the sea or lake bed and the state of the tide. These affect how close to shore the windsurfer will generally sail: shallow-shelving beaches at low tide are likely to put the windsurfer much further out to gain deep enough water to avoid running aground; an even longer

Windsurfer at Cuesta del Viento, Argentina (Chiz)
Panning enables you to capture the feeling of motion (shutter speed 1/50sec here)

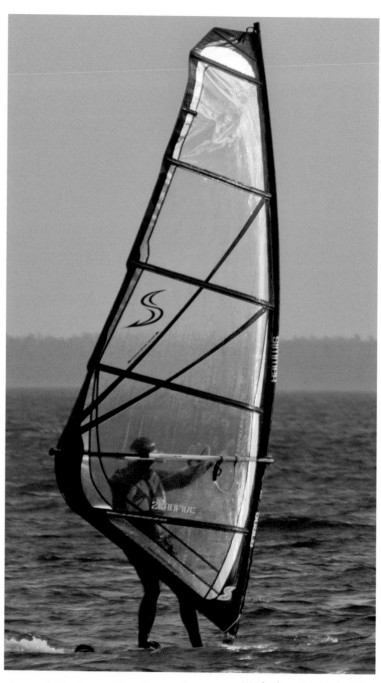

Windsurfer at Yyteri, Finland (Jon)
The direction of the light is crucial to this image

lens will be needed here. The wind direction is also key, as this determines the course that participants take. If the wind is directly on- or off-shore, then it's unlikely that the participants will be coming in and out of shallow (and nearby) water at high speed, instead they'll be blasting along parallel to the coast and turning at some distance out to sea. Panned shots with a long lens are the best option here.

Cross-shore winds are best for close-up shots of the participant carve gybing (turning at speed) as they will be likely to be doing so near to the beach. If the wind is slightly biased to an onshore direction, the sail will form a more pleasing angle than in a truly cross-shore wind. If windsurfers spot you taking pictures, or better still you've spoken to them beforehand, they may co-operate in trying to line their gybes up to give the best chance of a good shot.

Kite-surfing pictures are hard to get – no two ways about it! Kite and surfer are usually a long way apart, and both can move very quickly. Kite-surfing is also particularly unpredictable – typically changing the best framing of the image from landscape to portrait and back again in a split second. Perhaps due to this, the ideal frame shape is often square with this sport. Cropping pictures later is easy enough, especially with digital cameras, but it helps to think about this at shooting time.

The distance factor makes full-on action shots hard to get, but you can get some great 'environmental portrait' shots of surfers entering and leaving the water – perhaps with emotional expressions of rapture at fantastic conditions – or sheer exhaustion! A wide aperture will help concentrate attention on the person – the background is typically far enough away to blur out easily.

The challenges of surfing photography can in many ways be similar to those of wind- and kite-surfing. One thing that may be more of an issue is the lack of a brightly coloured sail or kite to add colour interest to the image. It may be worth asking your mates to wear as brightly coloured kit as possible – a bright T-shirt and board shorts on their own or over the wetsuit. Another challenge with surfing is that the wave is a critical part of many shots, but you may not want to take your camera through the rinse cycle! In which case, going on shore with a long lens, parallel to the line of waves (ie further along the coast than the beachfront) may provide a useful vantage point.

With all water-based surf- and wind-sports, wind, tide and swell will determine when the action's best, but morning and evening usually produce the best light. The direction of the light will make a great difference as to whether you will get best results with silhouette-type images, or if the subject's face is lit up by natural light (it's rare you'll be close enough to even consider flash!). And on a west-facing beach evening shots often give some very pleasing silhouette effects.

FINAL THOUGHTS

Water sports can be truly exhilarating to take part in, and you'll really want images that reflect this, but it's a very tough challenge to get these while participating. Making the decision to step into the role of spectator, at least for a short while, allows a much wider range of options and oddly, because of the use of long lenses in particular, can sometimes enhance the sense of involvement in the resulting images. This is easy enough in beach-based activities like surfing, or when watching whitewater events, but presents some tough decisions about what to carry and how to carry it when heading off on a long canoe/kayak journey. Chapter 10 (trekking) may provide some help, but the need to stow in waterproof outer layers remains paramount for less accessible gear.

8

ON THE WATER

Northern Arch, Poor Knights Islands, New Zealand (Chiz)
Diverse and brightly coloured marine life – without flash to hold the red wavelegths of light, this image
would lose its impact

9 UNDERWATER

FIRST THOUGHTS

Here there is virtually no distinction between participant and spectator – if you're underwater you're a participant! It's also one of the hardest genres of photography to master. It requires the tracking and 'unthreatening motion' skills of the wildlife photographer to get close to the subject, the sports photographer's skill of capturing the action, the studio photographer's skill in setting up flash with sometimes multiple different light sources, and all while you and the creature making the subject of the image are being tossed around at the will of the marine currents. That said, when you do get a good picture, it is all the more valuable for its hard-won nature. Oh, and just to add to the fun, there's no air down there other than what you bring with you!

Quite apart from all this, light behaves very differently in water: most obviously, it is absorbed much more quickly. While there's usually a fair amount of natural light around in the first 5–10m of water, by the time you're more than 20m down (even in clear tropical waters) much of the natural light has gone, and this happens at shallower depths in temperate waters or low-visibility conditions.

The light's a different colour too! In fact this is even more of an issue than the lower levels of light. Water absorbs reddish-coloured wavelengths far more quickly

Diver, Great Barrier Reef (Agincourt Reef), Australia (Chiz)
Your buddy is an obvious subject

than greeny-blue ones. This gives many underwater photographs a rather blueish tinge like cheap 10-year-old prints left out in the sun. This 'colour-shift' happens very quickly – through as little as 50cm of water. The absorption of light in water is also responsible for lower levels of contrast and saturation throughout the image. Many underwater cameras have a special 'underwater' white balance setting, which goes some way to counteract this effect. But there are only two real solutions: either get very close to the subject or use flash (see below).

A helpful dive buddy with a strong torch may provide an adequate light source to restore colour to the image where natural light is moderate to dim (typically between 2m and 20m depending on latitude and conditions). But below these depths a flash is the only way to light the subject adequately.

Are you ready to shoot underwater?

This might sound like a trivial question, but it's actually quite important. There's a lot to grasp just keeping yourself safe underwater. Diving accidents do happen, especially to the inexperienced; adding photography to the mix at this stage is asking for overload. When you have good control over personal buoyancy, navigation, air-usage and efficient fin motion, then – and not before – it's time to start playing with photography. You might consider only taking the camera underwater while snorkelling until your diving skills mature. After all, the best light and many of the best images are actually found within the first 5–10m from the surface, so it's not a bad option in its own right!

Excellent personal buoyancy control is vital for underwater photography. If you want an eye-level shot of a manta ray just 15cm above the sea bed, then your camera has to be steady at that level – and this means holding yourself really steady, without kicking up sand or other debris from the sea-bed. For some shots that might mean shooting upside down!

Rico Rico cave, Stingray (Dasyatis pastinaca) *(Chiz)*
Getting that eye-level shot of the stingray on the sea floor requires very good buoyancy control (all underwater shots are from the Poor Knights Islands, New Zealand unless otherwise stated)

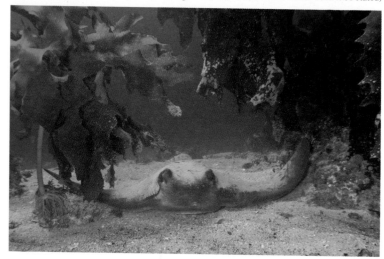

It's all too easy to lose track of depth when following fish with a camera underwater, and it takes very little time to break 30, 35, even 40m depth without intending to. This can have serious consequences in terms of safe return to surface without getting the bends or running out of air. At best, your next dive may be cut short or limited to very shallow depths if you've gone too deep. These risks increase with the second or even third dive of the day. So, it's best not dive with your eye continuously glued to the viewfinder – just as you wouldn't on land; instead look for the image without the viewfinder, take the shot (without following the fish for ages!), then check your depth before looking for the next shot. The same also applies to currents. Moving with the current is very easy, and if photography makes you lose track of distance, this too has the potential to cause serious problems.

My first dive in the Poor Knights was extremely frustrating. Armed with a full set of underwater photography gear in good weather conditions, the dive turned into a nightmare as I used loads of air unnecessarily adjusting my buoyancy up, down, up again, down again. I ended up spending just 25mins underwater failing to maintain any position and taking no worthwhile pictures. Why? Other commitments had kept me from diving for more than a year, and I'd forgotten that it takes a dive or two to remember some of the basics in buoyancy control. I'd have done far better to leave the camera gear at base, and concentrate on recapturing my diving skills for the first dive or two, then bring the camera gear underwater when my buoyancy control had returned again. (Chiz)

All these are of course basic diving issues that you should be aware of anyhow, but that's the point; it's all too easy to forget about them when concentrating on photography. And it goes without saying that no image is worth destroying a creature's habitat, or worse still, endangering its life. If you can't get an image without destroying the coral surrounding the subject, don't take it – however visually appealing it may be. Move on and find an alternative – as they say, there are plenty more fish in the sea.

UNDERWATER HARDWARE

Several compact cameras are rated for underwater use to varying depths – typically somewhere between 1m and 10m. Check the specifications before dunking it! These cameras are primarily aimed at snorkellers, and can give good results within their depth limits. The top 10m of water still has a reasonable amount of natural light – at least if it's clear – so flash isn't always necessary. And 10m should be more than enough for any sane person when snorkelling or free-diving.

Using compact cameras brings the issue of shutter lag. Digital compacts are much better than they were, but still slower than DSLRs. However, you can minimise lag by using good-quality batteries and charging them fully before each dive, starting with a newly-formatted memory card, and using the fastest write-speed memory card you can get.

If your camera is not rated for underwater use, then it will need a dedicated housing. These come in various shapes, sizes and costs. Some cheaper options are listed in Chapter 8 but these are typically less useful at diving depths. Picking up from there, the

Mary's Wall, surface seaweed photographed from right underneath (Chiz)
Several compact cameras are rated for underwater use and can work well for simple
near-surface shots

diving photographer really has a choice of two types of housing: flexible housings and dedicated (rigid) compact camera housings.

Dedicated rigid housings for DSLRs also exist, but they typically cost £2000plus for the housing alone, never mind the extra accessories that are usually 'required'. Anyone contemplating one of these should already be well versed in the basics. Then what you really need is a master-class in lighting techniques – which is outside the scope of this book.

Flexible housings such as those from Aquapac or ewa-marine provide the cheapest means of taking your camera underwater. They are easy to use, as all controls are available by pressing through the housing. And in some ways they are less prone to flooding as they allow the air pressure inside to equalise with the water pressure outside, so if water does seep in, at least it doesn't gush in under pressure! As the air gets compressed within the casing as you descend, the casing eventually clings so tightly to the camera that no further compression is possible. In practice, their limits are reached before this point, as the water pressure itself can start to press buttons.

These housings tend to be limited to shallower depths: most Aquapac housings are rated to just 5m – ideal snorkelling territory – while ewa-marine housings are typically rated to 20m (sometimes up to 50m).

Dedicated rigid camera housings are the obvious, if not only, choice for photography below around 20m. But bear in mind that below about 10m artificial lighting of some description also becomes essential, if only to register the true colour of the subject and give good contrast.

Rigid camera housings usually rely on O-ring technology to guard against leakage. If this should fail, it tends to fail catastrophically due to the pressure difference between the water outside and the air inside. With good maintenance this shouldn't happen,

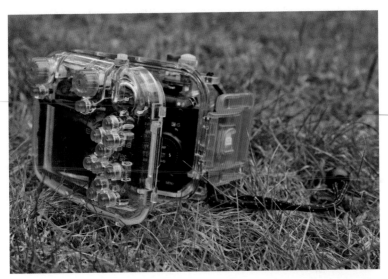

Dedicated rigid camera housing (Chiz)

but Murphy's law applies underwater too... It's vital that the O-ring and sealing groove are impeccably clean and that the correct sort of lubricating grease is used.

Such housings usually start at around £200 for a compact camera. Third-party makes such as Ikelite, Inon and 10bar tend to be pricier, but often have additional features. Nearly all rigid camera housings are specific to a particular camera make and model: if you change your camera, you also need a new housing.

If the cost of the gear and potential for flooding is becoming daunting, then underwater photography may not be for you! However, there is another option: renting a compact underwater camera. Renting is becoming more popular, but check in advance whether this is available in your intended dive location, as facilities are still rare outside the major centres. For the more experienced, renting underwater flash is also occasionally an option.

> Unless you have a very large budget, the choice of camera equipment for under-water photography is more limited than other genres, and it may be hard to find a compact camera that shoots **RAW** images. But, if you possibly can, shoot RAW.
>
> In post-processing, you can sometimes massively increase the contrast levels and turn what had looked like a so-so picture (low-contrast but of course well framed and exposed!) into something you're much happier with and nearer to what you actually thought you saw.

GETTING BETTER PICTURES UNDERWATER

Many of the techniques explained in Chapter 4 apply just as much below water as they do on the surface, as do the framing principles in Chapter 3. However, the key technique to remember is to get low. Particularly with underwater photography, shooting

UNDERWATER

Rico Rico cave, yellow wrasse (Halichoeres trispilus) *(Chiz)*
Getting low creates much more impact (aperture f/2.8, twin external flash)

at a figurative eye-level with your subject, or even from below, leads to much more dramatic and pleasing shots. Shooting from above, by contrast, usually includes too much of the sea bed as a background, and your subject often gets lost in the sand or other clutter. It's far easier to shoot from above – especially if your buoyancy control isn't perfect – but the results speak for themselves!

Getting low relates directly to the need to keep it simple. What is the image about? A wonderful sea anemone – or the entire sea floor, with every plant, piece of coral and grain of sand? Usually it's the anemone. Backgrounds may help the viewer focus on the main subject, but they shouldn't distract from it. Capturing nothing but blue water

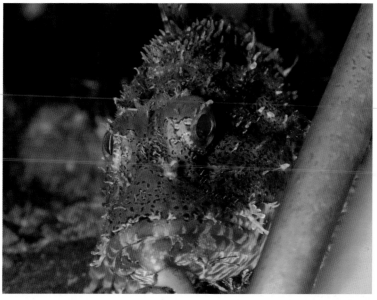

Trev's Pinnacles, scorpion fish (Scorpaena plumieri) (Chiz)
Filling the frame with your main subject. Finding the scorpion fish can be harder than getting a good portrait of it!

behind the fish or coral is a good way to make it stand out, whereas a clutter of background shapes, colours and textures can swamp the subject. Using a wide aperture (shallow depth of field) can also reduce background clutter.

Blenny, Landing Bay Pinnacle (Chiz)
This shot works because the crack gives a feeling of depth for the blenny to emerge from

The **eye** (with creatures that have them) is a natural focal point. Consequently it's also a key point to get sharply focused! The viewer's brain will forgive a tail or background being softly focused, whereas it will rarely forgive the eyes being soft.

Filling the frame with your main subject automatically minimises the background, but sometimes you will want to show some background to put things in context. One thing that can make or break a picture is whether it gives a sense of depth or ends up looking flat and two-dimensional.

Contrasting colours also make for stronger images – in underwater photography the dominant background colour is usually blue or green, so the colours which give the strongest visual contrast are yellows to reds: a bright yellow fish against a deep blue background, or a vivid red anemone against the green leaves of living sea-kelp.

Most of these principles are common to all photography, but some things are very different underwater. The rapid attenuation of light as you descend, and the loss of reddish colours in particular, mean you need either to be close to the surface, or use flash. In partial compensation, because water resists movement much better than air, you'll find that your hands are effectively steadier and you can sometimes use a slower shutter speed than up top. However, this does nothing to compensate for the diminution of colours.

Mary's Wall (Chiz)
Without a flash you're effectively stuck with the natural lighting, but you can make a big difference by changing your alignment to it

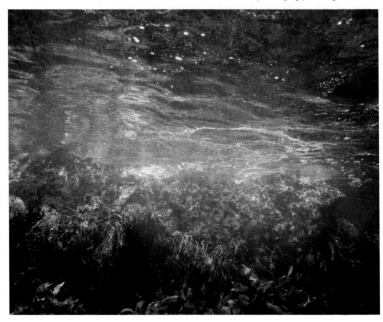

*Tangalooma Wrecks, Brisbane, Australia, stingray (*Dasyatis pastinaca*) (Chiz)*
Backscatter is a constant problem with flash, and on-camera flash is worst of all

Without a flash you're effectively stuck with the natural lighting, but you can make a big difference by changing your alignment to it. Where natural light comes in at an angle from the surface (ie when the sun is low in the sky), then orienting yourself sideways to the incoming sunlight will often give much clearer results.

Flashing it underwater

Flash underwater, especially with external flash guns, is a specialist (and expensive!) business. A high percentage of amateur underwater photographers never investigate it. This is a shame, as it can make a huge difference to the colour and contrast of underwater photography. Most professional underwater images use it.

But although the on-camera flash is tempting, it often produces poor results. A built-in unit, or any flash mounted close to the camera lens, will illuminate every bit of suspended matter in the water – if it doesn't just light up the interior of the housing! In completely crystal-clear water you may escape this 'backscatter' effect, but this is rather more rare than most photographers would wish! Avoid stirring up the sea-bed as much as possible for best visibility and clarity. If this is impossible, allow time for the particles to settle back down again.

A detailed explanation of underwater flash photography is outside the scope of this book, but a few basics are worth mentioning:

Water absorbs light far more quickly than air, so the effective range of a flash gun is much less than on the surface. Using a diffuser on the flash gun (usually an odd little translucent but of plastic attached with a string, which clips into position around the top of the lens section of the housing) – especially when using wide-angle lenses – gives better results and avoids 'flash shadow' from a compact camera housing, but reduces the effective range still more. You'll probably want to use a fairly high ISO

UNDERWATER

rating (which probably needs to be set before leaving the surface – you can't open the housing underwater!) but even so, don't expect to be able to shoot subjects more than a few metres away.

Moving the flash as far off the camera as possible, whether above, below, or to the side, improves the lighting quality just as it does on the surface, as well as reducing backscatter. However, this requires external flash, which is expensive to buy (or even rent). Moving the flash gun back from the camera can also reduce backscatter, and using wide apertures will make it less obvious. Backscatter is relatively pale in colour, so shooting against a paler background makes it less conspicuous than against dark backgrounds.

Rigid arms holding the external flash to the camera help stabilise the weight and reduce leverage and strain on the camera housing above water. They also help to keep gear together while moving from one location to another. However, once in position, unclipping them allows the external flash to be positioned more freely and at greater distance. But you may need the help of your buddy to hold the flash heads in position when unclipped!

*Sugar Loaf, mosaic moray eel (*Enchelycore ramosa) (Chiz)
This moray makes a scary-looking image, but it may be hard getting close enough for flash to be viable, as (unlike UK moray eels) they are rather timid

Middle Arch, purple sea urchin (Strongylocentrotus purpuratus) (Chiz)
Flash shows the true colours of this sea urchin – and getting low creates much more impact

Many housings (especially those designed for compact cameras) don't allow the use of TTL flash. However, many flash guns have an adaption called a manual control-ler. This small device attaches to the rigid arm, detects when on-camera flash is fired, and relays the signal to fire the flash gun. You have to guess or calculate the correct power setting for the flash, and underwater this can change very rapidly with flash–subject distance. Such controllers are often easily triggered by reflections of the sun in small surface waves. Manually controlled flash should be switched off at or near the surface to avoid damage to the flashgun.

Detection of on-camera flash can be improved by taping a small reflective strip (as simple as part of a metallic sweet wrapper) inside the camera housing (in front of the flash). By preventing forward scattering of the on-camera flash it also stops it interfering with the effect of the external flash, and prevents it adding to the backscatter.

FINAL THOUGHTS

Spare a thought for your buddy. Photography underwater is very time-consuming, and if your buddy has no interest in it, it may ruin their enjoyment of the dive. Try and find a dive buddy who does understand the joy of photography, and is happy to hang around one area for a while. An enthusiastic dive buddy can be invaluable for helping to spot good subjects, and assisting with illumination while you compose the image!

10 TREKKING AND EXPEDITIONS

FIRST THOUGHTS

There are no spectators on a trek or expedition. It can be an all-encompassing experience: beautiful, demanding, exhilarating, stressful and – nearly always – deeply rewarding. Trekking may put extra demands on you and it can certainly put extra demands on your photographic hardware and skills. These are not the times to be fumbling with unfamiliar equipment. Gear and techniques should be tried and tested on home ground first. 'Trekking' implies travel on foot, but of course you can also trek on bikes, on horseback, by kayak, or on skis. The basic definition of a trek is any multi-day trip in a more or less remote environment, carrying everything you need – with or without porters or pack animals. However, much of what we'll say in this chapter applies to other extended trips too. A long hut-to-hut tour in the Alps doesn't require you to carry food or stoves, but Alpine huts don't tend to sell photographic equipment.

HARDWARE

If you smash a lens or run out of batteries halfway through the trip, there's no camera shop just round the corner. While saving weight is bound to be important, it's even more vital to have gear that's utterly reliable. A more rugged camera may weigh a few extra grams, but a camera that doesn't work is pure dead weight.

Mike Elston, Sierra Nevada, Spain (Chiz)
Awesome sunset over the Alpujarras from the Elorrieta Hut (shutter speed 0.4 sec)

◀ *Chiz Dakin, Markha Valley, Ladakh (Chiz)*
Treks are about people as much as about places

River crossing, above the Hispar Glacier, Karakoram (Jon)
However reliable your camera, hazards abound, and accidents can happen

Venturing into new and unfamiliar environments can give you a whole raft of new things to deal with. Don't make photography another of them. It's tempting to buy a new camera for that 'trip of a lifetime', but you're better off sticking with the one you know and understand. It could, however, be a very good idea to have it checked and serviced before you go. Camera servicing always seems expensive, but neglecting it can prove even more costly, not to mention heartbreaking.

However reliable your camera, accidents can happen. No camera will survive being dropped into a glacial torrent. Carrying a spare is a very good idea, but expensive if you don't have an old camera lying around. This is worth discussing with the rest of your team, especially if two or three of you have the same make of camera – you may be able to share the cost and weight of a spare camera between you. And even a compact camera as backup is better than no camera. You may be able to pool other gear too, such as long lenses, cleaning kit, or a tripod.

As this suggests, planning and preparation are crucial. Few treks are undertaken at a moment's notice, or planned 'on the back of an envelope'. If you're getting your camera serviced, allow plenty of time. Work out exactly what you need to take. Then pack it, weigh it, take it for a long hike over local hills – and think again. It might be tempting to take 15 different lenses to cover every eventuality, but who's going to carry them? A 300mm lens is pure dead weight if you don't have a functioning camera to put it on. Backup for the absolute basics takes priority.

'Absolute basics' really means four items: camera, lens, memory cards, batteries. If you don't have all of these you're in trouble. Individually or collectively, you need spares for all of them. We've already mentioned backup camera bodies. When it comes to lenses, if your basic everyday lens is a standard zoom like an 18–70mm, a second lens of similar range is a natural backup. A prime lens within the same range may be smaller and lighter. Pick the widest one you can get or perhaps a 50mm macro lens: it both backs up the standard lens and adds the extra dimension of close-up shooting.

Alpe Buscagna, Piemonte, Italy (Jon)
If one piece of new kit is worth considering, it is almost certainly a wide-angle lens

It is infinitely more important to have this basic backup than extra lenses of extreme focal length. However, many treks take you into landscapes that are on a larger scale than the British hills. If you regularly shoot with your widest lens here in the UK, it may not seem wide enough in the Alps or the Andes. If one piece of new kit is worth considering, it is almost certainly a wide-angle lens. Stitching shots together to create a panorama is a fairly commonplace and straightforward way to get a wider horizontal spread but it's not so easy to create extra vertical coverage.

You might take a chance on going without backup lenses. You might take a chance on going without a backup camera. You'll probably get away with it – most times! However, this does mean you need to be ultra-careful about carrying and looking after your gear. Operations like changing lenses incur the most risks.

You may think lenses rarely fail, but it does happen. On my first major trek, in the Karakoram, my main zoom lens swallowed a piece of grit on the jeep-ride into the mountains before we'd even started trekking. This left me with 24mm and 50mm lenses and a 2x teleconverter (and shooting on 35mm film – it was a long time ago). It seemed like a disaster, but turned out remarkably well. With such limited and well-defined options to play with, I learned a lot about framing too.

(Jon)

Whether or not you chance your arm on camera and lenses, there are two things you cannot afford to skimp on: power and storage. With very rare (and non-digital) exceptions, cameras need batteries. And all cameras need something on which to store images, whether it's film or memory cards.

Jungfraufirn, Bernese Oberland, Switzerland (Chiz)
More moderate lenses (55mm here) can still capture something of the scale of huge landscapes

Power

Digital cameras go through batteries like there's no tomorrow. But on a trek, tomorrow is the problem. Running out of power halfway round the Annapurna circuit is the stuff of photographic nightmares.

The first question is how long your battery normally lasts. An SLR battery may deliver 1000 shots or more under favourable conditions. You might think that 1000 shots should easily be enough for most treks. After all, if you shoot 1000 images, you're going to spend a long time organising and editing them when you get back.

A thousand sounds like a lot, but on a three-week trek it's fewer than 50 shots a day: maybe four or five per hour of daylight. Suddenly it doesn't sound so generous after all. Even with serious restraint, it would be well to plan on taking a couple of fully-charged spares, perhaps more.

There are many reasons why a battery may not achieve its stated number of shots. Low temperatures, for example, can severely reduce capacity (although the battery may recover when warmed up). The other major drain on the battery is extensive use of the rear screen, whether it's for Live View photography, shooting movies, or reviewing images you've taken.

A sensible precaution before going on a trek would be to run a practical test in the most realistic conditions you can manage – starting with a charged battery, of course.

Even if you can score 1000 or more shots on one charge when shooting normally, trekking may lead you to change some of your usual habits. It's going to be hard to resist the temptation to review your shots at camp in the evening, and maybe show them to others too. If you score 1000 under 'home' conditions, assume you might only manage half this when trekking. Then divide this by the number of days trekking to give the number of shots you have per day while on trek.

Of course, trimming your shooting to the batter(ies) you choose to carry isn't always the only option. You may have access to mains power at times; you may have occasional opportunities to purchase AA batteries – but don't place any reliance on these unless you can check beforehand. Talk to your trekking company if you're going with one.

Non-SLR cameras usually have smaller batteries, which may give far fewer shots on a single charge. However, some use AA batteries, which are available in some pretty remote spots.

Some SLR cameras can also accept accessory battery packs, which may also accept AA batteries. However, they do add weight and bulk to the camera.

FreeloaderPro solar charger

There is also the option of using a solar charger, like the FreeloaderPro from Solar Technology. This comes with a CamCaddy cradle, said to accept virtually any camera battery (there's a compatibility checker on the Solar Technology website). The weight of the panel and cradle together is about 250g, or the equivalent of about four or five typical SLR batteries. And this rather assumes you'll get plenty of sunshine! And beware, solar chargers are not particularly quick to charge even in strong sunlight.

A really extended trip, of a month or more, could just be one of those rare times when a completely manual film camera is still the best option – if only to avoid the battery issues of both camera and storage device. However, the number of films you can carry will limit the number of images you can capture. So perhaps a solar charger and several batteries, plus plenty of memory cards, combined with very restrained shooting, is still a viable digital option. In which case, it's arguable that shooting JPEG images (largest size and highest quality) is preferable, to avoid the storage and backup issues created by huge RAW files. Just be extra careful with a) the camera settings at time of shooting and b) the cards themselves – especially those filled with unbacked-up images!

Storage

We may as well stick with that 1000-shot benchmark. Multiply everything by X if you feel you'll shoot more!

Next question: how many images can you get on the memory card(s) you have now? The answer depends on the image size and quality your camera produces. You can do lots of maths or simply connect a current memory card to a computer and see how many images use how much space. If a card is half full with 120 images, then you would need at least four such cards to accommodate that hypothetical 1000 images. And given that memory cards are relatively cheap and they add very little bulk and weight, it would seem a no-brainer to take more.

Memory cards are pretty robust but not invulnerable. They are also small and very easily dropped or lost. Pick your moment to change cards and store them in a secure case or pouch. Cards full of images are doubly precious.

Backup

Storage is only half the story. A lost or corrupted memory card can lose you hundreds of images of what may be the trip of a lifetime. Backing up as you go is the best way to guard against such traumas. Unless you're vehicle-based or otherwise have a high level of logistical support, you're unlikely to be lugging a laptop computer around with you.

> You might take your laptop if you're on a large mountaineering expedition with a fixed base camp. With porter-support or even jeep transport to this point you can consider a solar-powered setup, including a laptop to which you download your shots after each foray up the peaks, and a satellite phone so you can update the expedition website every day. This sort of setup is now commonplace for many commercial expeditions. It obviously demands a large budget, and with that much valuable kit at stake you'll want your base camp permanently staffed.

Some high-end cameras have dual card slots, which provide a form of instant backup – but it loses much of its value unless you store your backup cards separately from your primary cards. Otherwise, unless you are shooting very small JPEGs (and why would you do that?), the main backup device to look at is a dedicated multimedia storage viewer. These are essentially portable hard drives with the addition of a small screen which allows you to view and organise your shots. Capacities start at 80GB and weights vary from around 300 to 600g. And it's another device which needs power, so it's worth having spare batteries if relying on this for an extended trip. The best known examples come from Epson and Vosonic. An iPad, and some varieties of iPod, can also be used, but needs a special camera connector. And check that the available disk space isn't already full to busting with your music library!

Extras

Having covered the four essentials (cameras, lenses, storage, power), the rest is merely very, very important. Some kit for keeping your gear clean is almost a fifth essential. The minimum is a supply of clean cloths or tissues for cleaning lenses and filters and a soft brush or 'puffer-brush' for removing dust from cameras. Keep the cleaning kit

Campfire, Matho Valley, Ladakh (Chiz)
Carrying a tripod can really pay off for night-time shots (aperture f/5.6, shutter 0.5 sec, ISO 4000)

itself clean in sealed plastic bags. You would have to be very brave, if not foolhardy, to attempt cleaning an SLR sensor at a campsite or even in an Alpine hut, so take great care when changing lenses. As well as normal precautions like standing with your back to the wind, it may be necessary to clean dust off the exterior of the camera and lens, and ensure that hands or gloves are as clean as possible.

A very small toolkit could also save you a lot of grief. The most useful item is a small, jeweller's type screwdriver for all those tiny screws on cameras and lenses. Check your gear regularly in case any screws are working loose.

If you really need a tripod, then a lightweight one can be stretched beyond its normal abilities with a bit of cunning – clipping a couple of walking-poles or an ice axe to the centre column, then piling rocks on top of these can make a lighter-weight tripod capable of steadying a system camera far in excess of its 'comfortable' load. Of course, you do need a good supply of rocks or other heavy objects!

Carrying

The next consideration is how to carry everything. This is another area which really needs working out before you go. It may even make you revise your kit list again. If you're not happy carrying loads of extra gear when walking or riding at home, are you sure you want the extra burden on a demanding trek? Or does your kayak have room when you've loaded it with all the camping/cooking gear and supplies for the journey?

For walking, anything you expect to need during the day goes round your neck, round your waist or on your back. You can't get at it in a porter-load or on the back of a mule. For kayaking, everything you need while away from shore has to be attached under deck bungees, or within your cockpit (as on a day trip). The porter-load

Reuben Dakin, Saastal, Switzerland (Chiz)
Expeditions on skis or by bike make the question of load carrying quite critical

equivalent is the place where you store cooking, camping and food supplies! And that's the place for backup gear, a tripod (if needed for evening shots) and that 300mm lens that you're only going to use for the total eclipse. If you're serious about photography on this trip then you will end up carrying more than some of your companions. You'll probably regret it many times during the trek, but feel superior afterwards. Still, the right approach to carrying your gear will make a big difference. But don't wait until the trek to work it out. Give your carrying/storage system, whatever it is, a good shakedown on days out at home first.

Checklist

This isn't necessarily a rundown of everything you must take; rather it's the things you need to at least consider taking:

- main camera body
- spare camera body or compact camera
- default lens eg 18–70mm
- backup lens eg 20mm or 50mm macro
- memory cards
- batteries
- more memory cards
- more batteries
- other lenses: wide-angle; telephoto
- lens hoods; spare front and rear lens caps
- camera rainguard or waterproof case
- filters: UV or skylight filter (attached to each lens); polarising filter

- cleaning gear: brush; cloths/tissues; toolkit
- flash gun
- carrying gear: camera pouch and waist-belt; padded cases for other items; plastic bags, preferably resealable, for batteries, cleaning gear, etc. secure storage for memory cards
- camera support (eg tripod; monopod; bracket for ice-axe or trekking pole; beanbag)
- insurance
- and for multi-day water-based treks (kayaking or sailing) – sufficient waterproofing for everything that needs it, and some emergency spares.

INTO ACTION

Planning doesn't just involve gear and how to carry it. You can also think well ahead about the sort of shots you'll want to take. Great set-piece views will be obvious, but the thing about trekking is that it's an all-encompassing experience. For those days, weeks or months it is your life, and you'll want to record all its aspects. It can be worth having a mental, if not written, list of possible subjects. But treks are also about unexpected and surprising experiences, so preconceived ideas are a starting point, not a straitjacket.

Treks are about people as much as about places; team-mates, porters, guides, local people you encounter, that famous climber comatose in a Kathmandu bar. You're sure to want portraits of the team, but think about whether you want them to be staged or candid. It could look distinctly odd if you get back home and one of the team is missing from your portrait gallery; friendships have been broken over less. So make sure, before it's too late, that you've got everyone.

Vary the scale. However stunning each shot may be individually, an unbroken series of scenic views quickly brings on stunning view fatigue in the most avid viewer. Besides, stunning views are only one part of the trek experience. Details – a flower in a crevice, crystals in rock – give more feeling for the environment. Other details, from mundane stuff like the food you ate and even slightly gruesome stuff like blisters help to remind you, and inform those who weren't there, what the whole experience was like. A rounded portrait includes the lows as well as the highs!

However well prepared you think you are, actually being there can still be close to overwhelming. Immersion in new environments and experiences can lead to photographic overload. There's more to this than filling all your memory cards in the first week, although that is definitely a factor. Remember that 1000-shot benchmark; on a three-week trek it is under 50 shots a day, or just a few per hour. Stay aware of the limits of your image storage capacity (usually memory cards) from day one.

Everything may look new and strange, but a lot of it will start to seem commonplace very quickly. Coca-Cola signs in remote villages are (unfortunately) not that unusual. Over-shoot at first and you may find that you need to start deleting images to make room for new ones. This is a time-consuming and sometimes stressful process – and it consumes lots of battery power, which is also unhelpful.

It's also worth asking whether photographing everything you see in the first few days is getting you closer to the new environment or keeping you at a distance from it. There is a lot to be said for taking more time to absorb the new sights and sounds and spells, to get more of the feel of the region and to get to know the people a bit better.

Pony, Chilling, Ladakh (Chiz)
Look for portraits of the 'team' – in its widest sense!

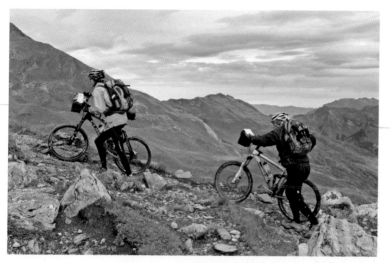

On the Grischa Tour, Graubunden, Switzerland (Jon)
Commitment! The tough bits are probably when you're least inclined to take photos,
but they do help to put the whole thing in perspective

This is especially true of the people you're travelling with – fellow trekkers, guides, porters, and so on. You'll be together for the duration of the trek: get to know people a bit first before thrusting a lens in their faces.

Longer trips are often where all aspects of photography come together. Trekking doesn't really require you to learn new techniques, but it may involve rapidly and repeatedly shifting between existing ones. It really pays to be comfortable with shooting places, people, action and wildlife; familiar, well-grounded technique is a lot less likely to get muddled or slow you down in a whirl of new experiences. Don't let fiddling with the camera come between you and the enjoyment of those experiences. If it seems like this is happening, go back to basics. Put the camera on Auto mode for a while and let it take care of the technicalities.

To me, putting technique aside for a time makes sense – but it also makes the strongest possible case for shooting RAW. Automatic exposure and automatic White Balance are great things to fall back on, but they won't get it dead on all the time. Shooting RAW gives you much greater scope to correct these things when you get back home.

This does not mean reverting to point and shoot mode. Instead it should free you to think more clearly about what you are seeing and how you want to capture it. Remember those fundamentals: what to point at and when to shoot. Bring those to the fore once more.

And then, as the trek progresses and you settle into it all, gradually reintroduce some refinements of technique. When you're faced with a stunning view, go for Landscape mode or even Aperture-priority. It's at those moments when you really have to stop, whether to take in the view or to admire a single flower, that it makes most sense to spare a few extra seconds to think specifically about photography.

10

Kettle (Jon)
Don't make every shot a grand landscape: little details can say just as much about the experience

Sierra Nevada, Spain (Chiz)
Golden evening light high up in the mountains – you have to trek to see this unless you enjoy a long walk down in the dark. Incidentally, this is almost the reverse angle to the opening landscape shot of this chapter: keep looking behind you!

FINAL THOUGHTS

If you have the photography gene, then trekking can very easily be 'the best of times and the worst of times'. There's just so much to take pictures of, and every single possible shot has extra potency because of the awareness that you will very likely never come this way again. Whether you've allowed for shooting one, two or even five thousand images, at some point it won't seem like enough. You will have to turn away from what look like great shots.

Get over it. What are you going to do with those thousands of shots anyway? Unless you're shooting as a pro, photography is meant to be part of your trekking experience, not to dominate it to the exclusion of all else. Enjoy your photography and leave yourself plenty of space to enjoy the rest of the trekking experience too.

10

11 EXTREME CONDITIONS

FIRST THOUGHTS

One person's 'extreme' is another's 'bracing'. If you enjoy getting really muddy on a mountain bike, or battling up a Scottish gully through spindrift avalanches, you're going to want shots that reflect this. We're talking about extremes here: extreme sports, extreme conditions, or ultimately both. These present real photographic challenges. More than ever, this suggests thinking ahead, and getting thoroughly familiar with gear and techniques on easier ground.

Going to the edge puts greater stress on you. Time, energy, concentration, and load-carrying capacity are all stretched. Photography has to fit in around the demands of completing the course, getting to the top, or simply surviving. The mantra 'light, fast and simple' becomes doubly relevant. You may have very limited carrying capacity for gear; you may only be able to free one hand to take the shot. In really extreme situations, your own safety and that of your companions may leave little room for photography. However, really extreme situations, provided you survive them, make great memories, so you'll want a record if you can possibly get one.

Those who photograph extreme sports professionally often speak of the concern they feel about encouraging their subjects to take risks, and the potential guilt

Icebergs, Antarctica (Chiz)
Cold, wet, salty and often windy: this is potentially a very destructive environment for cameras

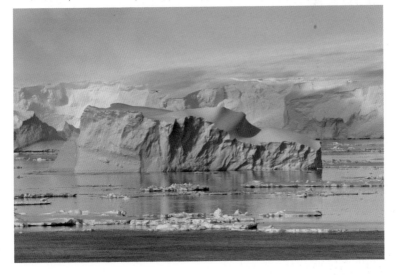

◄ *Canyoning, Lechtal, Austria (Jon)*
In this extremely wet environment a waterproof case for the camera was essential

Reuben Dakin, Cairngorms (Chiz)
Frost settling on a mountain walker: one person's 'extreme' is another's 'bracing'

if anything goes wrong. But these subjects are usually also professionals: sponsored athletes, for whom getting the photo of the climb or dive or leap is vital to continuing their career. For the rest of us, the balance is different. When decisions are being made about whether to push on or retreat, photography simply shouldn't be a consideration.

HARDWARE

It's the outdoor photographer's eternal dilemma; when it comes to camera gear and how to carry it, speed, quality and control are often at odds with lightness and convenience. Extreme sports and/or extreme conditions accentuate this dilemma still further. Bigger cameras are typically more robust and more likely to keep on working in foul conditions, as well as being easier to operate when wearing gloves.

Cameras may also require extra protection, which adds more weight and bulk and can also make operation more awkward. There are no easy, one-size-fits-all solutions. As well as the challenges of different activities, which we've mostly examined in earlier chapters, conditions beyond the norm – whether cold, wet, windy, hot or dusty – pose specific problems for cameras as well as for photographers.

WET

In a British context, rain is the commonest concern. Any lover of the outdoors in these islands can hardly avoid going out in the rain. Sometimes it clears up, sometimes it doesn't. Those folks who head for the pub at the first spots of drizzle probably think you're mad. Let's show them just how beautiful things can be in the rain!

Great landscapes – and more – can be done in the wet. Long-range views may be flat, if visible at all, but in compensation you get a different look at the near and middle ranges. Colours of foliage can be at their most intense and the crystal structures of rock are much more clearly revealed. Drifting rain acts like fog, veiling the outlines of trees or rocks in mystery.

But rain on the lens can blur your pictures, and rain in the works can wreck your camera. To keep rain off the lens, use a lens hood and keep the camera angled down when not actually shooting. Even so, especially when the wind's in your face, it can get spattered in seconds. A dry, clean cloth or tissue is worth its weight in gold. And of course you'll be wiping the water off the UV or skylight filter that you fitted after reading Chapter 2, rather than off the lens itself.

A few seconds' exposure to rain won't harm most cameras, but do try and keep it to a minimum. Know what you want to do before pulling the camera from its case. Top-line cameras, especially professional ones, should be well sealed against the weather. Small print in the specifications should tell you what level of inundation the camera's supposed to cope with. But don't take anything for granted. It still makes sense to keep the camera as dry as possible. Keep it in a good protective pouch, or inside your jacket, as much as possible (assuming the jacket itself is waterproof!).

If you plan to take more than a few shots in the rain, the camera itself really needs a jacket of some sort. This can be anything from a simple plastic bag all the way up to a full underwater housing, which could cost more than the camera itself! (See Chapter 7).

A basic 'rain guard' is just a stout plastic bag, open at the bottom, and with a rubber collar in one side that fits around the lens. You can cobble something together with a large plastic bag and a couple of stout rubber bands, but a ready-made rain guard is not an expensive item; ewa-marine, for example, do one for under £20. More sophisticated rain guards, designed to accommodate long lenses and allow much better access to controls, may be two to four times the price.

Rain guards always have an opening somewhere, but waterproof cases like the Aquapac range give complete protection from any amount of rain or spray. Their cases for compact cameras cost little more than a rain guard, although their SLR case is

Abbot's Way, Dartmoor (Jon)
Rain does not stop play – but it does lower contrast, and there's a limit to how far you can get it back in post-processing

several times more expensive. It fits most SLRs, but not the larger professional models. In really torrential conditions their ability to take silica gel to keep condensation at bay may be a very worthwhile consideration.

Rain guards leave the lens itself exposed, although sheltered by a hood; Aquapac and other waterproof cases place an optically clear cover over the lens. For best results this should be parallel to the lens front element and as close to it as possible. Remove lens hoods before placing the camera in the case.

Whatever form of protection you are using there is a problem when the wind drives rain or spray towards you. Drops on the lens (sorry, the filter) or cover will be very obvious in pictures. Occasionally these can produce an interesting effect but 99% of the time you'll want to clear them before shooting.

There are several ways to encourage rain-drops to run off rather than clinging to the lens. Rain-X is a product sold mostly for keeping car windscreens clear. There are variable reports on how effective it is and whether it damages lens coatings. Other suggestions include waterproof sunscreen and even rubbing with half an onion! These could be worth a try on a cheap filter but never risk it on the lens itself. Repeated use of Rain-X is also reported to damage the acrylics used in some lens covers. Generally it seems just as effective to keep a soft microfibre cloth in a dry pocket and wipe the filter or cover whenever necessary.

If you need to change lenses when it's wet, be very, very careful. Give the camera every bit of shelter you can. Again, familiarity with your equipment is an advantage. If you can change lenses blindfold, then you can do it in the shelter of your rucksack or under a jacket. This is worth practising at home, but with most cameras it really isn't that difficult. However, the safest option is to fit the right lens (usually a wide-angle zoom) beforehand and keep the camera in its rain guard or case throughout.

There are a number of digital compacts sold as 'waterproof' or 'weatherproof'. 'Weatherproof' is probably best taken to mean 'showerproof'. These can be a good bet for general wet-weather work, kayaking, and so on. Unless they're declared suitable for underwater use, they aren't. Bear in mind that hanging around in waterfalls, as you may do when canyoning or caving, exposes you and your gear to water under pressure. This really should be considered as underwater use! All of these cameras seem to attract a higher than average level of complaints from users and even though they are sold as 'weatherproof', warranty may not cover use in demanding conditions. They may be a lot cheaper than an SLR but will look inordinately expensive if they fail without warranty cover.

Fresh water is bad enough. Salt water is even more destructive to cameras. This concerns not just surfers and sea-kayakers, but rock climbers on sea cliffs and even

A rain guard by Think Tank Photo (Jon)

walkers on cliff tops. Salt spray can drift a long way. Exposure to such conditions should be minimised. At the very least, always carry the camera in a pouch, not just slung round your neck. And, as soon as possible, clean off your gear. A clean soft cloth moistened in fresh water is good; deionised water is even better. Clean all surfaces, not just the lens or filter, then allow the camera to dry thoroughly, preferably in a warm (not excessively hot) dry place.

COLD

Getting cold can impair your performance; it can be just as problematic for cameras. Most camera specifications state that they shouldn't be used in temperatures below freezing. This is clearly not good enough for outdoor users! However, this doesn't mean that the camera will definitely and immediately fail at lower temperatures; rather, it means that the manufacture is no longer prepared to promise that it will go on working.

The commonest problems are with batteries. Cold shortens battery life, often severely. The first line of defence is to ensure the battery is fully charged before you go out. Even better, carry a spare, and keep it somewhere relatively warm, like an inner pocket. Changing batteries with cold fingers can be a fiddly process, but swapping a cold battery for a warm one is often all it takes to revive a moribund camera.

Once again, SLR cameras have the advantage. The cameras themselves are bigger and heavier, so they cool down more slowly anyway. They generally have bigger batteries, too, which again are more resistant to chilling out.

The other area which is likely to be affected is the camera-back LCD screen, which may become erratic or blank out entirely. LCDs are sensitive to cold anyway and, being on the outside, will cool down faster than the internal electronics. The camera

Stok Kangri, Ladakh (Chiz)
At 6100m, the altitude was more of an issue to the photographer than the sub-zero (Celsius)
temperatures. The camera (a DSLR) had no problems at all.

Husky, Gålå, Norway (Jon)
A preponderance of white can cause problems for many metering systems

may still be taking perfect pictures but you can no longer confirm that it is. But don't stop shooting, because that will guarantee that you won't get any pictures!

With many compact cameras, the screen is used not just for playback but for framing the shot in the first place. If the LCD screen starts acting up, framing your shots may involve more guesswork than usual, but inexact framing is usually better than no shot at all – and you will get better with practice. However, this also makes the case for the old-fashioned viewfinder, as found in more traditional compact cameras as well as SLRs. The worst problems are likely to be found on the small number of cameras with touch-screen operation – clearly, these do not recommend themselves for outdoor use.

An alternative approach is to keep the camera under your clothes, only pulling it out when you're ready to shoot. This is a lot more comfortable with a compact than an SLR. However, condensation on lenses and viewfinders can be a problem, so simply shoving the camera next to your skin isn't recommended; keep it under one or at most two highly breathable layers (the Parámo system seems far better than Goretex here for avoiding condensation issues). This minimises the heat loss to yourself as well.

We've both photographed all day in Finnish winter temperatures of –15 to –25⁰C and had no problems at all. Admittedly this is with chunky pro and semi-pro SLRs, and starting every morning with a fully-charged battery, but they were still operating well outside their official comfort zone.

Neither battery nor LCD failures are likely to be permanent. Once the camera returns to a regular operating temperature, normal service should be resumed. However, don't be tempted to hurry up the warming process as rapid fluctuations in

temperature can cause problems of their own. Condensation on the outside of the camera is harmless but condensation inside can do a lot of damage. The safest strategy when moving from a cold environment to a warm and humid one like an Alpine hut is to leave the camera in its case for an hour or longer, preferably with some silica gel in there too.

Of course, simple low temperatures are not the only challenge you may face. Blowing snow and spindrift has a nasty habit of getting into everything, including your camera pouch; such conditions really combine the challenges of cold and wet. Changing batteries, memory cards or lenses in such conditions is definitely a last resort and should only be undertaken with extreme care.

Cold shooting

Cold usually means frost or snow, which can create fantastic photo opportunities. Even the most mundane and familiar landscape can be magically transformed after a hard frost or deep snowfall. In high-latitude winters, the sun tracks across the sky without ever rising very high. While this makes the days shorter, it also gives lovely acute light for most of the day. Visibility can also be at its best; good winter days have a special crystalline clarity. It all adds up to a unique, vibrant quality of light, even before we factor in the power of frost and snow to transform familiar landscapes.

However, lots of white stuff around can cause problems for many metering systems. This is where you want the LCD screen to keep functioning so you can check the histogram and/or highlights display. Normally, the camera will tend to reproduce all those whites as something nearer a middling grey and positive exposure compensation of +1 to +2 may be needed.

Robin Beadle above Mattmark Reservoir, Saastal, Switzerland (Chiz)
Ski touring: travelling light is a requirement, but you'll still want to be able to capture shots of your mates showing off

Ylläs, Finland (Jon)
Picking your spot to stop and shoot is central to cross-country skiing photography

SNOW SPORTS

After cycling, snow sports can involve some of the fastest motion the outdoor photographer is likely to encounter. This applies first and foremost to downhill skiing, although it's very dependent on the skill of the participants. Snowboarders travel more slowly and make wider turns, but expert cross-country skiers can move pretty fast at times.

On the piste, don't stop to take pictures without checking behind you. Stopping at the edge of the piste is usually safer than stopping right in the middle. Make sure you're well ahead of your companions to give yourself the necessary time to stop, get the camera out and be ready to shoot. Unless you're simply a much better skier than they are, arrange this beforehand. On a typical piste skiing holiday you may do some runs several times. The first time down, you may simply want to get the hang of the run (especially at the start of the week!). Use the second run to scope out one or two good shots for shooting and then take the shots on the third descent. If you've pre-arranged things with the team, and they have at least a modicum of control, they should be able to carve turns as they pass you at a negotiated distance. If you trust them and you have a wide-angle lens this could be very close indeed and the results can be spectacular. A much wider separation – 5 to 10m – and a longer lens will work well for panning shots. Read Chapter 7 for more on photographing high-speed motion.

Freestyle skiing and boarding create great opportunities for shots of aerial action, and it will usually be relatively easy to predict where this will happen. In these shots skiers and boarders may be seen against a dark high-altitude sky rather than a white snowy backdrop, so the exposure problems may be the opposite of normal and some negative compensation may occasionally be needed. If the action is close to you, using flash will help to sharpen it up, but don't use flash without warning the participants.

The demands of cross-country skiing photography are quite similar to cycling or mountain biking. Prepared trails (or loipes) are fairly narrow and as soon as you step off

to the side, if not enveloped in trees, you may sink into half a metre of powder snow. Picking your spot to stop and shoot is a definite art. Simply stopping in the tracks is only an option on quiet loipes – and with a team who are forewarned to the possibility!

Ski touring combines the trekking and snow-safety issues of winter mountaineering with the speed issues of downhill skiing. Ridge lines and arêtes make excellent backgrounds. If you are unsure of your abilities to stay upright, the best advice is to shoot mostly uphill (when you're unlikely to fall over), and put the well-padded camera away safely in a rucksack for steep downhills or tricky ground, getting it out only while stopped (which may be purely for taking a pre-arranged photo of your mate at speed!)

In all forms of skiing, carrying the camera on the hip is not an option as it will interfere with arm movement and pole use, and round the neck is definitely not advised. For small cameras a zipped pocket is best for safety and accessibility, otherwise the best option for easy access of system cameras is to carry it on your chest. Simply clipping the camera pouch to rucksack straps with short lengths of bungee cord and/or miniature karabiners can be very effective. Alternatively, if carrying nothing else, the camera pouch can go on a waist belt, but slide it all the way round to the small of your back. Picking the best option can depend on what least affects your balance. For a skier of limited ability it might depend whether you think you are more likely to fall on your back or on your face! For more advanced skiers, although the likelihood of falling forwards is probably greater than backwards, it is easier to 'curl up' around the camera (to protect it as you fall) if it is on your chest rather than on your back. You may well find this comes naturally.

While the safest and most comfortable place to carry a system camera is in a backpack, this means you'll take fewer photos and it will take longer each time to stop and get ready. As with cycling photography, quick-access zips on rucksacks help somewhat here.

Reuben Dakin, Descending from the Augstbordhorn, Switzerland
Ridge lines and arêtes make excellent backgrounds

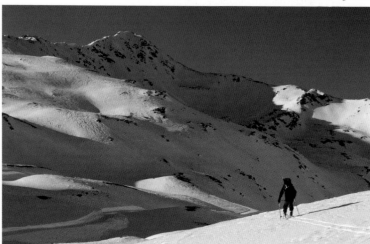

Ice on pool, Buckbarrow, Lake District (Jon)
Sometimes small details are best for showing how cold it was

How do you show the coldness of the environment in an image? Setting a slightly bluer white balance to normal can help with this, if it doesn't make the image look odd (particularly an issue with people shots) but far more often it's the layers of clothing people are wearing in shots, the hoar-frost on their clothing, hair and rucksacks, or the glistening of snow and ice in the image that tell the tale.

WINDY

Hurricanes and tornadoes regularly kill people. In fact much lesser winds can be life-threatening in some circumstances: if you're teetering along an exposed mountain ridge, or in a dinghy off a rocky lee shore.

From the strictly photographic point of view, high winds can yield great dramatic images, and of course activities like sailing need at least a breeze. But anything from a fresh breeze upwards can create various problems. The most obvious is the risk of camera shake.

If you can hand hold a 50mm lens at 1/60sec under calm conditions, give yourself an extra margin in rough weather. Up the shutter speed to 1/125sec or higher as the wind rises. Image stabilisation can help you hold the camera steady, but fast shutter speeds may still be needed to capture motion due to the wind; for instance, a really sharp shot of a breaking wave calls for a minimum speed of 1/500sec.

In really high winds, a tripod probably isn't the answer. No tripod on earth will stay put in a tornado and only an unfeasibly heavy one is likely to be much use in a force 8. There are definitely times when you're better off hand holding (see p44). Don't rule out alternatives such as monopods, beanbags and flat rocks either.

If you are using a tripod, any or all of the following can help: don't extend the legs too far; splay the legs wider than normal; weight the tripod down with your rucksack; stand upwind to give it some shelter (without blocking the camera's view!); wait for a momentary lull.

Fumaroles: Atacama Desert, Chile (Chiz)
It was close to zero away from the water and steam and obviously a lot hotter close to it.
Rapid changes in temperature and humidity can be stressful for cameras and lenses

HOT

Camera specifications will normally give a maximum as well as a minimum operating temperature. Heat by itself will probably cause the photographer to fail before the camera, but heat coupled with high humidity creates rather more problems, and these are the sort that can lead to permanent damage to equipment. The greatest risk is transferring rapidly from a cool dry environment, like an air-conditioned hotel, to a hot and humid exterior. This can be shocking for the human body and can cause serious condensation within cameras and lenses. The only solution is to pack cameras in plastic bags with sachets of silica gel and allow plenty of time to reach ambient temperature before unpacking. This also applies on your return to air-conditioned spaces.

Long-term exposure to hot, damp conditions can create additional issues, like bugs infesting your gear, fungus growing on lens coatings, and so on. The usual advice is to keep everything in sealed bags as much as possible, with lots of silica gel, and change lenses no more than absolutely necessary.

Hot shots

How do you actually show how hot it was? The environment in a shot may suggest the temperature, but this can be misleading: you can be roasting on a glacier and freezing in a sandy desert. Rippling heat-haze and mirages do indicate heat, but people provide many of the best clues, wrapping themselves against the sun, seeking out any patch of shade, taking a drink, or just sweating!

DUSTY

After sea water, dust, sand and grit are among the most insidious and corrosive enemies of delicate equipment. It can be susceptible in all kinds of environments: deserts and beaches are just the most obvious. In extreme conditions, like a sandstorm, the

Cleveleys shore, Lancashire (Jon)
You don't have to go to the Sahara to experience a sandstorm!

opportunity to get a great shot is directly at odds with the risk of the camera swallowing some nasties. A weatherproof camera, or a rain guard, could be just as much use here as in the rain.

The times of greatest risk are when changing lenses and memory cards. If you know you're going out in a sandstorm, or one is expected, make sure the memory

Landcruiser, Wadi Rum, Jordan (Jon)
Typical desert transport, which combines the hazards of dust and vibration

card has plenty of space, then pick one lens and stick with it. A zoom lens might seem to be a good idea, but zoom lenses are mechanically more complicated than prime lenses so there's more to go wrong – and good shielding with a rain guard is doubly important. In really dusty conditions you won't be able to see far, so a wide-angle lens is probably your best bet. Travelling by Jeep to get to places, (particularly if it is not air-conditioned in hot dusty countries) can be a big problem for dust too – keep all camera gear in sealed bags in this situation.

GOING UNDERGROUND

Caves are often wet and dirty. They frequently involve crawling through confined spaces or dangling on ropes and ladders. Oh yes, and they're dark.

All these factors make caves particularly challenging for photography. But precisely because it's so different from the everyday surface environment, it's all the more important to have a record. If you can come back with a few shots that convey the fascination and the beauty of it, you may start to persuade a few people that you aren't, after all, totally mad.

As with any potentially dangerous activity, your safety and that of your companions comes first. Apart from obvious things like not falling down a shaft when you step back to reframe, bear in mind that taking photos in caves can be time-consuming. Too many stops are annoying and mean that as the trip progresses everyone's that bit more tired. However, where ladders or Single Rope Technique are involved there will be times, when others are rigging or climbing the pitch, when you may be able to shoot without delaying anyone. Sumps and crawls may create similar opportunities.

Looking after your gear, while not a life-and-death matter, is still important. It needs the best possible protection against impacts, dirt, and water. Fully waterproof

Greenglow Caves, Waitomo, New Zealand (Chiz)
Off-camera flash mixes with daylight to give a fairly satisfying result
(aperture f/8, shutter 5 sec, ISO 100)

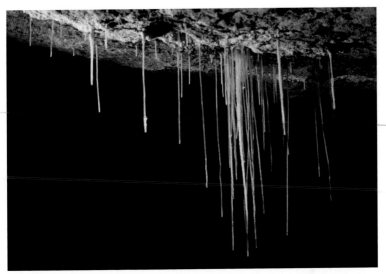

Greenglow Caves, Waitomo, New Zealand (Chiz)
Side lighting from off-camera flash is what makes this image – if the flash was fired directly at the stalactites they would lose their texture (aperture f/5, shutter 2 sec, ISO 100)

cases or dry bags are usually needed, and cameras and lenses will need further padding inside them. Even so, this is a risky environment for your shiny new system camera. Professional caving photographers reckon to write off an average of a camera a year just through the dust, mud and humidity encountered. A weatherproof compact may be less scary to carry and will fit in a padded pocket or down the top of a caving suit, but this could be one place where shooting on film still makes sense, especially if there's a good old-fashioned, metal-bodied, mechanical SLR available. If you are taking an SLR, try and manage with just one lens. The cave environment is about as risky a place to change lenses as we can think of.

In fact the safest way to handle any camera underground is to secure it in a waterproof case – such as those made by Aquapac – before you start, and leave it there until you emerge. Even so it will need further padding against the inevitable knocks.

Even for a single camera, lens and external flash gun, and definitely for anything more than this, then the best approach we've seen is to use one or two medium-sized metal boxes (such as ex-army ammunition boxes) well padded with foam. Adding a couple of sachets of silica gel can also be very useful to help counteract the normally high humidity underground. These boxes are then placed in a caving-friendly dry bag, which is tougher than most dry bags sold for trekking and can be clipped to the caver for security on descents, or left on the ground while setting up shots.

But this isn't lightweight or low-bulk, and this level of commitment needs to be fully agreed to by all the team before the start.

Shooting underground

The quickest and easiest way to get photos as you go along is with on-camera flash. This is subject to all the usual limitations: limited range, harsh lighting and 'red-eye'.

With built-in flash there's not much you can do about these. But in caving there's some justification as the results will bear a definite resemblance to the light you get from your own headlamp.

A single flash gun is useful for taking photos of your companions, and for small formations, but won't give a bigger picture of the environment. And if there are crawls, or pitches, or it's just wet, you'll need to unpack and re-pack camera and flash for each shot.

A flash with a bounce head allows more subtle lighting in small passages, but as dark rock is a poor reflector, you'll need a powerful gun. Extras like diffusers, or a sync lead that allows you to take the flash off the camera, will improve the lighting but it all means more gear and more delay. With some DSLRs the built-in flash can be used as a wireless controller to trigger a remote flash and this may allow you to keep the camera itself well sealed, but the flash gun will have to be more exposed to the elements.

Modern flash is loaded with claims about super-smart linkage to the camera's exposure meter. Such things are really fairly irrelevant to caving photography, where it is usually far better to set both camera and flash guns on manual. This is especially so once you start playing with more than one flash, as the camera's processor can start making all kinds of odd decisions that can become hard to override successfully.

For simple shots, set a shutter speed of around 1/60 or 1/30sec and the flash gun to full power initially. The aperture will depend on distance to your subject and ISO setting but f/5.6 is usually a good standby. Make sure you set the same aperture and the same ISO on the lens and on the flash. And finally, don't forget to focus – it's a good idea to use a powerful torch to help you with this! If you find the flash gun overpowers the foreground, then set the power to a fraction of full power, eg ½ or ¼.

You can also take photos just using the light from headlamps. This can work very well for formations and will look better than on-camera flash. You can do pictures of people this way too, but they'll have to keep still. The high-ISO abilities of modern digital SLRs make them ideal for this sort of shot, especially coupled with an IS/VR lens. Even so, exposure times may be quite long and extra measures may be needed to keep the camera really still. Assuming you don't want to carry a tripod, (although it's worth at least a lightweight one for many shots, it can be made stronger than you'd expect by not extending the legs) then a beanbag sometimes works very well, or simply bracing the camera firmly against a rock wall or ledge (not a fragile stalactite). The more of you there are, the more headlamps and the brighter the light, but people will probably still need to be fairly static for such shots. Real action is still likely to need flash.

For decent shots of larger passages, chambers or shafts, a single flash just won't be up to the job. However, you can get stunning shots of such spaces through 'painting with light', more soberly called 'open flash technique'. It sounds grand, but doesn't need a lot of fancy gear. What it does require is time and a tripod. It also helps greatly if there are two or more of you.

In simple terms, you stand the camera on a tripod, lock the shutter open and walk around with the flashgun, firing it with its test button. As you move around, successive flashes illuminate different areas and you build up a complete picture. Put like that it sounds simple enough, but there are a few complications.

Locking the shutter either requires a cable release or needs someone to stand there and keep their finger on the button. Unless the tripod is very solid, this is very likely to

11

Glow-worms, Greenglow Caves, Waitomo, New Zealand (Chiz)
As long as you can shoot without compromising basic safety, extreme conditions can also
produce some of the most memorable images. (aperture f/4, shutter 30 sec, ISO 1600)

jiggle the camera and ruin the shot. It also requires the camera to be in Manual or Bulb mode; nothing else will do.

It takes time for the flash to recharge after each firing. A long series of flashes may take several minutes to complete, which will allow any background light to register. This might defeat the object of using the flash in the first place. If the space is completely dark this won't be a problem – but then how do you see what you're doing? A headlamp will leave a trail of light as you move around between flashes.

The simplest solution is to cover the lens between flashes. This is another reason why two people are needed: one to move around with the flash, one to stay with the camera and cover the lens between flashes.

It can look quite odd to see the same person appearing in several places, although in caving photos this is often unavoidable and viewers get used to it. If you are holding the flash gun, even pointing away from the camera, it's quite likely that you will appear as a relatively anonymous silhouette. Sometimes you can hide yourself from the direct view of the camera, perhaps behind a large stalagmite or boulder.

In a chamber with a high ceiling, even multiple flashes just won't reach the roof, and you will be left with pools of darkness. It's best to frame the picture to exclude most of these areas.

With all this in mind, this technique may appear to be strictly a last resort. In reality, it isn't particularly difficult, and the results can be immensely effective. It does, however, require thought and planning, as well as time. You need to work out in advance where and how often you may want to do it, and make sure your companions are happy with the time factor.

It is a bit hit-or-miss, certainly a far cry from 'what you see is what you get'. It takes some practice before you can anticipate the outcome even approximately. However, a wide variation in results can still look acceptable; they'll probably just mean that the pools of light will be larger or smaller. If you'd like to try it, the usual advice applies: practise first. You can do a dry run in your cellar, or in any dark room, but make sure it's really dark. The larger the space, the more flashes you'll need. It's a good idea to try with small – room-sized – spaces first, where two or three flashes will suffice.

CANYONING AND COASTEERING

Canyoning and coasteering combine the watery hazards of pursuits like kayaking (Chapter 8) with many of the photographic demands of rock climbing (Chapter 6). A particular issue is that both may involve leaping into water from a considerable height. A small compact in a waterproof case can be stowed inside the wetsuit for these moments, but leaping with larger cameras could be dangerous and it's usually best to throw the camera ahead of you. Waterproof cases and dry bags provide some impact protection because of the trapped air they contain but additional padding should be provided. A few layers of bubble wrap around the waterproof case, inside the dry bag, will weigh next to nothing and are easily removed when you want to use the camera. Even this may not be enough protection when the drop is more than a few metres: look for ways to get closer to the water or to lower the camera on a line. One final thing: just make sure that the camera/case/bag combination does actually float!

Aurora Borealis, Ylläs, Finland (Chiz)
Shooting at night is a trade-off between high ISO levels and long shutter speeds, both of which risk serious levels of noise. The best compromise will vary from one camera to the next: experiment to find out (aperture f/4, shutter 15 sec, ISO 400)

If you're comfortable with digital imaging software, there is an alternative variation to this technique. Instead of taking one shot with a really long exposure and many bursts of flash, take lots of shots and combine them later. This will be a slow and fairly skilled job but it does have some advantages. This way, you can even shoot when you're alone, by triggering the camera with an inexpensive remote-control device. The routine would be roughly like this: set the camera to an exposure time of 1 or 2 secs; move into first position, point the flash gun at the desired area; turn off the headlamp or look away; trigger the shutter with the remote; fire the flash; listen for the camera shutter closing. Move to position 2 and repeat until finished.

Then there's just one final problem: who's going to carry the tripod?

Incidentally, this technique is also useful out of doors at night; one popular adaptation is for a shot of an expedition campsite. When it's almost totally dark, set the camera on a tripod and lock the shutter open, then walk round firing the flash inside each tent in turn. Just make sure all the occupants know you're coming round!

FINAL THOUGHTS

In really extreme conditions, photography will sometimes be the last thing on your mind. This is as it should be: survival comes first, and you have a responsibility to yourself, your companions, and to anyone else who may be put at risk if things go wrong, like rescue teams. But as long as you can shoot without compromising basic safety, extreme conditions can also produce some of the most memorable images. And, while it might be nice to have everything technically perfect, in really extreme conditions almost any shot will probably have a strong story to tell. Pushing for better results is a good thing, but it relies heavily on preparation; both equipment and technique need to be sorted beforehand.

12 BRING IT BACK HOME

FIRST THOUGHTS

This is a book about outdoor photography, not about computers. Still, in the digital age, the computer is an integral part of the photographic process. Without access to a computer, what we can do with the images we shoot is much more limited. Computers of one form or another are central to the ways we store, organise and display those images.

Today the choice of both hardware and software is wider than ever. Mapping a way through this maze is crucial to getting the best from our photographic efforts.

HARDWARE

Essentials

If you shoot digital, you need a computer. That's not really up for debate.

Of course, computers take many forms. The iPad is a computer. In fact it's probably the first mobile device that's really worth a second look as a platform for photography. The screen is great – clear, bright, vivid, and big enough to give a really good look at images. There are thousands of photo-specific apps for it too, although many of them only do one small job, like applying a simple image effect or uploading to a specific networking site.

However, the iPad also has significant limitations. It doesn't have USB or a card-reader, so transferring photos from your camera requires a separate connector. And it has limited storage capacity, especially if you are shooting RAW, never mind if you also have music or videos on there. There simply isn't room to store a full collection of photos. As a way of storing and reviewing images during a trip of a week or two, it's brilliant, but for permanent and secure storage and organisation of the thousands of images you will eventually amass, you still need a 'real' computer.

This can be either a desktop or laptop. Hard disk capacity in laptops tends to be smaller, but they can also be linked to external hard drives for extra storage. Apart from this, almost everything we say in this chapter can apply to both desktop and laptop systems.

Operating system. One of us uses a Mac and one a PC. There was a time when Macs were the automatic choice of professional photographers, and they're still extremely popular, but in reality you'll see little difference between Mac and Windows systems when actually using any mainstream software packages. In terms of overall user experience, speed and stability, there's probably more difference between Windows 7 and Windows Vista than between Windows 7 and Mac OS X. Keeping the OS up to date (provided the hardware can handle it) is generally recommended.

◀ *Kite-surfer (Chiz)*
Those things we go to the outdoors for: freedom, movement, light, space

Computers take many forms: iPad, desktop or laptop (Jon)

Processor. Editing photos can be quite demanding on the processor but any recent system (netbooks excepted) should be well up to the task. If your computer runs slowly or freezes, processor speed is not the most likely culprit.

Memory. On the other hand, if your system runs slowly when handling large files such as photos, memory (Random Access Memory, or RAM), is the first suspect. This is where the system holds the data it's actually working on. Fortunately, adding more RAM is usually the cheapest and simplest upgrade you can perform. Realistically, to run the latest operating systems and photo editing software, 2GB of RAM is a minimum, 4GB is better and it's often said that you can never have too much.

Storage. Storage, which usually means a hard disk drive, is where the system keeps all your photos. A single digital image may be 1MB or less, but RAW files from recent

How many photos do you have on your system now? If you can answer that question right away – even approximately – then either:
1 you shoot very sparingly
2 it's a very new system
3 you're a sad geek like Jon ... or rather, well done, you're obviously well organised already.

cameras are more like 15–20MB. As you amass a substantial collection of images they quickly start to eat up available disk space. This may encourage you not to shoot too freely; even so, it underlines the importance of having adequate space. Fortunately disks can often be swapped out, and replacement internal drives are much cheaper than buying a new computer! Unfortunately, you need at least two hard disks for backup.

THE SCREEN

The screen, or monitor, gets a section all to itself because it is an often undervalued and yet utterly crucial element of digital imaging. The screen is key to interacting with your images; it's where you assess if they're sharp, if they're too dark or too light, if they're too warm or cool in colour. However, the same image can look quite different on two different screens, and even, sometimes, on the same screen in different circumstances. You only have to wander round a TV or computer showroom to realise that screens can take the same input and make it look very different. So how can you tell if the screen you're looking at is 'right' or not? How can you tell if the screen image is a good guide to the results that may come out of your printer, or be confident that Auntie Mary in New Zealand will see the images in your emails the same way you do?

Part of the answer is to have a good quality screen to start with. It isn't something you can skimp on. If money's tight, go for quality first, not size. A big screen is nice for sorting large numbers of images – in fact for all sorts of reasons – but if it can't show you accurate colour it's a false friend. Take a close look at specification sheets or independent reviews and compare criteria like contrast level, colour saturation, resolution and gamut. 'Gamut' is a measure of the total range of colours that a screen can display. A wider gamut is better, especially if you work with RAW files. This is all part of something called colour management, which is a huge topic in itself.

It's also important to look at where you'll be using the screen. The colours of your surroundings and especially of the ambient light can skew your perception of the image on screen. Glossy screens, which are now common, are also susceptible to reflections. In an ideal world, the surroundings will be neutral in colour and the screen will be the brightest thing in sight. Of course, we don't all live in an ideal world, but sometimes merely repositioning the screen or turning off overhead lights can make life a lot easier.

Above all, however, the screen needs to be properly calibrated. This sounds complicated but it doesn't need to be. It does, however, need to be done. Calibration means measuring the actual colours that the screen is displaying. These are used to build a colour profile. Colour profiles (or ICC profiles) enable different devices, like cameras, computers and printers, to liaise with each other about how colours should be displayed. This complex process is known as colour management.

In Mac OS X you can use the Display Calibrator Assistant. Go to System Preferences: Hardware: Displays, click on Color and then on

Hardware calibration in progress on a computer screen

Colour management begins with the selection of colour space, as mentioned in Chapter 2. Colour space is sometimes used to mean colour profile – as in your camera menu settings. But really it's just a technical way of saying 'these are all the colours that we know how to display in this circumstance' and some of these colour spaces – such as sRGB or AdobeRGB – are defined by international standards.

If that's making your head hurt then, roughly speaking, a digital projector or TV can display fewer colours than a monitor, a decent photo printer can deliver more, and often photo-processing software can handle a far wider range of colours than can be displayed on any of these! Which is why sRGB is the one that most people should get to know about; although it covers a smaller range of colours than AdobeRGB and ProPhotoRGB (used by Lightroom), it most closely matches the range of colours that most digital displays can show, especially projectors. It's also the colour space many online or high-street printers expect and giving them images in a different colour space (eg AdobeRGB) is likely to lead to unexpected results. (CMYK is yet another colour space used by traditional printers, but you shouldn't come across this unless you work in the commercial printing industry or produce books!)

For the ultimate in precise calibration, professionals usually employ a hardware device to measure the colours directly off the screen. Such hardware calibration is not massively expensive and can easily pay for itself in ink that you no longer waste on prints that never look quite right. However, it may be a step too far for the average amateur. Software or visual calibration is an easier and cheaper alternative – in fact it shouldn't cost you anything but a few minutes of your time. (But don't try and use both hardware and software calibration together – that will really confuse the computer!)

Software or visual calibration: the Display Calibrator Assistant in Mac OS X

Calibrate, then simply follow on-screen instructions. In Windows 7, go to Control Panel, type Calibrate in the search box, then click Calibrate display color, then follow the on-screen instructions. The fine detail of the procedure will then depend on which adjustment options are available for any given monitor.

In earlier versions of Windows, calibration tools can be found in Windows Media Center if the system includes it. Otherwise you may have to search online for some help – but it's worth it. And now you have to go and check that Auntie Mary in New Zealand also has a properly calibrated screen...

ACCESSORIES

How do you get the images from the camera onto your computer? Most cameras can connect directly via USB and a cable is often supplied. However, many users prefer to insert the memory card into a card reader. More and more computers have inbuilt card slots, but in their absence external readers are simple and inexpensive.

There's another option if your computer is on a WiFi network. An Eye-Fi card replaces the normal memory card (currently SD format only) and then allows direct connection to the network. You'll have to connect with the (supplied) card-reader first time out to install the software; after that, images can be uploaded to the computer whenever you're within range of the network, without any fiddling with cables.

Most of us still control our computers through the keyboard and mouse. As an alternative to the mouse, many professional photographers and designers use graphics pads, which allow more accurate drawing. They can be very useful if you do a lot of detailed work on images in programs like Photoshop.

Wacom Graphics tablet (Intuos3) (Chiz)

And for all those pre-digital images (or if you still shoot on film) scanning them opens up many more ways to view and share your images. A decent scanner is not cheap but it's a one-off investment. It's also a great way to bring old slides or prints out of retirement.

A printer would seem to be an essential tool too, but in fact these days most of our images never get printed at all. This may be good for forests and – given the scandalous cost of ink – good for the wallet too. If you print relatively rarely it may be

Doing the scanning yourself is time-consuming; having it done commercially is expensive. However if you carefully select the best images (100 or so), **commercial scanning** could compete with the purchase cost of a scanner and should deliver better results.

Monte Paterno, Dolomites (Jon)
A scanned image: scanning brings 'legacy' slides and prints into the digital fold

more economical to use an online or high-street printing service. This may also produce better quality. If you primarily produce your own prints on a high-quality inkjet printer, then it may be worthwhile setting your camera to capture the AdobeRGB colour space (see p43) for a wider tonal range in your finished prints. And this is especially true if you're experimenting with specialist third-party papers, such as those from

Print dialog box in Photoshop

Hahnemühle/Harman, Somerset, Ilford etc. (Just as different films had different characteristics, which gave a different feel to the image, so do inkjet papers, and it may take some experimentation to find the one that you like best).

Also you should ensure that whatever paper you use has a matching colour profile specifically for your type of printer and that you choose to use this setting in your photo-processing software. If the prints are very different in colour from what you see on screen (assuming you have calibrated your screen!), then it may be that you need to tell your printer not to use its own printer profiles (often this is something called ICC calibration, colour controls, or even something as obscure as 'Mode'.) If you end up with both software and printer profiles trying to be used at the same time the prints typically come out with a magenta tone, but sometimes it can be just a 'that's not quite right' look. If that still doesn't solve the problem, you may need to get a custom profile made for your printer and each specific paper you wish to print on.

SOFTWARE

Software is at least as important as hardware to the overall experience and quality of results. Most key software is available for both Mac and Windows. There are numerous apps, including free ones, that will handle JPEG files. The choice is not quite so wide on the Mac, but then too much choice is not always a blessing. On either platform, the number of apps that will manage and convert RAW files is much smaller, but there's still a reasonable choice.

There's a whole list of processes involved in digital photography, and all need software. We'll group these under two main headings: Keeping it safe and Making it look right. There's also the whole area of sharing your images with the wider world, which we'll cover in Chapter 13.

Between what's preinstalled on your system and what the camera maker supplies, you may already have apps to do all these jobs, but it is worth asking how well they do them. Switching between multiple apps, from different sources, with inconsistent interfaces, is also a recipe for confusion and irritation, so a single app that bundles all the tasks into one must be worth looking at. We'll mention specific apps as we go through the various processes.

Keeping it safe
This is an umbrella heading for several processes. It starts with the transfer of images from camera to computer, but there's also the vital question of backup, and the equally important one of how you find your images again.

Transfer and storage
How do you extract the pictures from your camera into more permanent storage? Yes, you copy them to your computer, but how? Are they simply dumped into the main Pictures folder? If you do this, chances are they'll be organised into lots of folders all identified by date. And of course you just know that 14/1/2009 was that fantastic day on the Tongariro Crossing …

This may look as if we're jumping ahead to Organisation and Retrieval, but they are interlinked. If you simply copy your images across, you'll still have to do something later about organising them. And if you simply copy them across then you're probably copying them all, including all the duds, near-misses and shots you took just to check

the exposure. Do you really need these eating up space on your hard disk and making life more complicated?

Being a bit more systematic when you first transfer images from the camera makes every succeeding stage easier – and the good news is you probably already have the software to do it. Something will have been supplied with the camera, for a start. Camera makers' own software is notoriously variable in quality but it's certainly worth looking at. If you're a Mac user, you'll have another great choice in the form of iPhoto. iPhoto is one of those apps which does a bit of everything, so we'll come back to it. There's no equivalent app that comes with the Windows operating system, but Photo Gallery is a free download from Windows Live; Picasa from Google is also free. Neither is as powerful as iPhoto, especially in relation to RAW files, but both will do all the basics. For a more powerful (if more expensive) integrated option, Lightroom is the way to go on Windows (and perhaps a Mac). We'll come back to this too.

Install Picasa and it will automatically start to scan your hard disk for all the photos stored there. This is helpful if you haven't been systematic about organising photos, but if you have a lot of them (especially RAW files) it can take a long time. Not just go-and-make-a-cup-of-tea sort of time but quite possibly in the go-and-prepare-a-five-course-meal league.

Whatever software you choose, it should allow you to see thumbnails of all the images on your camera/memory card and select the ones you want to import. It should also allow you to begin to organise your shots. All the apps named above now have features that help you link photos directly to faces and places, for example.

Backup

It's tragic, but most people don't think about backing up their photos until it's too late. But stop and think about this: when you transfer images to the computer and then format the memory card for re-use, those images only exist in one place. If anything happens to your hard drive, be it fire, theft or hardware failure, they are gone forever. Images can sometimes be retrieved from damaged or corrupted hard dives, but it may be costly and there's no guarantee you'll recover them all. And insurance may cover the monetary value of a stolen computer but what value do you put on 10,000 images, or a lifetime's memories? The cost of a second external hard disk is trivial in comparison.

There are many ways to back up, but there are two main approaches. First, you can backup on import, which saves a copy of everything you select from the camera. Many photo apps can do this automatically, as long as you give them a secondary disk to back up to.

Alternatively, you can backup later. An incremental backup keeps pace with changes on your primary hard drive, which means that edited images are backed up. You'll need a separate software app, like Retrospect or Apple's Time Machine, to handle this. Do check carefully, as some backup software may compress files (notably JPEGs) quite severely.

There are numerous online backup services too. Picasa includes 1GB of free online storage; some camera makers' software also has an online element. It's usually insufficient to store all your pictures but can be an extra safe haven for the most important stuff.

Organisation and retrieval

How do you keep track of all the pictures you have? How do you go about finding a particular shot or subject? This becomes a chronic problem as time goes by and your collection of pictures runs into thousands.

Apps like iPhoto and Picasa can now exploit Face Recognition technology. This means that they are spookily good at finding all the images of a particular person – but they won't actually know who that person is until you tell them. It's rather similar with their location features. Some cameras now have built-in GPS, but in most cases you have to tell the software where the shots were taken – although this can be very simply done either by dragging-and-dropping photos to a map or by typing in any location name in the relevant database (usually Google Maps).

Picasa's Face Recognition abilities are excellent

But faces and places aren't the only ways you might want to organise your photos. For instance, you might at some point want to find all your rock-climbing or mountain-biking shots. Rather than searching for all the locations where you've climbed or ridden, it's much easier if you can search directly, by linking images to the relevant categories. Different apps use different terminology – Tags, Events, Albums, Keywords, Collections and so on – but the basic principle is the

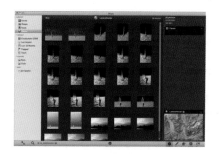

The Places feature in iPhoto

Photoshop Elements' Organizer with images 'tagged' and in 'Albums'

same. You either drag a tag onto a group of photos, or drag selected photos onto the appropriate tag.

Any image can have as many tags as you care to create. These can include location information, especially locations that Google Maps doesn't acknowledge (the names of crags or peaks, for example, are rarely included). We've already mentioned that you'll probably tag different activities. You could use all sorts of other categories too: wildlife or landscape, for example.

And you might want to subdivide further. For example, you could split your climbing photos by grade, or split your mountain bike photos between Trail Centres and Natural Trails. How far you want to take it depends on how often, and how precisely, you might want to look for pictures. Suppose, for example, you might one day want to search for photos of Julia leading rock climbs graded VS and above ... If your tagging system accommodates each of the underlined words, you're in business.

However far you want to take it, the sooner you start the better. It's much easier to tag photos either as you import or immediately after, rather than tackling a collection of thousands in one fell swoop. Of course, if that big collection already exists, there's no alternative. It will still save time in the long run.

Making it look right

This is sometimes called image editing, but this may be confusing: 'editing' can also mean sorting and grading your images (eg 'rejects' and 'keepers'). We could also talk about optimisation, enhancement, or simply 'making it look right'. Insider-speak often refers to 'processing' or 'post-processing', which is the term we use. Whatever you call it, it starts with the recognition that not every photo straight from the camera looks quite as good as it might do.

If you shoot JPEG, then it is perfectly possible to accept every photo exactly as it comes form the camera. However, this rather assumes that you're really careful about your shooting settings, frame every shot perfectly and never hold the camera at a wonky angle. Even so, are you quite sure there aren't a few shots that wouldn't benefit from a little more attention?

If you shoot RAW, then there's no option; your shots will require post-processing before you can do anything with them. This is not as onerous as it sounds: as long as you have the right software, you'll be able to see previews of each shot right away; after this, different software packages work in different ways. We'll take a closer look in a couple of pages.

Basic processing and quick fixes

Most of the apps mentioned so far have basic image-enhancement features. In iPhoto, for example, there's a 'Quick Fixes' tab which reveals the following: Rotate, Enhance, Fix red-eye, Straighten, Crop and Retouch. Most of these are self-explanatory, but let's just reiterate that Fix red-eye, or its equivalent in other apps, is usually far preferable to a Red-eye reduction flash mode (see p77). Retouch is a quick way to smooth over blemishes, such as dust-spots on an SLR sensor or actual spots on skin; more advanced apps have more powerful tools for these tasks. Enhance is a one-click control to improve brightness, colour and contrast, but there are no options: it's take it or leave it. Many other applications will have similar controls.

'Quick Fixes' in iPhoto

If you want more precise control, iPhoto has a range of options under its Effects tab. There are buttons labelled Lighten, Darken, Contrast, Warmer, Cooler and Saturate: again, all pretty self-explanatory. You can click a button more than once to strengthen its effect. You can also apply defined treatments such as B&W, Sepia or Antique. Again, many other apps offer comparable effects.

If you've never investigated image enhancement before, these simple controls are a good place to start. One of the benefits may be to make you more critical; instead of simply accepting what the camera delivers, you start to ask whether an image might look better (whatever 'better' means: we could write a whole book on that one question!) if it was a little lighter, or had more contrast, or more saturated colour. Remember, no image is an exact copy of the world; it is a representation of it, and you have great freedom to decide how you want that representation to look. This experience might encourage you to delve into the more advanced enhancement controls that most photo apps provide; it may also encourage you to think more about what you're doing with the camera itself. It must make sense to think about, say, colour balance or saturation when the scene's right there in front of you, instead of shooting 'blind' and relying on fixing it later.

More about processing

Photo processing is a big topic; there are many books and websites dedicated to nothing else. It's certainly more than we can cover in detail in this book. It's also where many photo apps show their limitations. That's certainly true of Photo Gallery and Picasa; iPhoto still holds up pretty well, but there are also some real big beasts stirring in the undergrowth.

There aren't many computer apps whose name has entered the language. Adobe Photoshop is one of them. Photoshop is the undisputed king of the hill, but it's a heavyweight professional package with an equally heavyweight price tag. And nearly all of its key features, at least as far as the average photographer is concerned, can be found at a much lower price in Adobe Photoshop Elements. Specifically, Elements has full

12

support for RAW files; if kept up to date it can work with RAW files from just about any camera. Full Edit mode has comprehensive adjustment tools, while Quick Edit and Guided Edit modes offer simplified editing tools on the lines of iPhoto and Picasa.

Photoshop Elements also includes an Organizer module for sorting and finding images. You can use Elements to manage the import process too, making it something close to an one-stop shop for nearly all your digital imaging needs. Organizer offers both Albums and Tags for powerful management of your photo collection.

There are, of course, many competing programs, including some free ones, that offer a range of editing tools. The great advantage of Photoshop Elements, and to some degree iPhoto too, is that they are well-established, mainstream apps with a wide user base. They're tried and tested packages and there is a wealth of support available if you're struggling, or want to take your skills to the next level, with many dedicated magazines, books, and online communities. Also from Adobe, and of increasing importance to photographers is Lightroom (see below).

Programs like these allow you to do almost anything with your images that you can think of. We can't do more than outline a few of the options.

Stitching images to build a panorama in Photoshop

Framing options This does not mean (well, not usually) putting a frame around a picture. It means doing things like cropping, straightening, and resizing images. It may also include stitching them together to build a panorama. (Photoshop Elements can do this, iPhoto can't). Virtually all photo apps will have basic tools for these tasks, but more advanced packages will give much more precise control.

Tonal controls Even the most basic apps will have a few controls to lighten or darken images, adjust colours and so on. Advanced apps give far more options for finer control. If you're familiar with the histogram (see p71), then it's only a small step to using the Levels control. This allows you to make adjustments on the histogram display. For example, if an image looks flat because its tones don't cover the full range, Levels allows you very quickly to shift the brightest areas close to white and the darkest almost to black. iPhoto has a basic Levels tool; Photoshop Elements has a more sophisticated one including the ability to work on the Red, Green or Blue colour channels individually.

The companion to Levels is Curves. iPhoto has no Curves

The Levels tool in Photoshop Elements

Bit depth describes the level of detail of colour information held for an image. If an image is called '8-bit' it means that for each colour channel there are 2^8, or 256, possible levels of brightness for each pixel. '16-bit' images have not twice but 256 times as many possible levels.

256 levels per channel may sound a lot but actually if you do substantial adjustments to tone or colour you can soon run out; smooth areas like skies may start to look less smooth.

JPEG images are always 8-bit. RAW images are often saved in camera as 12- or 14-bit, and are then converted to 16-bit in the RAW conversion process. This is just one of the reasons why shooting RAW gives much more room for manoeuvre in making adjustments to tone or colour.

Of the apps mentioned so far, only Photoshop and Lightroom can work with 16-bit images.

tool. Photoshop Elements has a fairly rudimentary version: you can't adjust the tone curve directly but only by proxy through sliders. It's a good way to get an idea of how Curves works, but for the full experience you'll need big daddy Photoshop itself.

Levels and Curves can be used to adjust colour balance, especially when you can work on the individual colour channels. Almost every photo app has some tools for making colour adjustments.

Sharpening Sharpening is one of the most misunderstood, and often most over-used, tools in the box. On TV cop shows the resident computer geek can take a seriously indistinct image, rattle the keyboard for a few seconds (doing what, exactly?) and then reveal a clear image of the villain's face or car registration number.

This, of course, is pure fantasy.

In fact a pedant may say that there is no such thing as sharpening. You can't add detail to an image, you can only make existing detail more visible. This is basically done by increasing contrast, and specifically the local contrast on either side of an edge.

And there are strict limits to how much local contrast you can add before edges become over-emphasised. In over-sharpened images lines and edges appear to have a kind of halo. Practically every imaging app has a sharpening tool, but it needs to be used with care.

Remember: you can always add more sharpening but it's well-nigh impossible to remove it later if it's gone too far. Be aware, too, that sharpening is sensitive to the size of an image. When you view it in small size – say on the camera-back – heavily sharpened images can look great, but when you take them up to full size on a large monitor they can look awful. So it's worth making sure that in-camera sharpening settings are not too fierce.

Local adjustment The controls we've looked at so far all work on the whole image. Sometimes – for instance if you darken the shadows – you'll see the effect clearly in some areas while others appear unaffected. Often, however, you might want to limit adjustments to just part of an image: lightening the foreground for example, while leaving the background unchanged.

BRING IT BACK HOME

12

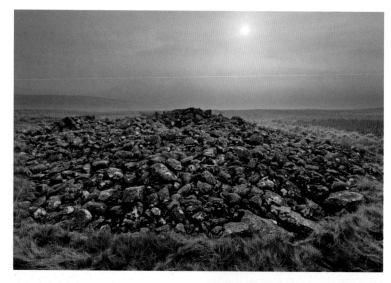

Ancient Cairn, Rough Fell, Lake District (Jon)
A high dynamic range image created using Layers and Layer Masks,
alongside two of the original source images

The most intuitive way to do this is through exposure brushes. These are usually called Dodge (which makes an area lighter) and Burn (which makes it darker); these terms come straight from the old-style darkroom. You simply drag the tool over the area you want to change. Photoshop Elements has these, iPhoto doesn't.

However, these tools are nowhere near as flexible as an alternative method which is available in advanced apps like Photoshop Elements. This method uses Layers and Layer Masks, which sounds complex but is easy to grasp in practice. It's like having two versions of an image, one on top of the other. Suppose the 'front' image appears correctly exposed in most areas but the foreground is too dark. You can lighten the 'back' image using Levels or any other method, then scrape away areas of the front image to reveal the lighter version behind. The advantage of doing this with Layer Masks, rather than any other method, is that if you reveal too much you can just paint it back again. In fact you have complete control over every aspect of the process and can make any other adjustments you wish to either front or back version.

Dust spots on the sensor – and therefore spots on the image – are an occasional fact of life with interchangeable-lens cameras. Many applications have a dust-spot removal tool, where you click on the spot, and the program then 'heals' it using information from a similarly-coloured clear area. Some, like Lightroom, will even allow you to apply dust-spot corrections over a batch of images, although this can produce odd results if the content of the image is not fairly similar between shots!

Wyresdale, Lancashire (Jon)
Dust spots on the image: an enlarged section, and the complete (cleaned-up) image (below)

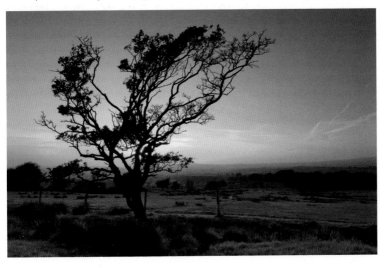

As well as blending different versions of the same image, Layer Masks can also be used to combine entirely separate images. A common example is replacing a dull grey sky with a bright blue one. This is a controversial practice and quite alien to the 'I was there' ethos of outdoor photography. However, there's a more interesting application too. When the tonal range of a scene is too great for a single shot to capture, you can take several shots at different exposures ('bracketing') and merge them later. This takes us into the area of High Dynamic Range (HDR) photography. Photoshop itself (not Elements) has an automated Merge to HDR tool, but it seems a little unpredictable. Doing it 'manually' using Layer Masks is only slightly slower and keeps you in full control.

RAW conversion RAW conversion is a complex process. And it happens to every single image you shoot. If they're saved as JPEGs that just means the conversion process happens in the camera, controlled by settings over which you may have little or no influence. Saving the shots as RAW and converting them on the computer gives a lot more flexibility.

There's a fundamental difference between RAW files and JPEGs once they arrive on your computer too. If you open a JPEG in, say, iPhoto, and tweak the tones and colours, when you hit Save the new values are saved to the original file, overwriting the original (we'll discuss another problem with this later on). But if you open a RAW file, the results are saved as a new image (normally JPEG or TIFF format). The original RAW data is not affected and you can return to it any time you want. This is known as non-destructive editing.

JPEG images are small files because they use compression, but every time you resave (not just close) a JPEG image it applies this compression again. Doing this many times over eventually degrades the original JPEG to a noticeable degree. If this is important to you (and why wouldn't it be?) it is doubly important to back up your images, with two copies, immediately you download them. That way you can always get back to an 'original' quality JPEG image if the working copy gets too degraded.

You're hardly short of choice when it comes to RAW conversion software. If your camera shoots RAW, then the manufacturer will provide some software, although user-friendliness is highly variable. iPhoto and Photoshop Elements can both handle RAW files. iPhoto treats them as 8-bit images, while Photoshop Elements uses the full power of Adobe's Camera RAW processing engine – the same as 'big' Photoshop. However, after conversion, Elements only handles the new images in 8-bit mode. There's a decent list of dedicated RAW converters too: Capture One, Bibble, DXO Optics Pro and more.

But it must be said that all these have recently been somewhat overshadowed by Adobe Lightroom and Apple Aperture (which is Mac-only). Both programmes integrate their organising (Library) and editing (Develop) functions so that you can move seamlessly from viewing a page of thumbnails to tweaking the colours of one or two of them. Essentially both programs show you a preview of the image, which changes to reflect the adjustments you're making. However, they don't create a new file then

The Develop module in Adobe Lightroom

and there, but merely record the adjustments you've made. As and when you need to export a JPEG for the web or send a TIFF to a high-end publisher, the adjustments are applied to the exported file.

Once you get your head round it, it's hard to imagine working any other way. There's no interruption to the workflow: you just move smoothly from Library to Develop and back again. And because you don't create JPEG or TIFF versions until you need them, it saves on hard disk space too. In fact these apps can export directly to the web (and they now integrate with sites like Facebook and Flickr) so you can post images online without leaving a JPEG copy on your own system at all.

Actually, iPhoto works in a similar way, although its editing tools are far less sophisticated. Photoshop and Elements don't; they still expect you to save the results of conversion as a JPEG or TIFF. Some camera makers' software also attempts to emulate this integrated approach; Nikon View NX2 is one example. It just doesn't do it as well. The tools are there but the flow isn't.

FINAL THOUGHTS

Sitting in front of a computer for hours may seem the antithesis of all those things we go to the outdoors for: freedom, movement, light, space. But investing at least a little time at the computer helps to bring those things back home. Putting in enough computer time to keep your images safe, to make them look their best, and to make it easy to find them again, is not a waste but an investment. It helps you bring the outdoors indoors.

And maybe, if you really resent spending time at the computer, you need to spend a little more time thinking about it. Getting your workflow organised, as the professionals would say, is the best way to use computer time efficiently and effectively.

PUTTING IT ALL TOGETHER

FIRST THOUGHTS

This is what it's all about. As we observed at the end of the previous chapter, 'Sitting in front of a computer for hours may seem the antithesis of all those things we go to the outdoors for', but there's a corollary to this. What's the point of taking photographs, even of carrying a camera at all, unless those photos are going to be seen? It was a common enough experience in the days of film: an envelope full of prints arrived and was passed around a few times, then disappeared into the proverbial shoebox, possibly never to be seen again. Maybe we exaggerate, but only slightly.

In the digital age this should never happen. There are more ways than ever to get your photos out there – to share, in the contemporary parlance. Even if you're a hermit and you're only interested in preserving those visual memories for yourself, there are lots of ways to do this.

And this chapter also brings us full circle. What you do with your pictures – how you keep, display and share them – feeds back into what you do out there in the wild with the camera. It'll have a bearing on the type of pictures you shoot and how you shoot them, and maybe simply on how many you shoot. We commented right back in Chapter 1 on the damaging myth that if you shoot enough images you are bound to get a good shot. But blasting away willy-nilly creates other problems.

Biafo Glacier, Karakoram (Jon)
An (intentionally) obvious, and possibly even humorous, piece of manipulation

◄ *Heading to the Monchjochhutte, Bernese Oberland (Chiz)*
Sometimes a different viewpoint makes all the difference

You can guarantee no-one, even your most devoted admirer, is going to relish wading through hundreds of images, including rejects, similars, and just plain dull shots. But you're going to have to do it. Sooner or later, you've got to edit and select. And the more time you spend doing this, the more selective you'll want to be with your shooting in the first place.

Which of these is the most successful photographer – A, B or C? Discuss.

A goes out for a day on the hills and comes back with a hundred so-so shots.

B goes out for a day on the hills and comes back with half a dozen decent images.

C goes out for a day on the hills and comes back with one really great photograph.

Looking back over your images isn't just a way of recapturing the experience. It's also part of the learning curve. Which shots work? Which don't? Which ones really stick in the mind or make people go 'Wow!'? And in all three cases, why?

Don't just accentuate the negative. Look at what you already do well, as well as what you could do better. Try and work out which are the most important areas for improvement. Then see if you can work out whether what needs to change is something technical, like camera settings, or whether it's something that you did, like not seeing distractions within the frame.

For example, if you regularly find that your shots are improved by cropping when you get them on the computer, then think about 'cropping' them before you shoot instead. This is often as simple as zooming in a bit more or taking a few paces closer to the subject. But try and make that connection back from what you see on the computer screen to what you see on the camera screen or in the viewfinder.

But don't get bogged down. Don't try and change everything all at once. Don't look for every tiny fault in every image. Prioritise. And keep it simple.

HARD COPY

As corporate email signatures often say, 'do you need to print this?' That is the first question. Why print your pictures at all? Quite honestly, unless the printing is really top-notch, most pictures look just as good and often better on the screen of a computer, TV or iPad. (At time of writing the iPad really is on a different plane to other mobile devices).

But if you insist, for home printing there are two main options, unless you're looking to spend big money; the ubiquitous inkjet printer and the dedicated photo printer. Inkjets are cheap to buy but expensive to run; it's been calculated that the cost of ink can be the region of £1000/litre, which makes those moans about the price of petrol look trivial ... This expense starts to hurt if you print indiscriminately or you waste lots of paper and ink trying to get the colours just right. Getting reliable results from home printers still isn't as easy as it should be, but we cannot repeat too often: calibrate your screen. This is one step to reducing that waste. The next is: when you find a grade of paper and brand of ink that works well, stick with it. At most you might use one grade of paper for ordinary letters, one for newsletters and the like, and one for 'proper'

photo prints. There are also different qualities of inkjet printers – ones that say 'photo quality' will give far better results than all-in-one office printers, which frankly aren't up to photo printing.

Dedicated photo printers use different ('dye-sub') technology to produce prints that look and feel much more like traditional prints from the high street. The quality can be excellent. The media may appear expensive but when you compare with using photo-grade paper on an inkjet and allow for the fact there's usually less wastage, the difference is not so great. But there are two main snags; you're usually limited to traditional print sizes (6 x 4in or 7 x 5in) and you'll still need an inkjet to print letters and other stuff anyway.

If you print sparingly it may well be more economical to use a commercial printing service. This may also produce better quality. As well as the traditional outlets through chemists and photographic shops, there are print booths in many supermarkets and sometimes at tourist attractions, where you can insert the camera's memory card and get prints virtually straight away. It's often possible to crop, resize and perform other basic adjustments too. Be aware that these services will only accept JPEG files, so you're out in the cold if you shoot RAW. But if you shoot RAW you'll probably want to be doing at least limited post-processing on your computer before printing a copy saved as JPEG.

There's also a range of online print services such as PhotoBox and Snapfish. Once registered, these are generally a breeze to use. Online help will advise on the best colour settings to use on your computer (they'll normally expect files in sRGB colour space, which we mentioned earlier, for example). Prices are usually very reasonable and turnaround times just a day or two.

Both high-street and online outlets often have much more on offer than just the conventional print. Canvas mounting, printing onto mugs, clothing, cushions, fridge magnets are all options …

> Many people struggle to match print and screen for the simple reason that their screen is not calibrated (see p215–7); proper calibration and colour management are a vital first step to getting good prints, whether from your home printer or a commercial service.

Blurb.com: you can create and sell your own photo books (sales are not guaranteed!)

You can also get sets of photos made up into calendars and books. Blurb.com specialises in high-quality books. iPhoto users can also order books direct from within the app. Both have a good range of helpful templates to make laying out books a breeze.

And although it may be an online age there is still something very satisfying about the permanence of a good book or a fine print on the wall. Churning out loads of throwaway prints is a sad waste of resources, but creating carefully selected hard copy of really high quality is a great way to recall those outdoor experiences. They make great gifts for friends, especially the ones who've patiently posed on the edge of a crag or repeated sections of a bike trail for your camera.

13

SHARING

Putting a photo on the wall is a form of sharing (unless you really are a hermit), but of course the word usually refers to online dissemination in all its forms. Photos can be attached to emails or uploaded to social networking and dedicated photo-sharing websites. And of course you can create your own website.

The latest versions of all the main photo apps make these operations easier than ever. Once you have an account with, say, Facebook, uploading photos to an online album can be done with a single click or drag-and-drop. In fact it's so easy that we have to

Facebook: a page of photos; note that they are all watermarked

ask whether it's too easy. There are at least two important issues here.

First, there's the sheer volume of images being uploaded every day. There must be millions of images on the Internet which no-one ever sees. This is an odd sort of sharing! You can carefully select your finest photos and optimise them to look their best, but the world at large is not going to come looking for them. It's quite possible that a Facebook album will never be seen by anyone else, unless you use Facebook to build a network of friends. They at least will probably take a look … You can also set up Groups. A Group which involves the people you walk or climb or ride with is a natural place to share images from your exploits.

Facebook is not a dedicated photo-sharing site. There are many which are, the best-known being Flickr. Again, it's easy to create a 'Photostream' on Flickr, but however good your images are, the world will not beat a path to your door without some help. Adding Tags to your images will help people find them – assuming they are looking for kite-surfing photos or whatever the subject is. The more Tags you add, the better

the chances of your work being seen. Of course, you can also create Groups in Flickr and similar sites to share images with friends or colleagues.

The second issue comes down to what we mean by sharing. Simply allowing friends, colleagues and other interested people to see your images is one thing. However, does that mean that all and sundry can simply help themselves? If a small-scale blogger likes one of your images and posts it on their site without asking, you may never know, and you might regard it as trivial if you did find out. But there are plenty of well-documented instances

Flickr: a page of watermarked photos

of large-scale commercial operators trawling Flickr and similar sites for images which they can use in advertising campaigns and other business outlets. In other words, they're making money from your images and you aren't.

Some people may not care about this. Some people are just happy that their images are being seen and admired. However, what does seem self-evident is that you should have a choice in the matter. You may have gone to considerable lengths to get a shot, and spent more time pimping it in Photoshop Elements. It's your work and it should be up to you to decide who can do what with it. And in general the law supports you. Copyright is yours, automatically, in any photo you create. You don't have to register it or 'copyright' it. In the US, there is a system of copyright registration, which provides additional protection against infringement, but there's no such system in the UK and photographers' groups have vigorously resisted any suggestions of introducing one – we don't need an expensive piece of paper to say it's our image when the law already asserts that!

There are several things you can do to protect yourself and retain control over what can be done with your work.

Read the terms and conditions. Flickr's intellectual property/copyright policy clearly states that it respects your rights and gives a means to register a complaint if you think photos have been lifted from your Flickr pages. Facebook is another story: its 'Statement of Rights and Responsibilities' specifically gives them 'a non-exclusive, transferable, sub-licensable, royalty-free, worldwide license to use any IP content that you post on or in connection with Facebook'. In other words they can – at least in theory – sell your photos on to third parties.

This presents a dilemma for lots of us, not least those who are trying to make a living from our work. We want our pictures seen, as this is an important promotional avenue, but we don't want them to be misappropriated. There may be no absolute guarantees, but there are a few precautions we can take:

Camels, Wadi Rum: watermarks on images can be as obvious or as discreet as you wish

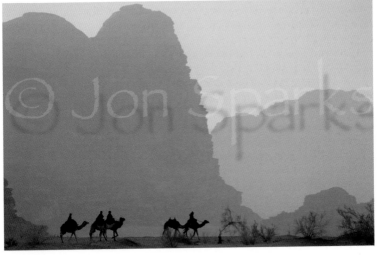

An image being marked as copyright in Photoshop

- Watermark images. Adding a name, website address or © symbol to photos provides some protection against theft. Many apps – mostly the more professional ones – make this easy and automatic. For instance, having created the right settings in Adobe Lightroom, John now uploads new photos complete with watermark to a Facebook album or Flickr Photostream simply by dragging them to the appropriate Collection.
- Mark as copyright. Many apps also allow you to embed your details in the image metadata. In Photoshop Elements, for example, look in File: File Info.
- Keep image sizes down. Don't upload images at larger sizes or higher resolution than necessary. If it's good enough to show online it's good enough to steal and re-use online, but at least smaller files should deter anyone from stealing it to use in print.
- Use privacy settings. On Facebook, for example, you can ensure that your photos are only visible to Friends, and it's also advisable to make sure your Friends know that your photos are private.
- Set licence conditions. You may not care about making money from your photos and you may positively wish to share them. You can still retain a choice over who has the right to use your pictures and how. The best way to set licence conditions is through Creative Commons. As they say: 'With a Creative Commons license, you keep your copyright but allow people to copy and distribute your work provided they give you credit – and only on the conditions you specify here.'

 You can also make your photos available through Wikimedia Commons, but use Creative Commons to set the licence conditions first.

Creative Commons enables photographers who wish to share images to define licence conditions

Truth and consequences

It's a very old cliché that 'the camera cannot lie'. This may even be true in some senses. However, realising that the camera may see things differently should give some pause for thought. And while the camera itself may not lie, many photographs, or images loosely described as photographs, clearly do.

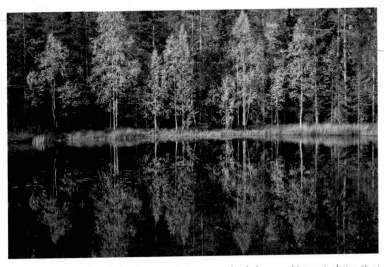

Finnish lake: black-and-white is a very obvious example of photographic manipulation (Jon)

Manipulation is nothing new. It didn't suddenly arrive with the first desktop computers. Various techniques, especially darkroom wizardry, have been used since the 19th century to combine, distort or alter the original image. The claimed first ascent

The 'Glowing Edges' filter in Photoshop: every photograph manipulates reality, but some more than others

of Denali ('Mt McKinley') was supposedly confirmed by a photograph. This wasn't 'manipulated', not even by traditional darkroom tricks. It was just taken on a different peak. However digital imaging has made manipulation more widespread than ever before, and potentially harder to detect.

There are three points to be made about this:

- **It's not easy.** Anyone with a computer and basic image-editing software can manipulate images, but doing it well is not easy; arguably it requires just as much skill and time as photography does. Manipulated images are rife, perhaps most obviously in advertising, but all too often also in news, features, and other supposedly 'factual' branches of the media. Yet, in many cases, even though the manipulation has been carried out professionally, it's still apparent. Sometimes we're not supposed to be fooled: there are many obvious 'fantasy' images. But just as frequently there are clear cues for the alert observer; objects without shadows, or light coming from different directions in different parts of the image.

- **It's not honest.** This is not an issue that concerns everyone. To some, the end justifies the means and that's that. But if you're booking the trip of a lifetime from a brochure or website, you want to be confident that El Dorado or Shangri-La really does look like that. And when you come back, you probably will want to be able to say to your friends, 'this is what it was like'. One of the qualities people value most about their outdoor experience is that it's real. So it makes sense to keep your pictures real.

 Of course, it's not as simple as that. It can be argued that every photograph manipulates reality. If you go for a moorland walk in many parts of England, there'll be pylons and wind-farms scratching the skyline. What is the difference between taking these out of your shots with the cloning tool in Photoshop, and simply framing the shots to exclude them in the first place? It's a tough one. It might make you think twice about excluding them from your shots anyway. Like them or loathe them, they are part of the scenery. Are you taking pictures of the walk you actually did, or the walk you wish you'd done?

- **It's not photography.** Nothing very controversial so far, but this argument is less clear-cut. It does depend what you mean by photography. However, we've already talked about photography's unique ability to catch a moment. For very many people the essence of photography is capturing what you saw, and even suggesting what you felt, at a particular place and a particular time. This view of photography certainly ties in with the way most people view their outdoor activity. That, too, is about being there and living in the moment.

Some artists deride photography because you can take a shot in 1/60sec – or less. This overlooks the fact that, while taking the shot may only occupy that tiny space of time, making it can demand far more, in terms of experience, imagination, concentration, observation and anticipation. And, for the outdoor photographer, simply getting there in the first place. It's also a weak criticism because it would seem to suggest that we should judge the worth of a work of art solely by how much time and effort went into it.

But what really makes this criticism completely misconceived is that photography's 'instant' nature is its greatest strength. Even the greatest artists in other media struggle to isolate and pin down a moment as a photographer can. The skill and satisfaction lie in being able to recognise, even to anticipate, such moments.

Messing around with the image after the fact destroys this quality. It dilutes the purity of the record of the moment and equally dilutes the skill and satisfaction of the photographer in being part of it.

Of course there are different types of manipulation. Cleaning up dust and scratches from a scanned image is a good example of manipulation that hardly anyone could possibly object to. Those blemishes have absolutely nothing to do with what you saw and felt at the time of taking the shot. At the opposite extreme, you could take a Chris Bonington photo of the summit of Everest and combine it with a shot of yourself taken on top of Box Hill. With enough skill you could make it look totally convincing. But it would not be honest, and it wouldn't be photography. And, as Sir Chris would be fully entitled to point out, it would also be theft.

FINAL THOUGHTS

The different threads in this chapter may seem disconnected, but there is at least one thing they have in common. They are all about valuing the photos you take: as a record or an evocation of your outdoor exploits, and as images which other people may find interesting, informative or attractive. If they have value, then what you do with them does matter.

You might look at it this way. If your photos don't have value, why not just delete them? Well, of course, we all need to edit and select, so we all delete some images. But if an image is worth keeping, then it has value and that value should be respected. Valuing images starts with backing them up to keep them safe, and making sure you can find them again. It goes on through making sure they look as good as they can, and with the ways you display and share them. And of course, it feeds back into how you go about shooting images in the first place.

They're your photos. It's your outdoors. Make the most of both.

Camping by the refugio at El Caballo (Chiz)

Appendix I
GEEKSPEAK

AdobeRGB	An internationally defined colour space, significantly larger than sRGB.
Aperture	The opening in the lens through which light passes to reach the sensor. It is described in f-stops, which are the ratio of focal length (f) to the physical size of the aperture. Thus they are written as f/4, f/11 etc.
APS-C or DX	A camera sensor roughly half the area of a frame of 35mm film, or approx 24 x 18mm. Most DSLR cameras use this size sensor.
Bit	A bit is the smallest unit of data, literally 1 or 0 (ie 'on' or 'off') that can be recorded.
Bit depth	The amount of information that can be stored for each colour channel on each pixel: 8-bit, for example, means that 28 (or 256) different values can be recorded.
Buffer	Internal camera memory used to store images while writing to the memory card.
Calibration	Measuring the colours displayed (on the camera, screen or printer) and comparing with a known reference value to build a colour profile.
Camera shake	Blurring of images (usually undesirable) due to inability to hold the camera steady enough.
Chromatic aberration	Inability of the lens to focus all wavelengths of light at exactly the same distance – leads to blue/yellow or red/cyan fringing around edges of objects in an image.
Compact system cameras	Cameras with electronic viewfinders (or screen-only viewing) and interchangeable lenses: like DSLRs without a mirror.
Colour cast	An overall colour tint (usually unwanted) affecting an image.
Colour management	The process of creating, applying and using colour profiles to ensure consistent colour as images move between devices and different computers.
Colour profile	A range of values describing how a device (camera, screen, printer) represents colour compared to a known standard. Used to help make sure devices display colours consistently.
Colour space (or gamut)	The range of colours a given device can display or capture.
Depth of field	Range of distances within which things appear acceptably sharp in the image. Shallow depth of field means a narrow range is in sharp focus, wide depth of field means that a much wider range is in acceptably sharp focus.
Dioptre/Diopter	Measurement of the corrective power of a lens. Some system cameras have dioptre adjustment for clearer viewfinder viewing.
DNG	Digital Negative image file. An open-source file standard for RAW images, intended to avoid older RAW formats becoming unsupported in future.
dpi/ppi	A measurement of resolution in pixels (or inkjet drops) will be used per inch of the image. Computer monitors typically use 72ppi, inkjet printers tend to use 240dpi, commercial printers use 300dpi or more.
Dynamic Range/ Contrast	The difference between the darkest and lightest tones the camera can record (dynamic range) or in the displayed image or scene in front of you (contrast).

EVIL cameras	Electronic viewfinder – Interchangeable lens: see Compact system cameras.
Exposure	The amount of light falling on the camera sensor – determined by combination of aperture, shutter speed and ISO.
	(Or, if you're sitting patiently waiting for the blizzard to stop and produce that perfect snow shot, a condition also called hypothermia!)
Exposure compensation	Deliberate over- or under- exposure to allow for the fact that cameras don't always get it right.
F-stop or f-number	Numbers that indicate how wide the aperture is: see Aperture.
Fill-in flash	Flash used as supplementary light to reduce harsh shadows on nearby subjects.
Filters	Accessory pieces of glass or resin placed (usually) in front of the lens to modify the light reaching the camera sensor. Typical filters include polarising and UV/protective filters.
Flare	A string of coloured blobs disfiguring an image shot towards the sun – caused by reflections within the lens.
Focal length	The distance that a lens would need to be (if it had just a single glass element rather than a compound set of elements) to sharply focus an object at a distance of infinity.
Focusing	Making the image sharp by moving the lens elements so that the rays of light converge at the film sensor.
Four-thirds sensors	The third main sensor size used in system cameras – smaller again than APS-C sensors.
Framing	Composing pictures – without the baggage of rules! Or what you did with a really good image once you've printed it.
Full-frame/FX sensors	A camera sensor the same size as a frame of 35mm film – see p35.
Gamut	See Colour space
Grey/ND grad	A graduated filter placed in front of the lens, that darkens part of the image (usually the sky) to help avoid burned out highlights (or overly dark shadows). Sometimes called a grey grad, sometimes an ND (or Neutral Density) graduated filter.
Highlights	Not something you put in your hair, but the brightest bits of the image.
Histogram	A graph showing the range of tones in the image.
Image stabilisation	Technologies designed to reduce the effects of camera shake. Also called Vibration reduction.
ISO sensitivity	A measure of how sensitively the camera's sensor reacts to light.
JPG/JPEG	An image using the Joint Photographic Experts Group definition of image compression. The only image recording option on many compact cameras.
Macro lens	A lens capable of capturing an image at 1:1 reproduction size.
Megapixel	One million pixels.
Mirror lockup	A function that raises the mirror of an SLR before pressing the shutter button, to minimise vibration.
Noise	Speckly interference in the image: the digital equivalent of grain. Has two parts – colour noise and luminosity noise.
Painting with light	A technique used to light large dark spaces.
Panning	A technique used to create motion blur by moving the camera at the same speed as the subject.
Perfect camera	Doesn't exist!
Pixel	A contraction of 'picture element'. An individual coloured dot, one of many dots (usually millions) making up a digital image.
Pixel size/pixel pitch	The size of each light receptor on the camera sensor. Larger pixel size means a better-quality image.

Polarising filter	A filter that reduces reflections and can increase colour saturation without adding a colour cast.
Post-processing	Any processing done in software after taking the picture.
Prime lens	A lens with a fixed focal length.
ProPhoto RGB	An internationally defined colour range that is larger than Adobe RGB.
RAW	A generic term for image files recording the raw data from the camera's sensor.
RAW viewer	Software used to view RAW files and convert them to more widely useable formats.
Rule of Thirds	A bunch of ROT!
Rules of Photography	Things that are nothing more than guidelines (at best!) and to be broken as soon as you've understood the basic principles!
Scene mode	Groups of settings predefined on the camera, designed to give better results from specific sorts of images than the all-purpose automatic setting.
Shutter	Mechanism which opens for a defined amount of time to allow light to pass through to the camera sensor.
Shutter lag	The delay between pressing the shutter button and the camera taking the picture. Long shutter lag makes action shots difficult.
Shutter speed	The amount of time for which the shutter is open.
SLR/DSLR Cameras	(Digital) Single Lens Reflex camera. Cameras built around a mirror that flips out of the way when the shutter is pressed.
Sensor	The light-sensitive chip that records the image.
sRGB	An internationally defined colour space used by most amateur photographers, high-street and online printers, and virtually all computer monitors.
Superzoom lens	A zoom lens with a very wide focal length range.
System camera	Cameras with interchangeable lenses.
Telephoto lens	A lens with a long focal length – useful for distant subjects or wildlife.
Ultra-zoom camera	A camera with a large focal length range from one fixed lens.
Viewfinder	The part of the camera that the photographer looks through to compose the image. Some compact cameras and lightweight system cameras have no viewfinder, relying on an LCD screen instead.
Vibration reduction	See Image stabilisation.
Visualisation	The process of working out what you want the picture to show before picking up the camera.
White balance	A control that sets the colour temperature of the image to match the conditions seen by the camera.
Wide-angle lens	A lens with a short focal length that captures a wide angle of view.
Workflow	The sequence of actions between taking an image and its end-use.

Appendix II
MOVIES

This is a book about photography, not about video. Shooting stills and shooting movies are two different games. We're not trying to claim that one is 'better' than the other, but they do require different approaches, and shooting video definitely deserves a book to itself.

However, it's increasingly standard for almost any digital still camera to be able to shoot movies as well, so we thought we should at least give a few pointers.

SIZE MATTERS

More and more cameras can now shoot in 'Full HD', more properly known as 1080p. This gives a frame size of 1920 x 1080 pixels. Movies of this quality will display perfectly on an HD TV, and will look excellent on most computer screens. (Many older 'HD' and 'HD-ready' TV sets, and the majority of computer monitors, actually have a lower resolution).

However, many movies will only ever be played through YouTube, Vimeo or similar online channels. The resolution required for these is far lower. True, Vimeo does have an HD channel, but this uses a 1280 x 720 frame size. An iPad screen is 1024 x 768 pixels and most mobile devices have much lower resolution than this.

This is important because high-resolution movie clips can eat up space on the camera's memory card. A 4gb card will typically hold around 20 minutes of 'Full HD' footage, depending on quality (compression) settings. This can be particularly crucial on extended trips. There is no point in shooting movies at a higher frame size setting than you're actually going to need – although you do need to think carefully about this, as there's no chance of scaling the movie up later if you do decide you would like to show it on a big screen.

The pixel count of the movie frame is much lower than still images from the same camera, so you might think that the advantages of larger sensors (p35) are immaterial here. Not so. Larger sensors still give better dynamic range and lower noise levels, especially in lower light levels. They also allow much shallower depth of field to be achieved than small-sensor cameras (which includes the majority of HD camcorders). There's also the availability of super-wide lenses to consider. For all these reasons, shooting video on system cameras allows results and effects that are not possible with compacts and standard camcorders, and many video specialists are now using them for just these reasons.

HELMET-CAMS

Helmet-cams are an increasingly popular option for many extreme sports. Their obvious advantage is hands-free operation, allowing you to shoot at times when you couldn't possibly do so otherwise; some also have voice-activated recording. They also give an athlete's-eye view which is hard to replicate by any other means, but this may be a mixed blessing. That one fixed viewpoint does tend to lose its freshness pretty

quickly. Many users have tried to vary it by mounting the camera in other places: on a chest strap, on the frame or bars of a bike, on the mast or boom of a wind-surfer and so on. Obviously the possibilities of doing this depend on the flexibility of the original mounting system or your ability to improvise.

HANDLING ISSUES

On digital stills cameras, movie shooting is an extension of the Live View mode. On cameras with no viewfinder, of course, Live View is the only viewing mode available to you. If you use such a camera, whether it's a regular compact or one of the new generation of compact system cameras, familiarity with Live View should stand you in good stead when it comes to shooting movies.

On an SLR, on the other hand – as you're probably already well aware – Live View mode is usually relatively awkward to use. This is fair enough; the SLR design is fundamentally built around the viewfinder. Fold-out screens, which are generally just a nuisance when shooting stills, can be an advantage for move shooting.

However, it's hard to resist the conclusion that the newer varieties of system camera should score highly when shooting movies, as they combine the advantages of large sensors with ergonomics which are (or at least should be) more specifically tailored to Live View/movie operation. Sony's Translucent Mirror (SLT) cameras even allow movie shooting using the viewfinder instead of the rear screen, which should produce steadier shots.

And steadiness of shot is a big issue when shooting movies. Fast shutter speeds, combined with image stabilisation, can cover up camera shake when shooting stills, but there's no hiding place when shooting movies, especially with longer lenses. It's a fact of life: we all have wobbly hands. The result isn't (usually) the sort of blur that we see with camera shake in stills, but motion over time, such as the frame jiggling up and down or side to side.

It follows naturally that the first and simplest way to make your movies look more professional, and more enjoyable to watch, is to use a tripod. Any tripod will do for shots where the camera's staying static, but a proper video tripod (or tripod head) will be much better when you want the camera to move. Slower panning shots – such as the camera panning across a big landscape – can be done well enough on a standard tripod, but faster pans or ones where the camera moves in two dimensions (following a downhill skier or mountain biker down a steep slope, for example) are much easier with the right support.

Of course, just as with stills, tripods aren't the only way to stabilise a camera. Careful handling is a start, monopods are often great, and then there are all the other options: bracing the camera against a rock or tree, using a beanbag, using walking- or ski-poles, and so on.

There are many films which do use wobbly camera-work to create an impression of reality and immediacy. *Cloverfield* is a great example, and some of the climactic battle scenes in *The Lord of the Rings: Return of the King* use camera movement very effectively – but it's all done deliberately and in a very controlled way.

There's a particular issue with many cameras when it comes to zooming the lens while shooting. This is one area where compacts may do better than SLRs as they often have a motorised zoom. There aren't yet any motorised-zoom lenses available for system cameras: if someone could come up with, say, an 18–300mm power-zoom

interchangeable lens at a sensible price it would probably be of great interest to many movie-makers. Manual zooming is almost impossible to do smoothly when hand holding the camera and even on a tripod it's hard to keep the zoom rate constant. Practice may help, or it may just convince you to keep zoom shots to a minimum.

It's impossible for us to say much that's helpful about focusing and exposure when shooting movies. Cameras vary too much. Read up on your particular camera and play around with it to get an idea of how it works before shooting any movies that really matter.

EDITING

We've just spent a couple of pages talking about shooting movies. But the fact is that cameras don't shoot movies at all. They shoot movie clips.

Other than a very short YouTube segment, almost every movie you'll ever see is composed of many different clips. Very often they aren't even seen in the same order in which they were shot. The process by which a collection of clips becomes a movie is called editing.

If you're even the tiniest bit serious about making movies, then there's no alternative to getting to grips with editing. The bad news is that this means even more time at the computer, and probably indoors. (You can of course edit on a laptop, and even – sort of – on an iPad). However, serious image editing does require serious hardware. Even so, the final 'render' to produce the finished movie can take much longer than the actual duration of the movie itself. The good news is that the software required for this is easy to use and readily available. In fact there's a very good chance you'll have it on your computer already.

Apple's iMovie is included with all new Macs as part of the iLife suite. Windows Movie Maker should be found on any system running Windows XP or Vista; for Windows 7 it needs to be downloaded from windowslive.com – if you can stomach its demands for large amounts of personal information. If you don't have one of these already, and maybe even if you do, you could also take a look at Adobe Premiere Elements.

All of these are remarkably easy to learn and to use and can turn a collection of clips into something resembling a real movie. As well as reordering your clips and cutting out the uninteresting bits, you can also add in other media, like still photos/slideshows, music and narration.

It's often said that you can rescue a poorly shot movie with good sound – but not vice versa. Sound is a whole extra ball game. If you're serious about video, get a camera which allows you to attach an external microphone – and make it a directional one. This preferentially picks up sound in a 'beam-like' manner from the direction you're pointing it, which helps to cut down on unwanted background noise.

Another tip is to cultivate musical friends who can create you a soundtrack. Copyright applies to sound recordings as well as images and you can't legally use copyright music in a public performance – which includes posting your movie on the Internet. YouTube and co will not support you if you do! There is copyright-free music available – but it can be hard to find exactly the right track.

Of course 'real' movie makers don't just start from a random selection of clips and somehow assemble them into a great movie in the editing suite. The logistics of major movie productions demand that everything is carefully planned far in advance. This

starts with the screenplay, and then the storyboard, which actually sketches out each shot and scene, long before a single frame is shot.

It's well worth doing something like this for any movies you plan to shoot, too. Your 'storyboard' or shooting script might be nothing more complex than a list of wanted shots on the back of an envelope, but it can go a long way to avoiding frustration and ensuring you do have all the shots you need. This is especially important when shots would be hard to repeat, as in an expedition in a remote area. And of course, this doesn't mean you are restricted to only shooting what's on your list. If something happens that wasn't allowed for – a nearby avalanche, a close encounter with some special wildlife – grab the shot and gratefully add it to the mix.

With both images and sound, continuity is a key issue. This means making sure that clips and audio tracks segue into each other without distracting 'jumps' or odd changes of position/clothing/lighting etc. This can be such a challenge on its own that professional film crews will have one or more crew members dedicated to this and nothing else.

Appendix III
LINKS AND FURTHER READING

Jon Sparks
www.jon-sparks.co.uk
http://jonsphotothoughts.blogspot.com
Twitter: @jsparkphoto
Facebook and LinkedIn: Jon Sparks

Chiz Dakin
www.peakimages.co.uk
Twitter: @peakimages
Facebook and LinkedIn: Chiz Dakin

National Academy for Sport and Outdoor Photography
www.nasop.co.uk

ONLINE RESOURCES
Camera and lensreviews: www.dpreview.com
Landscape photography: www.landscapegb.com
Water and light in underwater photography:
 www.seafriends.org.nz/phgraph/water.htm
British Society of Underwater Photographers: www.bsoup.org
Monitor calibration and colourmanagement:
 www.cambridgeincolour.com/tutorials/color-management1.htm
Tony Riley: www.imageplace.co.uk/imagetune.html
Online print services:
 PhotoBox: www.photobox.co.uk
 Snapfish: www2.snapfish.co.uk
 Blurb: www.blurb.com
Social networking and sharing: Facebook: www.facebook.com
 Flickr: www.flickr.com
Licensing: Creative Commons: http://creativecommons.org/choose
Wikimedia Commons: http://commons.wikimedia.org/wiki/Main_Page

EQUIPMENT SUPPLIERS
Principal camera makers:
Nikon: www.nikon.co.uk
Canon: www.canon.co.uk
Sony: www.sony.co.uk
Pentax: www.pentaximaging.com
Olympus: www.olympus.co.uk/cameras
Fujifilm: www.fujifilm.com/products/digital_cameras
Panasonic: http://panasonic.net/avc/lumix/index.html
Samsung: www.samsungcamera.co.uk

Lenses, flash and cameras:	www.sigma-imaging-uk.com
Camera support:	
Gorillapod:	http://joby.com
MonsterPod:	www.monster-pod.com
Velbon:	www.velbon.co.uk
Vanguard:	www.vanguardworld.co.uk

Camera/lenspouches, backpacks, harnesses, Pixel Pocket Rocket, etc:
 www.thinktankphoto.com

Water/dust resistant camera pouches
 www.aquapac.net

Rain guards:
 www.ewa-marine.com
 www.thinktankphoto.com

Waterproof camera cases:
 www.aquapac.net
 www.ewa-marine.com

Rain-X: www.rainx.co.uk

Underwater housings suppliers:
 www.camerasunderwater.co.uk
 www.oceanoptics.co.uk
 (also some good technique articles on both sites)

Waterproof housings manufacturers:
 www.ikelite.com
 www.inonuk.com
 www.10bar.com

Solar chargers: http://www.solartechnology.co.uk/shop/freeloader-pro.htm

Mobile storage:
 Epson: http://tinyurl.com/2wce7uu
 Vosonic: www.vosonic.com
 iPod/iPad: www.apple.com/uk

Eye-Fi cards: http://uk.eye.fi

SOFTWARE:

Picasa:	http://picasa.google.com
Retrospect:	www.retrospect.com
iPhoto, Aperture:	www.apple.com/uk
Photoshop, Photoshop Elements,	
Lightroom, Premiere Elements:	www.adobe.com/uk
Capture One:	www.phaseone.com/en
Bibble:	http://bibblelabs.com
DXO Optics Pro:	www.dxo.com/uk/photo
iMovie:	www.apple.com/ilife/imovie
Windows Movie Maker:	www.windowslive.com
OnOne:	www.ononesoftware.com
Topaz:	www.topazlabs.com

FURTHER READING

Sparks, Jon
The Digital SLR Handbook
(Ammonite Press 2009)

Cornish, Joe
First Light: A Landscape Photographer's Art
(Argentum 2002)

Edge, Martin
The Underwater Photographer
(Focal Press, 4th edn. 2010)

Howes, Chris
Images Below (Caving photography)
(Wild Places Publishing 1997)

Rouse, Andy
Wildlife Travel Photography
(Lonely Planet Publications 2006)

Krogh Peter
The DAM book (O'Reilly Media; 2nd edn. 2009)

INDEX

A

abseiling 121, 128, 130, 131
accessories 49, 105, 217
action . 55, 114,
115, 118, 122, 123, 130, 132, 140, 144,
148, 155, 158, 159, 162, 201, 208
AdobeRGB . 43
aperture. 20, 21, 24, 31, 40, 41, 42,
45, 61, 62, 63, 64, 69, 78, 87, 88, 93, 105,
119, 143, 144, 165, 173, 208, 241
Aperture-priority mode. *See* exposure
autofocus 21, 42, 46, 88, 90, 92, 94, 95, 103,
105, 149
Auto mode . 189

B

background. 20, 59, 60, 63, 68, 78,
79, 97, 102, 114, 118, 119, 128, 144, 146,
155, 165, 173, 176, 210, 225
blur. 146
backlighting . 97
backscatter 175, 176, 177
backup . . 180, 181, 183, 184, 219, 220, 228
batteries 37, 49, 78, 169, 179, 180, 182, 183,
184, 186, 198, 199
beanbag 49, 73, 89, 90, 110, 126, 187, 208,
244
boosting the ISO 128
bouldering. . . . 109, 121, 123, 126, 127, 129
bracketing. 73, 228

C

calibration. . . . 215, 216, 219, 232, 233, 240
camera bag . 110
camera support 49
canyoning 151, 197, 210
care and cleaning 51
carrying the camera . 49, 83, 110, 111, 122,
123, 136, 138, 139, 202, 203, 207
Cartier-Bresson, Henri 17
caving . 206, 208
changing lenses. . . . 161, 197, 200, 205, 207

climbing 9, 81, 83, 109, 120, 121, 122, 123,
128, 130, 131, 132, 206, 210
close-up . . 48, 49, 61, 86, 89, 92, 102, 103,
105, 107, 112, 165, 180
lenses . 92
coasteering . 210
cold. 198
colour . 29, 39, 70, 167–168, 174, 215–217,
224, 233, 240, 242
colour space 43, 216, 218, 242
communication. 116, 127, 141
compact cameras . . 32, 33, 35, 86, 87, 110,
136, 146, 153, 169, 170, 180, 186
Compact System Cameras. 37, 240
composition 55, 56, 61
computers 56, 213, 232, 237
contrast 21, 40, 67, 69, 71,
72, 78, 105, 133, 147, 168, 170, 171, 174,
175, 196, 215, 222, 223, 225, 240
copyright . 235
cropping 36, 39, 46, 154, 165, 224, 232, 233
cycling 109, 135, 136, 144, 201

D

depth. 18
depth of field. 20–21, 42, 47, 61–63, 78, 93,
97, 103, 114, 119, 240, 243
details . 187
digiscoping . 87
digital zoom . 46
dinghy. 153, 159
diving . 169
dry bag 152, 207, 210
dust. 204
dynamic range 40

E

ethical issues. 85
expeditions 49, 179, 184
exposure . . 21, 41, 53, 69–70, 71, 105, 155,
200, 201, 208, 241

Aperture-priority mode.. 41, 61, 93, 105, 119, 189
Manual mode.............. 40, 41, 69
modes...................... 21, 41
Program mode 41
Shutter-priority mode .. 41, 93, 116, 143, 144
extension tubes.................... 92
extreme sports..................... 121

F

face recognition 43, 221
fell-running...................... 118
figures............ 33, 59, 63, 74, 77, 116
film........................... 207
filters 49, 51, 65, 73, 92, 110, 152, 159, 161, 186, 241, 242
fish-eye lens 48, 159
flare..................... 68, 70, 88, 97
flash . 42, 49, 72, 73, 78–81, 105, 128, 147, 147–148, 176–177, 201, 207–211, 222
fill-in..................... 73, 155
Flickr...................... 30, 234
focal length.. 32, 33, 35, 43, 44, 45, 56, 58, 61, 63, 86, 87, 88, 105, 181, 242
focusing
20, 42–43, 57, 58, 61–63, 62, 77, 78, 91, 98, 103, 114, 126, 148, 149, 208, 241
continuous focus 95
manual...................... 103
modes........................ 94
Focusing 94
foreground 12, 15, 20, 27, 42, 45, 57, 58, 59, 60, 63, 73, 113, 157, 208, 225
framing 55, 96, 224, 241
freeze 23, 97, 118, 143, 144, 158
f-stop........................... 12

G

gill scrambling................... 151

H

heat........................... 204
histogram 71, 72, 200, 224, 241
holding the camera 34, 48, 88, 89, 203, 240

I

image noise...................... 40

image stabilisation 34, 48, 49, 61, 74, 88, 89, 117, 203, 241, 244
infinity.................... 62, 63, 241
insurance 187
iPad.................... 56, 184, 213
iPhone........................... 56
iPod........................... 184
ISO .. 23–28, 33, 35, 39, 61, 75, 79, 94, 96, 105, 128, 142, 144, 211, 241

J

JPEG 29, 30, 31, 38, 40, 183, 219, 222, 225, 228, 229, 233, 241

K

kayaking . 83, 152, 153, 154, 157, 158, 159, 185, 187, 197, 210
kite-surfing 159, 162, 165, 213

L

landscape 21, 41, 42, 54, 55, 56, 57, 63, 74, 77
Landscape mode.............. 146, 189
LCD screen............... 155, 198, 199
lens........................... 186
lenses 33, 35, 43–48, 45, 46, 57–59, 61, 70, 73, 83, 86, 93, 103, 119, 132, 136, 144, 147, 159, 180–181
long .. 63, 83, 86, 89, 92, 114, 128, 157, 163, 165
zoom 34, 87, 92, 119, 159, 161, 181, 206, 242
light
hard 67
natural 65
painting with 208, 241
side-lighting 97
soft 67
Lightroom . 94, 96, 216, 220, 224, 225, 227, 228, 229, 236, 248
Live View... 36, 37, 49, 112, 148, 155, 182, 244

M

macro 48, 86, 91, 92, 103, 105
macro lens 180, 186, 241
manipulation.................. 237, 239
megapixel........................ 28

INDEX

memory cards . . . 29, 38, 49, 180, 181, 184, 186, 187, 200, 205
 Eye-Fi . 217
metering 69, 70, 105, 208
monopods. 89, 159, 244
motion 118, 144, 147, 152, 163, 244
motion blur 97, 116, 118, 144, 147, 148, 158
mountain biking 135–138, 145, 244
mountaineering. . . 121, 122, 131, 132, 133, 184, 202
movement. . 23, 55, 103, 118, 143, 146, 158
movies . 12, 243
moving subjects 103

N
nature 63, 67, 81, 85, 96, 167

O
one-shot mode . 95
organisation and retrieval 219, 221

P
panning. . 118, 142, 146, 148, 149, 163, 241
panorama 57, 181, 224
people. . . 53, 112, 113, 114, 118, 119, 132, 145, 154, 157, 187, 193, 201, 206, 208, 210, 211
Photoshop. . . 217, 218, 221, 223, 224, 225, 226, 228, 229, 235, 236, 237, 238, 248
pixel 28, 29, 35, 225, 240, 241
places 53, 132, 187
playback . 18
point and shoot. . 11, 12, 15, 18, 25, 74, 189
polariser 49, 152, 161
portrait 21, 31, 42, 77, 78, 79, 165
Portrait mode 31, 146
post-processing 73, 152, 171, 196, 222, 233, 242
power . 182
pre-focusing 103, 149
prime lens. 44
Program mode. *See* exposure

R
rain guard 195, 197, 205, 206
RAW 30–31, 33, 72, 94, 171, 183, 189, 222, 225, 228–229, 240, 242
red-eye 78, 207, 222

reflector. 68, 73, 81, 104, 105
remote control 105, 112, 127
road cycling . 135

S
safety. 155
sailing 152, 159, 187
salt water. 151, 152, 153, 159, 161, 197
Scene modes. 42
screen . 18
self-timer. 77, 112, 113, 126
sensor 21, 23, 28, 29, 30, 34, 35, 36, 37, 39, 40, 51, 67, 72, 73, 86, 87, 88, 91, 95, 103, 161, 222, 240, 241
 APS-C 35, 36, 37, 43, 240, 241
 DX . 35, 36, 240
 Four Thirds 35, 36, 37
 full-frame 35, 36, 241
 FX. *See* full-frame
shade 72, 102, 128, 155
sharing . 234
shooting from an ab rope 129
Shutter-priority mode. *See* exposure
shutter speed. 12, 21, 23, 24, 40, 41, 42, 48, 61, 69, 79, 88, 93, 94, 97, 105, 116, 118, 125, 143, 144, 146, 157, 158, 163, 174, 203, 208
skiing . 201
SLR 19–20, 29–30, 35, 40, 43–44, 48, 51, 61, 136, 153, 163, 182–183, 198–200, 207, 242, 244
SLT (Single Lens Translucent). 37, 244
snorkelling . 169
snowboarding. 201
snow sports. 201
soft lighting. 80
software 219, 220, 238, 248
solar charger . 183
Sports mode . 146
sRGB. 43
stalking . 97, 99
storage 49, 219, 221
sunlight. . 17, 21, 23, 34, 65, 66, 67, 69, 70, 71, 105, 128, 133, 147, 155, 175, 183
superzoom
 camera . 34
 lens. 46, 88
surfing. 159, 165

system camera 122, 202, 244

T

teleconverter . 88
telephoto lens 146, 242
TIFF . 30, 228, 229
time . 18
trekking . 179, 189
tripod 61, 70, 73, 74,
 89, 93, 103, 110, 126, 152, 159, 163, 180,
 185, 203, 208, 211, 244–245
TTL (through the lens) 19, 20, 61, 177

U

ultra-zoom . 34
underground . 206
underwater . 167

V

video . 12
viewfinder . . 15, 18, 33–37, 44, 56, 61, 103,
 199, 242
 electronic . 37
visualisation 15, 56, 242

W

walking 57, 73, 97, 109, 110, 111, 114, 115,
 116, 118, 131, 138, 185
waterproofing . 152, 153, 155, 161, 169, 207
white balance 39, 53, 72, 168, 203, 242
wide-angle 43, 73, 122, 127, 146, 159, 161,
 181, 201, 206, 242
wildlife 55, 83, 85, 86, 87, 88, 93, 94, 96, 97,
 99, 101, 107, 154, 156, 159, 167, 189, 249
wind . 203
windsurfing 152, 159, 163

INDEX

LISTING OF CICERONE GUIDES

BRITISH ISLES CHALLENGES, COLLECTIONS AND ACTIVITIES
The End to End Trail
The Mountains of England and Wales
 1 Wales & 2 England
The National Trails
The Relative Hills of Britain
The Ridges of England, Wales and Ireland
The UK Trailwalker's Handbook
Three Peaks, Ten Tors

MOUNTAIN LITERATURE
Unjustifiable Risk?

UK CYCLING
Border Country Cycle Routes
Cycling in the Peak District
Lands End to John O'Groats Cycle Guide
Mountain Biking in the Lake District
Mountain Biking on the South Downs
The Lancashire Cycleway

SCOTLAND
Backpacker's Britain
 Central and Southern Scottish Highlands
 Northern Scotland
Ben Nevis and Glen Coe
North to the Cape
Not the West Highland Way
Scotland's Best Small Mountains
Scotland's Far West
Scotland's Mountain Ridges
Scrambles in Lochaber
The Ayrshire and Arran Coastal Paths
The Border Country
The Central Highlands
The Great Glen Way
The Isle of Mull
The Isle of Skye
The Pentland Hills
The Southern Upland Way
The Speyside Way
The West Highland Way
Walking in Scotland's Far North
Walking in the Cairngorms
Walking in the Hebrides
Walking in the Ochils, Campsie Fells and Lomond Hills
Walking in Torridon
Walking Loch Lomond and the Trossachs
Walking on Harris and Lewis
Walking on Jura, Islay and Colonsay
Walking on the Isle of Arran
Walking on the Orkney and Shetland Isles
Walking the Galloway Hills
Walking the Lowther Hills
Walking the Munros
 1 Southern, Central and Western Highlands
 2 Northern Highlands and the Cairngorms

Winter Climbs Ben Nevis and Glen Coe
Winter Climbs in the Cairngorms
World Mountain Ranges: Scotland

NORTHERN ENGLAND TRAILS
A Northern Coast to Coast Walk
Backpacker's Britain
 Northern England
Hadrian's Wall Path
The Dales Way
The Pennine Way
The Spirit of Hadrian's Wall

NORTH EAST ENGLAND, YORKSHIRE DALES AND PENNINES
Historic Walks in North Yorkshire
South Pennine Walks
The Cleveland Way and the Yorkshire Wolds Way
The North York Moors
The Reivers Way
The Teesdale Way
The Yorkshire Dales Angler's Guide
The Yorkshire Dales
 North and East
 South and West
Walking in County Durham
Walking in Northumberland
Walking in the North Pennines
Walking in the Wolds
Walks in Dales Country
Walks in the Yorkshire Dales
Walks on the North York Moors – Books 1 & 2

NORTH WEST ENGLAND AND THE ISLE OF MAN
A Walker's Guide to the Lancaster Canal
Historic Walks in Cheshire
Isle of Man Coastal Path
The Isle of Man
The Ribble Way
Walking in Cumbria's Eden Valley
Walking in Lancashire
Walking in the Forest of Bowland and Pendle
Walking on the West Pennine Moors
Walks in Lancashire Witch Country
Walks in Ribble Country
Walks in Silverdale and Arnside
Walks in the Forest of Bowland

LAKE DISTRICT
Coniston Copper Mines
Great Mountain Days in the Lake District
Lake District Winter Climbs
Lakeland Fellranger
 The Central Fells
 The Mid-Western Fells
 The Near Eastern Fells
 The North-Western Wells

The Southern Fells
The Western Fells
Roads and Tracks of the Lake District
Rocky Rambler's Wild Walks
Scrambles in the Lake District
 North & South
Short Walks in Lakeland
 1 South Lakeland
 2 North Lakeland
 3 West Lakeland
The Cumbria Coastal Way
The Cumbria Way and the Allerdale Ramble
The Lake District Anglers' Guide
Tour of the Lake District

DERBYSHIRE, PEAK DISTRICT AND MIDLANDS
High Peak Walks
The Star Family Walks
Walking in Derbyshire
White Peak Walks
 The Northern Dales
 The Southern Dales

SOUTHERN ENGLAND
A Walker's Guide to the Isle of Wight
London – The definitive walking guide
The Cotswold Way
The Greater Ridgeway
The Lea Valley Walk
The North Downs Way
The South Downs Way
The South West Coast Path
The Thames Path
Walking in Bedfordshire
Walking in Berkshire
Walking in Kent
Walking in Sussex
Walking in the Isles of Scilly
Walking in the Thames Valley
Walking on Dartmoor
Walking on Guernsey
Walking on Jersey
Walks in the South Downs National Park

WALES AND WELSH BORDERS
Backpacker's Britain – Wales
Glyndwr's Way
Great Mountain Days in Snowdonia
Hillwalking in Snowdonia
Hillwalking in Wales
 Vols 1 & 2
Offa's Dyke Path
Ridges of Snowdonia
Scrambles in Snowdonia
The Ascent of Snowdon
The Lleyn Peninsula Coastal Path
The Pembrokeshire Coastal Path
The Shropshire Hills
The Spirit Paths of Wales
The Wye Valley Walk
Walking in Pembrokeshire
Walking on the Brecon Beacons
Welsh Winter Climbs

INTERNATIONAL CHALLENGES, COLLECTIONS AND ACTIVITIES
Canyoning
Europe's High Points

EUROPEAN CYCLING
Cycle Touring in France
Cycle Touring in Ireland
Cycle Touring in Spain
Cycle Touring in Switzerland
Cycling in the French Alps
Cycling the Canal du Midi
Cycling the River Loire
The Danube Cycleway
The Grand Traverse of the Massif Central
The Way of St James

AFRICA
Climbing in the Moroccan Anti-Atlas
Kilimanjaro: A Complete Trekker's Guide
Mountaineering in the Moroccan High Atlas
Trekking in the Atlas Mountains
Walking in the Drakensberg

ALPS – CROSS-BORDER ROUTES
100 Hut Walks in the Alps
Across the Eastern Alps: E5
Alpine Ski Mountaineering
 1 Western Alps
 2 Central and Eastern Alps
Chamonix to Zermatt
Snowshoeing
Tour of Mont Blanc
Tour of Monte Rosa
Tour of the Matterhorn
Trekking in the Alps
Walking in the Alps
Walks and Treks in the Maritime Alps

PYRENEES AND FRANCE/SPAIN CROSS-BORDER ROUTES
Rock Climbs in The Pyrenees
The GR10 Trail
The Mountains of Andorra
The Pyrenean Haute Route
The Pyrenees
The Way of St James France & Spain
Through the Spanish Pyrenees: GR11
Walks and Climbs in the Pyrenees

AUSTRIA
Trekking in Austria's Hohe Tauern
Trekking in the Stubai Alps
Trekking in the Zillertal Alps
Walking in Austria

EASTERN EUROPE
The High Tatras
The Mountains of Romania
Walking in Bulgaria's National Parks
Walking in Hungary

FRANCE
Ecrins National Park
GR20: Corsica
Mont Blanc Walks
Mountain Adventures in the Maurienne

The Cathar Way
The GR5 Trail
The Robert Louis Stevenson Trail
Tour of the Oisans: The GR54
Tour of the Queyras
Tour of the Vanoise
Trekking in the Vosges and Jura
Vanoise Ski Touring
Walking in Provence
Walking in the Cathar Region
Walking in the Cevennes
Walking in the Dordogne
Walking in the Haute Savoie North & South
Walking in the Languedoc
Walking in the Tarentaise and Beaufortain Alps
Walking on Corsica

GERMANY
Germany's Romantic Road
Walking in the Bavarian Alps
Walking in the Harz Mountains
Walking the River Rhine Trail

HIMALAYA
Annapurna: A Trekker's Guide
Bhutan
Everest: A Trekker's Guide
Garhwal and Kumaon: A Trekker's and Visitor's Guide
Kangchenjunga: A Trekker's Guide
Langtang with Gosainkund and Helambu: A Trekker's Guide
Manaslu: A Trekker's Guide
The Mount Kailash Trek

IRELAND
Irish Coastal Walks
The Irish Coast to Coast Walk
The Mountains of Ireland

ITALY
Gran Paradiso
Italy's Sibillini National Park
Shorter Walks in the Dolomites
Through the Italian Alps
Trekking in the Apennines
Trekking in the Dolomites
Via Ferratas of the Italian Dolomites: Vols 1 & 2
Walking in Sicily
Walking in the Central Italian Alps
Walking in the Dolomites
Walking in Tuscany
Walking on the Amalfi Coast

MEDITERRANEAN
Jordan – Walks, Treks, Caves, Climbs and Canyons
The Ala Dag
The High Mountains of Crete
The Mountains of Greece
Treks and Climbs in Wadi Rum, Jordan
Walking in Malta
Western Crete

NORTH AMERICA
British Columbia
The Grand Canyon
The John Muir Trail
The Pacific Crest Trail

SOUTH AMERICA
Aconcagua and the Southern Andes
Torres del Paine

SCANDINAVIA
Trekking in Greenland
Walking in Norway

SLOVENIA, CROATIA AND MONTENEGRO
The Julian Alps of Slovenia
The Mountains of Montenegro
Trekking in Slovenia
Walking in Croatia

SPAIN AND PORTUGAL
Costa Blanca Walks
 1 West & 2 East
Mountain Walking in Southern Catalunya
The Mountains of Central Spain
Trekking through Mallorca
Via de la Plata
Walking in Madeira
Walking in Mallorca
Walking in the Algarve
Walking in the Canary Islands 2 East
Walking in the Cordillera Cantabrica
Walking in the Sierra Nevada
Walking on La Gomera and El Hierro
Walking on La Palma
Walking the GR7 in Andalucia
Walks and Climbs in the Picos de Europa

SWITZERLAND
Alpine Pass Route
Central Switzerland
The Bernese Alps
Tour of the Jungfrau Region
Walking in the Valais
Walking in Ticino
Walks in the Engadine

TECHNIQUES
Geocaching in the UK
Indoor Climbing
Lightweight Camping
Map and Compass
Mountain Weather
Moveable Feasts
Rock Climbing
Sport Climbing
The Book of the Bivvy
The Hillwalker's Guide to Mountaineering
The Hillwalker's Manual

MINI GUIDES
Avalanche!
Navigating with a GPS
Navigation
Pocket First Aid and Wilderness Medicine
Snow

For full information on all our guides, and to order books and eBooks, visit our website:
www.cicerone.co.uk.

Cicerone's mission is to inform and inspire by providing the best guides to exploring the world

Since its foundation 40 years ago, Cicerone has specialised in publishing guidebooks and has built a reputation for quality and reliability. It now publishes nearly 300 guides to the major destinations for outdoor enthusiasts, including Europe, UK and the rest of the world.

Written by leading and committed specialists, Cicerone guides are recognised as the most authoritative. They are full of information, maps and illustrations so that the user can plan and complete a successful and safe trip or expedition – be it a long face climb, a walk over Lakeland fells, an alpine cycling tour, a Himalayan trek or a ramble in the countryside.

With a thorough introduction to assist planning, clear diagrams, maps and colour photographs to illustrate the terrain and route, and accurate and detailed text, Cicerone guides are designed for ease of use and access to the information.

If the facts on the ground change, or there is any aspect of a guide that you think we can improve, we are always delighted to hear from you.

Cicerone Press
2 Police Square Milnthorpe Cumbria LA7 7PY
Tel: 015395 62069 Fax: 015395 63417
info@cicerone.co.uk www.cicerone.co.uk